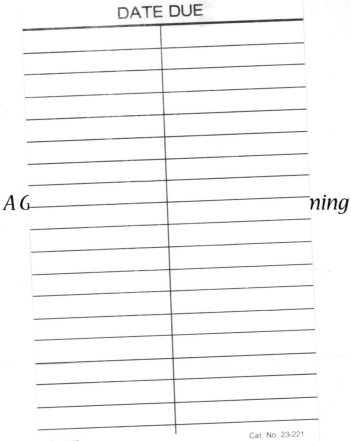

DATE DUE

A G *ning*

BRODART Cat. No. 23-221

**Backbeat
Books**
San Francisco

Published by Backbeat Books

(Formerly Miller Freeman Books)

600 Harrison Street, San Francisco, CA 94107

books@musicplayer.com

www.backbeatbooks.com

An imprint of the Music Player Network

United Entertainment Media

Distributed to the book trade in the U.S. and Canada by

Publishers Group West, 1700 Fourth Street, Berkeley, CA 94710

Cover Design: Peter Grame

Interior Design and Composition: Leigh McLellan Design

Production Editor: Mike Kobrin

Library of Congress Catalog Card Number: 99-65884

ISBN 0-87930-707-2

Printed in the United States of America

02 03 04 05 06 5 4 3 2 1

"Quincy McCoy has not come away from 30 years in the radio business empty-handed. He's written a great book about the life of the business—and the business of life. It's all here—from what to play to how to play it. But the accent is on the main ingredient in this mix, the straw that stirs the drink, YOU! And with that approach, McCoy has transformed radio from just another gig into a powerful tool for community action, social justice, and personal empowerment. Call it what you will—heart, soul, attitude—this book has it. And it's told with all the grace, style, and clarity of Louis Armstrong hitting a high C."
—Laurence B. Chollet, Book Reports, BPI Entertainment News Wires

"One of the most painful things for radio people to acknowledge is not just where radio is less than it could be, but where it is less than it used to be. It's a discussion that's essential, however, and Quincy McCoy conducts it with the deft touch of one who knows the business both from the inside and the outside."
—David Hinckley, critic at large, The Daily News

"When I was confronted with a problem or needed information concerning a certain issue, I would seek out an individual who was an expert in that area. Quincy McCoy is who veterans and beginners alike turn to when the truth is needed. This book will become a 'must read' resource for broadcasters—in schools and out—for years to come."
—Cathy Hughes, President and CEO, Radio One, Inc.

"Quincy McCoy has been an inspiration for my staff and me for many years. His unique and creative perspective has given me valuable insight on how to reinvent even the most mundane of tasks. In fact, the door to my office is adorned with 'Quincy Quotes,' alongside many of the greatest philosophers of our time."
—Danny Buch, Senior Vice President of Promotion, Atlantic Records

About the Author

Quincy McCoy has more than thirty years' experience in the radio and recording industries. A native of Utica, NY, McCoy began his on-air career at his local radio station, WTLB, in 1968. Over the years, he has been an on-air personality, program and music director, operations manager, and consultant at various AM and FM radio stations in cities throughout the U.S., including New York, San Franciso, Houston, Atlanta, St. Louis, Fort Lauderdale/Miami, and Washington, D.C.

McCoy entered the record side of the business in the late seventies, to become director of promotion and special projects for Fantasy Records. As an executive at this prominent label, he spearheaded numerous promotion and marketing campaigns. After five years, he returned to radio.

In 1995, McCoy joined *Gavin*, a leading trade magazine for the radio industry, as its Urban editor. Now a senior editor, McCoy has expanded Gavin's coverage of Urban radio with his thought-provoking columns that reach beyond music programming to dealing with the social and political state of Urban radio. His efforts earned him the Peter Brock Award for feature writing.

McCoy has also contributed to *Gavin GM*, a monthly magazine for radio general managers and professionals, and the London-based *Music Business International* magazine. He is a popular speaker at several major broadcasting conferences.

Contents

Handling Invisible Powers

by Stanley Crouch

Quincy McCoy is one of those people who makes sure that the most civilized way of doing things maintains a position in the business side of life. In an era such as ours, that is more than a little important, since so much has given way to the collective blues of suffering from the rude and the crude. McCoy is another kind of person. When I first met him some twenty years ago in New York, he was so silent or given to such short responses to whatever was being said that I would never have imagined that he would do so much in the world of radio or that he would become such a witty and insightful industry writer. He didn't seem particularly talented, though Teri Hinte of Fantasy Records, who seems never wrong, had a lot of confidence in him.

I have since learned why in ever greater detail. For one thing, McCoy, as his book will attest, understands the complexity of the connections that make our contemporary lives what they are. It is no secret to him that where you come from and how you are reared still submits to the national experience served up by our media. However different we might be in terms of our ethnic, religious, or class backgrounds, we are all linked by so many encounters with mass communications that, as one black woman said to me, she found herself in Africa relating more to white Americans than to Africans because of the television and radio experiences of weekly shows and recordings that they had in common. This is a point that Ralph Ellison used to make as well. When he was a boy growing up in Oklahoma City and had built himself a crystal set in the early days of radio, those airwaves were not segregated. This meant that every American who had the technology could get in on whatever was being offered, which created a transcendent Americana achieved through our machinery.

It is in the world of that medium, radio, that Quincy McCoy has made his mark. Radio, in the professional sense, once it moved beyond the status of novelty and went on to reshape the twentieth century, was always many things. Yet radio is, finally, quite often about the voice functioning on the invisible level of music. The radio personality, from disc jockey to reporter to talk show host to interviewer to narrator, is a guide and an entity, one known by sound and not by sight. It was the first talking appliance, if we can put it in that category. It was also a profession in which actors were able to play parts they could not have on stage or in film. In *Radio Days*, Woody Allen made a big joke of how the medium liberated people into careers early on because one's voice could do the complete trick. The big hero could be played by a little guy with a charismatic voice. The ravishing beauty could be a wallflower who created extraordinary fantasies through the quality of her voice.

As a man who has long been thinking through the problems of reaching audiences, of providing entertainment while slipping in more than a little information, more than a little humor, and more than a little good taste, McCoy has written a book that will take the subject around to some very fresh and informative places, whether or not they are in the business. This is because McCoy sees everything within a wide context and recognizes all of the various levels of individual talent, product, programming, markets, and how they interplay with the ongoing dilemma of how to predict what this fickle and equally invisible beast known as the public will like and how we can successfully offer them some quality it might not expect and might not be expected to enjoy.

Along the way, with curt but witty sentences and many appropriately representative anecdotes, Quincy McCoy offers us fresh perspectives on something we thought we knew from root to snoot. He creates the feel of his work and supplies the kind of clarity that allows the reader to step right into the circumstances, becoming one with the writer as well as the environment. That is essential to telling a story that is partly autobiographical, partly the portrait of an industry, partly the tale of how to make it in that world and what that world might do at its very best. That this man covers so much territory with so much humor and style makes this book something those interested in as well as those bored by the idea of radio will gain much from. One might ask more than that, but I don't know how such asking would apply to a job so well done.

Author's Note

*"I question and soul-search constantly into myself to be as certain as I can that
I am fulfilling the true meaning of my work, that I am maintaining my
sense of purpose, that I am holding fast to my ideals, that I am
guiding my people in the right direction."* —Martin Luther King, Jr.

One day, on a thirty-minute break from writing, I picked up my six-year-old son Louie from school. When he got in the car, he asked me, "So, what is your book about?" I looked at his smiling face in the rearview mirror, which gave me my answer. "Fun. It's about putting fun back on the radio. Radio needs to get back to what you and your friends do best, having fun."

Don't get me wrong. I'm not one of those old guys who thinks that all of modern radio is bad and without merit. Just the opposite; I think radio today has the potential to do great things, but it has become complacent and too dependent on research and technology. Radio, you're not really listening to your listeners, are you? You don't serve your communities any more, do you? I would like this book to help jump-start a discussion about what is right and what is wrong with radio. With consolidation's massive alteration of the radio landscape and the advent of the new millennium, right now is the perfect time to take a stand and get that discussion going.

This book clearly favors the creative side of the business; this was never intended to be a neutral book. Radio is too entwined with my life for me to write objectively about it. I'm passionate about it as an art form, and fearful that it is losing its creative edge. There are already too many books on research and business concepts, but not nearly enough on how people can make radio more creative and exciting.

Another motivation for this book was that there wasn't one like it when I started my radio career. There wasn't a book in which radio personalities or programmers could examine and compare knowledge, insights, and shortcuts. I hope that this book will be an informative guide for anyone interested in entering radio or moving forward in their broadcasting career. But most of all, I hope this book inspires readers to be like the passionate people in the chapters ahead; all enamored with the intimacy and the power of creative radio.

Acknowledgments

First, I want to thank the Lord, from whom all blessings flow. Thank you for your faith in me, that such a glorious mission has been placed in my hands.

I thank the Reverend Herbert Daughtry for pointing out the doorway to faith. Your message echoes in my heart and mind: "Keep the Lord first, and He will keep you first."

I'm greatly indebted to Ben Fong-Torres for his inspiration, wisdom, and meticulous work. I am truly blessed to have him as a friend and as the editor of this book.

At *Gavin*, thanks to Alexandra Russell for her valuable editing, assistance, and tireless support. Thanks to Peter Grame for his wonderful cover concept. Thanks to Reed Bunzel and Tony Sanders for their resources and support, and Annette Lai for her help. Thanks to Bob Galliani, who made it possible for me to return to the Bay Area and work at *Gavin*. Many thanks to David Dalton, the CEO of *Gavin*, for the necessary time off to complete this project.

I'm deeply grateful to Matt Kelsey, publisher at Miller Freeman Books, and his staff for having the courage to publish this first-time author. I also want to acknowledge Mike Kobrin for his editing and input; the fact that he is a lover of jazz and a kindred creative spirit made our collaboration a pleasure.

Thanks to my sisters, Mel, Margaret, and Darlene, and my children, Tom, Richard, and Nirvana, for their confidence in me. Thanks to "my boys," Dave, Bernie, Gene, and Jones, back in Utica for always letting me play the records at parties. Who knew?

Very special thanks to my wife, Carla, for her valuable input and insightful critiquing of this project. I thank her and our son, Louie, for their patience during the writing of this book.

Thanks to: Joe and Evie Tierno, Bob and Susie O'Donnell, Paul Dunn, Andy Young, Tim Hart, John Long, John Larrabee, Charles "Chaz" McCatherin, Earl "The Pearl" Lewis, Dr. Dave Dunaway, Don Cox, Alan Leininger, Bryan Adams, Spencer Abbott, Cliff Batuello, Bob and Sophia Perry, Patty Schneider, David Gardiner, Bob Hopper, Dave Sholin, Vinny Brown, Sam Weaver, Rose Galvez, John Mullen, Les Davis, Len Triola, Larry Chollet, Doug Crosetti, Norman and Selma Leighton, Stanley Crouch, Terri Hinte, Orrin Keepnews, Robert "Hollywood" Rhodes, Lorraine Nightheart, Jeff Nemorovski, Hillman Sorey, III, and Wayman Jones, who helped shape my thinking over the years.

A special thanks to Yo Yo Ma for his *Inspired by Bach* cello solos which filled my office with warmth and inspiration on many a cold winter morning. His relationship to the cello echoes the intimacy that radio and listeners should enjoy.

Special thanks to all of my friends and colleagues who allowed me to interview them for this project. Thanks for your honesty, courage, and creative spirit: Lee Abrams, Doug Banks, Buzz Bennett, Brian Carter, Jerry Clifton, Paul Drew, Terry Fox, Verna Green, Carl Hamilton, Cathy Hughes, William Kennard, Dan Ingram, Batt Johnson, Chuck Leonard, Karen Lightfoot, Helen Little, Jo Maeder, John Mason, Neil McIntyre, Paige Nienaber, Tom Poleman, Dave Sanborn, Michael Spears, Bill Tanner, Jay Thomas, and Robert W. Walker.

I dedicate this book to the memory of my mother, Emma Lou Reed, for her belief in me, and to my father, Fred Reed, Sr., for his undying dedication to her.

The Yellow Light

When I was a kid I was afraid of the dark.
But it was that fear that led to my love for radio.

In our house in upstate New York, my bedroom was next to the bathroom. My father kept a night light on in the bathroom, but whenever someone went in, they would close and, for some unfathomable reason, lock the door leading to my room, putting me in complete darkness. I would wake up and sit up in my bed with the covers pulled tightly around me. Across the room was the only light, which was mounted on a wall over my desk. In the darkness, the distance between me and that light seemed as wide as an ocean. Besides being too scared to get out of bed and wade through the black water to turn the light on, there was the fear that my parents would yell from the bathroom to stop wasting their electricity; or, if it was one of my three sisters, I'd be called a scaredy cat. So I would sit still and wait for the sound of the flushing toilet, the opening of the door, and the secure feeling that the little night light produced when it re-entered my room.

But nine times out of ten, whoever was in the bathroom would do their business, flush, and make their way back to bed, leaving my door locked, imprisoning me in darkness. I've always suspected that this was done by design—a family conspiracy to drive me mad. The only way to unlock the door was to go down an even darker stairway, through the empty house, and up another flight of stairs into the bathroom. I didn't have the courage.

Many nights I would sit there, imagining threatening shapes in the dark and cursing my family for their evil scheme. Of course they were all in on it—

why else would they *lock* the door? My requests for a bedside lamp were always refused with the oft-repeated but nonetheless vague reference to poverty.

Then, one night everyone in my family wanted to watch *The Outer Limits* on television, and I got an idea. I refused to go along unless they all promised me that when they went to the bathroom late at night, they wouldn't lock the door. Everyone agreed. "How gullible can he be?" they must have giggled to themselves.

We all watched *The Outer Limits*. It was the episode about the ventriloquist's dummy that was alive and drove its owner insane. You've already guessed: Someone went to the bathroom that night and locked the door. This time I got up and tried to force it open, but failed. For the first time, I walked through the black water to the wall light over my desk, but it wouldn't come on. Terrified, I jumped into bed. Out of the corner of my eye, I thought I saw the dummy from the TV show coming toward me. I reached down for my shoes—weapons against that wooden-headed invader—and hit my head against the floor-model Philco radio that filled in as a nightstand next to my bed. I cursed, but then it hit me; I turned it on.

I've never forgotten the beautiful warm yellow light that came from the face of that radio. It glowed like a jewel in the night, filling the area around my bed with a safety blanket of radiance. With my newfound courage, I began to turn the dial and, in the process, discovered a large array of stations—hometown stations in upstate New York, and others as far north as Canada and south to the Carolinas.

Radio became a habit, then an addiction. I would retire to my room earlier and earlier in the evening to listen. I began collecting favorite stations and remembering when the best time was to pick up their signals. The radio helped cure my fear of the dark. My little room became my sanctuary—a holy place of comfort and refuge. The radio became a close friend, one who always had a smile on his face, good news, and a joke or two to share. That feeling of comfort was a lesson that I never forgot, especially when, years later, it was my turn to be the friendly voice coming out from behind the yellow light.

1

A Creative Anarchist

I've been a part of the radio business for more than thirty years. In the beginning (1968), my dream was just to be good enough on the air to win the admiration of my friends and family. But radio got into my blood, took over my life, and soon I had only one desire: to be great. I wanted to be on the A list with guys like Dan Ingram, Chuck Leonard, and Larry Lujack. I wanted to work at legendary Top 40 stations like CKLW in Detroit and KFRC in San Francisco. I wanted to

A young Quincy McCoy at WTLB, circa 1968.

do great commercial breaks that would be envied and imitated. I wanted to be part of an exciting station aircheck; I wanted to work with talented people who were allowed the freedom to entertain.

I feel sad for most of today's radio (dare I call them) personalities, because they can't relate to that type of passion. It's the rare radio station that employs a full lineup of personalities who are paid to entertain. Radio with depth, energy, and style has faded from the airwaves, replaced by formula products that are safe, boring, and detached from their listeners.

I remember driving up and down the East Coast with an Ampex reel-to-reel machine. After I found the strongest frequency, I would make my own personal airchecks of great Top 40 stations like WKBW, WABC, WMCA, WAVZ, CKLW, WLS, WAPE, and WAYS. I may be dating myself with some of these call letters, but these stations were the learning institutions for many personalities and programmers. Sadly, most of the creative personalities that these great stations nurtured have faded from the airways.

Back in the day, each station bore its own sound. Each was special in its cadence, presentation, and personality. They entertained and served their communities. Any one of these great stations would be an excellent example of how to brand a station in today's world of radio-by-the-numbers. Branding, in short, is the station's identity. It's the way the station forms an emotional connection with the listeners. A distinct attitude that appeals to the listeners' sense of the world, real or imagined. A station they don't just listen to, but one they feel a part of. But more importantly, these stations were examples of creative radio at its best. They worked within the confines of tight playlists, yet created an exciting "showbiz" product, combining theater-of-the-mind techniques with energy and humor. Their unpredictable style attracted listeners hoping to hear some outrageous stunt or the next big hit.

Creative radio has been transformed by time and chance into an impassive emotional landscape. But it's impossible to permanently constrict the creative power of radio.

Commercial radio has always been about making money. Today the bottom line is even more important, especially to large radio conglomerates scrambling to pay back their Wall Street investors. The craving for revenue has diminished radio's appetite for entertainment. A general manager I worked with in the eighties loved to say, "Radio is not an art form, it's a business." He was wrong then and he's still wrong. Radio is both. Without good ratings from entertaining the listeners, it's impossible to reach revenue goals. It takes a marriage of art and commerce to produce great radio stations.

So what happened to radio's desire to entertain? First, it was derailed by its insatiable appetite for research. In the late 1970s, research became gospel. Our industry abandoned talent as its primary source of competitive advantage, and

instead embraced research salvation mantras like "more music, less talk," and copycat name brands like LITE, KISS, or HOT—all part of a universal new winning strategy. What made these strategies so short-sighted was everyone's ability to copy them.

Then, the search for great radio talent around the country slowed. The majority of radio stations became stripped of personality—and personalities. The human touch was gone. In its place was the safe, predictable sound of radio-by-the-numbers. Many operators embraced this trend because it was cost-efficient. It offered the option of not paying big money for some zany morning man or wild night jock, because the research indicated that all they had to do was play the best-testing records and shut the air talent up.

This kind of thinking has dominated modern radio, and unfortunately, it is leading us into the next millennium. From city to city, stations sound frightfully alike, entrenched in a transparent strategy for success, while another generation of air talent never gets a chance to develop. The time is right for creative anarchy.

We've deregulated our industry. Now, it's time to deregulate our thinking. Guided by research alone, radio has become inflexible in its approach to reaching and keeping customers. I would prefer that the industry use the word *customer*, as opposed to *listener*, because *customer* has character; it's friendlier, warmer, and more personal. A customer is treated like a unique person. Smart businesspeople bend over backwards trying to keep their promises to their customers. On the other hand, the word *listener* has a cold, statistical, feel to it. Sadly, all the emotional life has been researched out of it, stripping people of their individuality, diversity, and spirit; neatly categorizing them as one faceless group.

Today's customers are media-savvy and expect more from radio than it's been delivering. Times have changed, and it's time for radio to do the same. Some people would argue that radio has changed. It has. There have been some amazing technical advances. But when it comes to human interaction, we've reversed directions. Creative, flexible thinking in dealing with customers has lost ground to rigid corporate thinking. I believe that organizations that value suppleness remain vital and creative. Step back. Look, listen, and communicate *directly* with your customers. Passive research has made us passive and inclined to assume we know what listeners want and don't want. The harder we hold on

to specific assumptions, the more likely there's gold in letting them go.

In radio today, we have paperless studios. Computers now program the music, and have enhanced our stations' sounds and eliminated the tedious work. These improvements should enable air talent to spend more time working on creative presentation and ways to relate to their listeners—that is, if creativity were truly part of our vision. But even with all our technological superiority, we're stuck in a groove. The old saying applies: "We have met the enemy and he is us."

Radio has become a *second choice* for young listeners—even though it's a free form of entertainment. Prerecorded cassettes, CDs, and video games are now the top preferences. This proves that we have become unresponsive to what our listeners want from us. The proliferation of tape decks and CD players in cars and the growth of Internet radio illustrate what listeners want. Radio used to make a difference in people's lives. Does playing fifteen songs in a row really make for great radio?

Too many of us have deeply held beliefs and strong emotional ties to antiquated formulas and theories that are preventing us from seeing new opportunities and possibilities. Radio's lack of innovation and its unwillingness to take an active part in change have contributed to its failure to keep pace with our culture's growing diversity and its inability to incorporate that vibrancy into its organizations.

There is no greater celebration of life than creativity—especially at work. Let's face it: In this business, our work is our life. Isn't it worth the investment of time and energy to create a vibrant product? Great radio stations succeed because they encourage a strong creative environment; it's woven into the fabric of the station's lifestyle and is essential to its overall vision. A creative climate plus team members who collaborate well equals success.

I am a creative anarchist. My aim is to rejuvenate the creative spirit in radio. I advocate establishing a new playing field at work, one that allows people to freely tap into their creative spirit and apply it to their craft. For this to happen, the industry needs coaches who can combine their talent for listening—caring and staying in touch with their audience—with an ability to pass along knowledge to their players. In this book, I'll offer suggestions for better coaching through physical, mental, and spiritual exploration. If you want to

stand out, prosper, improve your basic coaching skills, and help your radio station break through today's conventional barriers, join my movement and become a creative anarchist. Rebel against the status quo and help restore creativity as a dominant fixture in radio's culture. If you feel your innovative skills are a little rusty, warm up with the creativity exercises below. They will help restore your imagination, ingenuity, and inspirational powers and prepare you for the regimen for coaching successful ahead.

Individual Creativity

- Learn as much as possible about whatever it is you want to do. Inspiration rarely comes unless we have immersed ourselves in a particular subject.

- Go against conventional wisdom. Don't follow rules; break them and be different.

- Daydream. Let your mind wander, and write down key images or words to help bring insights for problem-solving.

- Brainstorm. Usually considered a group technique, this is also an important method of private idea-generating. Record every single idea that pops into your head. Make no judgments or evaluations as you come up with ideas. Think illogically. Don't reject ideas because they don't "make sense."

- Imagery: The right side of the brain communicates with images rather than words. Think in pictures and tap into your senses. Look for qualities in the images rather than literal meaning. The more clearly you can create an experience in your mind, the easier it will be for you to dialogue with your intuition and change those images into words. Use metaphors.

- Relax: Don't grapple with a problem for too long. Take up a relaxing activity (meditation, swimming, hiking, biking, T'ai Chi); often the solution will pop into your head.

- Fun: Let yourself go—be loose and spacey. Don't always be serious. Adopt a more devil-may-care attitude toward pleasing other people and always being right. Get in touch with your emotions. Feel. Trust your heart, not your head.

2

A Face for Radio

"How did you get into this business? Who helped you in your career?"

Over the years, I've been asked these questions a lot, and I've always given a pretty pat answer and moved on. But recently in my dentist's office, I heard a song that took me back to the very beginning of my career. The song was "Up Up and Away (In My Beautiful Balloon)" by the Fifth Dimension and it transported me back to my first job at 1310 WTLB-AM in my hometown of Utica, New York.

A man who looked like Abraham Lincoln gave me my first break in radio. You could say that he gave me my creative freedom. He liberated me from a life of working in factories, foundries, or the phone company, even though I was enrolled in college. I had been pointed in the direction of factories since high school, when I enthusiastically announced to my counselor, Bob, that I wanted to be a writer. Bob smiled and said, soberly, "Let's be a realist and get you out of here with a good trade." He then proceeded to approve more shop classes for me in which I did very poorly because I wasn't interested in drafting or automobile engines.

To counselor Bob, I was a faceless future assembly-line worker. But I was lucky to have had three great teachers—Frank Rindinello, Kent Lewellyn, and Joe Spanfelner—who saw potential in me. They told me success stories and expressed an

interest in what I had to say. Because of their constant encouragement, I became president of the Drama Club.

Almost all the members of the club were white Honor Society students with outstanding grades. These kids had never set foot in the basement of the school, where the shop classes were held. They never saw the auto body or machine shop. Instead, they enjoyed advanced English class, where they read Hemingway, Faulkner, and Salinger. One student, a fellow actor, told me about a Shakespeare class. I went immediately to see Counselor Bob and sought enrollment. I wanted out of the dungeon. I wanted to jump through the window of opportunity.

Bob laughed and said that my grades were not up to par, and that I couldn't possibly succeed in that class. Refusing to be discouraged, I went to the teacher and pleaded to get in, but I never did. I learned that interest and enthusiasm weren't enough—you had to be prepared, even if that meant doing the preparation on your own.

From then on, I read what the smart kids read. Being prepared may sound like Boy Scout stuff, but it's a life lesson that I learned early. Whenever I think about the times I've failed—whether it was doing a bad break on the radio or being unable to motivate someone—it was due to a lack of preparation.

All through high school, I had the largest paper route in town. I delivered papers to all the businesses on Genessee Street, which was then the center of commerce in Utica. I was acquainted with many of the merchants, and I became very friendly with an old man named Meelan and his son Joe, who owned a rug store. I can still vividly remember the warm, earthy smell of the store, a splendid mixture of Mr. Meelan's aromatic pipe tobacco and the exotic rugs. They offered me a job measuring and cutting rugs. The timing was perfect, because I had become weary of getting up at 4 A.M. to deliver the morning paper. Little did I know this opportunity would start me on the path to radio.

While I was working at the rug store one day, a young man with a very deep, familar voice began telling Joe about his plans to travel to Europe and bum around, singing for his supper. It was 1967, and I was fascinated with the idea of someone just taking off and seeing the world. I had never met anyone crazy enough to do that. Simultaneously, the man's voice had captured my attention;

I knew I had heard it before. I made an excuse to interrupt their conversation and introduced myself. He said his name was Bob. Bob was Bob O'Donnell, one of the disc jockeys I listened to on 1310 WTLB, our local Top 40 station. I shook Bob's hand and listened in awe to the beautiful sound his words made. I was impressed by his voice and his command of the English language. At that moment, Bob became a role model for me. From then on, I associated radio with adventure, and I knew I wanted that in my life.

I became a student at Utica College in 1970. One day in the cafeteria, a student named Ivan came in all excited and announced he had just gotten a job working in the news department at WTLB. I remember feeling envious. I was amazed that I felt that way, because I had never consciously had any interest in working in radio.

While in college, I worked part-time for the telephone company in the dead equipment department. My job was to retrieve phones from people who didn't pay their bills or from companies that were closing. Lots of fun. This was long before people owned their own phones. The only creativity the job offered was inventing ways not to become dead equipment yourself at the hands of aggrieved customers!

One day I was removing a phone from a black community employment agency (these organizations were widespread in the U.S. in the late sixties, assisting businesses that wanted to employ blacks). In walked a tall, lanky white guy with a thin beard that ran from one sideburn to the other. His name was Paul Dunn, and he was the general manager of WTLB.

Dunn began explaining to one of the counselors that the student he had hired—Ivan—had only come to work one day. He said he was still searching for a young black person to work in his station's news department. I jumped up and excitedly told him that I was the person he was looking for. My enthusiasm, combined with the fact that I was in school, convinced him to invite me to lunch. At lunch, I told Dunn how I had met big-voiced Bob, who was still traveling in Europe. I implied that we were the best of friends. That lie and my unbridled desire to work in a creative environment were enough for Dunn to offer me the position. Two weeks later, I was working in the newsroom at WTLB. A

year later, Bob returned from Europe, and we actually did become friends. Here's Bob's take on the story:

I met Fred at a rug store, long before Quincy McCoy was born. The beginning of his radio career, to put it mildly, was a disaster. He couldn't go through a ten-minute newscast with successfully completing one sentence. He was embarrassed. But he was strong and determined. With a lot of hard work, Fred went from a hapless wanna-be to a forceful radio personality. When he took over the 7 P.M. to midnight shift on WTLB, nobody could touch him.

Fred, my wife Suzy, and I have been friends for a long time. Fred was an usher at our wedding. He was there to say goodbye when we moved to Nashville. That was a crossroads for all three of us. We were heading south to write songs and Fred's destiny was already clear in his mind, as he was preparing to take his first radio gig away from home. Our friend Fred has traveled a long way since the days at WTLB. He's been a major market program director, a record executive, he has won broadcasting and writing awards, and he's still looking ahead. Suzy and I live in Florida now and every now and then, a Gavin *magazine shows up in the mail, and we get to read his latest opinion or advice for the industry.*

Fred started with such a thirst for knowledge that I'm not surprised that Quincy is a radio coach today, giving back everything he's learned.

I'm an Affirmative Action baby. If it wasn't for Affirmative Action and a few liberal employers and educators, I never would have gotten my foot into the world of radio and records. It was 1968, and the United States was still reeling from the assassinations of Martin Luther King, Jr. and Robert Kennedy. Riots were becoming a common occurrence, fueled by either protests against racial discrimination or the war in Vietnam. Years of turmoil, marches, demonstrations, deaths, and destruction of property finally produced civil rights legislation that opened doors for women, poor whites, and colored Americans. As Curtis Mayfield so aptly put it in his song "We're a Winner," we were "moving on up." The sixties revolutionized the nation, and forced it to begin to stand up to its ideals.

WTLB in Utica, New York, was owned by Peter Strauss, who also owned three other stations in the state, including WMCA in New York City. WMCA, home of the "Good Guys," was a powerful Top 40 station, featuring DJ stars like B. Mitchell Reed and R&B radio legend Frankie Crocker, who was a "Good Guy" for three years. Strauss was a Democrat who had actively supported John F. Kennedy's presidential campaign in 1959. He instructed his station managers to hire minorities—professional or untrained—at all his properties. I was hired at WTLB and placed in the news department as a desk reporter. Eventually, I was given street assignments and began doing call-in reports from various city and county meetings. Later still, I began doing newscasts. I was awful. My writing skills were way below average, and I suffered from multiple speech impediments. I grew up on the east side of Utica, which was predominantly Italian. I hung out with guys who never pronounced the *ing* or *ed* endings of words. We didn't know it was necessary. For example, the word *going* was reduced to *goin'*. Even today, my best impression is that of a street guy in Brooklyn. *Fuhgeddaboudit!* But for reasons I still don't understand, the news director, Joe Tierno, worked with me tirelessly. He spent hours and hours (many of them outside of work) listening to me mispronounce words. I'll let Joe tell you this part of the story.

Joe Tierno, my most important mentor next to my mother.

WTLB-AM in Utica, New York, was the king of the airwaves. It was the only rock station around. I was directing the news department, and the person known today as Quincy McCoy was presented to me as Fred Reed, Jr. Later he would write in an article that he was an "Affirmative Action baby," and indeed he was.

Our general manager was Paul Dunn, who, aside from me, was the only other media liberal within a hundred miles. Dunn was the delivery man. He stood in my newsroom doorway alongside this gangly, gap-toothed kid, and said, "This is Fred Reed. I'm assigning him to your department."

I learned very quickly that Reedo, as he became known to me, hadn't the slightest notion of what went on in a broadcast newsroom, much less a radio station. In fact, it was hard for me to understand what he was saying most of the time. So I began by telling him that if he wanted to make it, he would have to endure the slings and arrows of his friends in the 'hood, who would surely make fun of him when he began using the English language properly. He agreed without so much as a whimper and the process began.

We spent hours, days, and weeks in front of microphones and tape recorders going over the kinds of stuff he would have to read as a news guy. I must confess it was a slow, frustrating, and painful process. Reedo was not an overnight sensation. In fact, his first on-air flight was pretty much a disaster.

We decided that a thirty-second headline newscast would be the best way to break the ice. In those days stations did the news on the top and bottom of the hour. We rehearsed and rehearsed for hours. When it was time, Dunn was perched by the radio in his office, other staff members were poised ready to listen, but more importantly they offered encouragement, because by this time Reedo had folded quite nicely within the station community.

He was so nervous, he could hardly say his name during the introduction of the newscast. He stumbled through that one and many more to follow, but we continued to practice together until he gained a degree of comfort. But a short while later, it was clear that what he really wanted to do was spin records.

"What do you think?" he asked anxiously. "I think you should go for it," I replied. We worked it out with Dunn and the "Q" was on his way. [Quincy McCoy was the air name I adopted in 1971. "Q" was the natural nickname that developed from it.]

Some years later he wrote about it all and wondered why I sat through all those hours, coaching. I said to him, "Because I knew how badly you wanted it." And he did. It's nice for an old guy like me to see how nice it turned out.

It was Joe's confidence that gave me the strength to persevere despite the peer and public humiliation that I suffered in the beginning of my radio training. That painful pressure—brought on easily by laughter or harsh criticism from friends or colleagues—was always pushing me to take the easy way out and just

quit. But I knew that this was a great opportunity, and that with God's help I wouldn't blow it. I didn't consciously realize how important it was for me not to fail. It didn't hit me until years later that, had I given up, I would have impeded the chances of others who came after me.

At dinner with Tierno and Evie, his wife, twenty years later, Evie remarked that it was hard to believe that the same skinny kid who used to stumble through UPI copy in her kitchen was now running a radio station in New York City. The Affirmative Action baby had grown up to meet the promise of what legislating a fair chance can do.

I was given the opportunity to work and grow in an industry that paid well and afforded me an enormous creative outlet. I became a DJ, music director, program director, operations manager, a radio consultant, and a director of promotion for Fantasy Records. I worked in Top 40, Urban, AOR, A/C, Big Band, and Jazz radio. I've traveled extensively, dined in some of the world's best restaurants, and shopped in fine stores. Today, my family lives in a nice neighborhood. Without the help of Affirmative Action, I still would have wanted all of the above, and would have gotten it—one way or another. Access to opportunity makes you a benefit to society; a lack of opportunity can make you a detriment, or worse, a menace.

To escape the misery of ghetto life with its narrow choices for black men, I, like many others, would have done almost anything to get out. Ghetto life, with its vicious anonymity, neglect, and poverty, suffocates lives. I could easily have fallen prey to the temptation of gangster life, like so many young men today. Affirmative Action programs are a life raft to many talented people who want to escape from that island of despair. All we want is the raft; we'll do the rowing ourselves.

As I reminisce, I realize that there are two important lessons in my story. The first lesson is: Don't let the window of opportunity close; when you have a chance, jump through it. The second: Be prepared to take advantage of opportunity.

3

Life Lessons

Most great coaches have had great mentors. Mentoring is essential to the coaching cycle. Once someone has bestowed on you the richness of their experience and furnished you with resources that help free you mentally and spiritually, suddenly and willingly you take on the central obligation of coaching and mentoring—you must give back to others.

Joe Tierno was my first radio coach. His encouragement, enthusiam, and care for me was reminscent of my most important mentor—my mother.

Emma Lou was my role model. If it wasn't for her strong belief that everyone can overcome barriers and roadblocks in life, and reach higher ground, I don't know where my life would have strayed.

My mother was tough. For years she endured terrible ailments, including cancer and, finally, Alzheimer's disease. Through all her illnesses, she never lost her faith or sense of humor. By her brilliant smile, Emma Lou told us how happy she was just to be alive. Her long struggle was a high-water marker for me whenever I became despondent about a lousy Arbitron book, being out of work, or fearful of a career change. One thought of all the pain Emma Lou suffered as an uneducated textile factory worker raising a family in pre-Civil Rights America quickly helped put things back in perspective. More importantly, her positive words and

unyielding faith in the human spirit always inspired me as a kid growing up in the fifties and sixties.

In his book *Sacred Hoops,* NBA Coach Phil Jackson says that selflessness is the soul of teamwork. "Creating a successful team—whether it's an NBA champion or a record-setting sales force—is essentially a spiritual act. It requires the individuals involved to surrender their self-interest." That quote always reminds me how unselfish Emma Lou was. She was dedicated to the idea of taking her family out of the ghetto, to a better life. She was a great role model: a provider, motivator, and spiritual advisor. In retrospect, Emma Lou was a great leader and a tremendous example of determination. She moved her family up, but never forgot to reach back and assist others to a higher level. She was a great believer in education, and worked hard to ensure that her children would get a shot at a college degree.

Emma Lou Reed

Emma Lou was born poor in Georgia and got married in her teens to Fred, the man who would be her husband for fifty-eight years. Emma Lou and Fred worked as migrant farm workers, picking beans for about twenty-five cents a bushel from the South to the North. They eventually settled in Utica, New York, in 1943. There, Emma went to work for a textile company called Beaunit Fibers. This proved to be both good and bad. Good because the company paid well and offered overtime and bonuses. It had a credit union that allowed poor folks a way to establish credit to buy houses and cars. On the other hand, Beaunit Fibers was a very demanding employer. Workers had to labor in extremely cold, hot, or dangerous conditions to produce their products. I worked there one summer in the bleach department, where we dyed yarn. The temperature was never under 110 degrees. There was always the danger of losing a finger in the machinery or being burned by dangerous acids. Later, my father told me that Emma Lou made sure I was assigned to that miserable job to solidify my intentions of going to col-

lege. "Her goal was to get you into college anyway she could," Dad laughed. "She made sure they gave you a job you would hate. Your mom knew how to motivate people."

My mother worked in an abnormally cold area called the winding room, where the thread was spun onto large spools. To keep the temperature cool, aluminum was sprayed into the air. Emma Lou's doctors later suspected that the aluminum may have contributed to her Alzheimer's condition. Beaunit also had a system of rotating shifts. One week she would work 8 A.M. to 4 P.M., the next week 4 P.M. to midnight, then midnight to 8 A.M. After twenty years, Emma Lou retired from Beaunit Fibers with a long list of illnesses. Shortly after her retirement in 1968, the company closed down and left town with Emma's and thousands of other workers' hard-earned pensions. She never became bitter. It was part of her working-class ethic of "no choice but to go ahead," but always with hope. She was grateful that she got a couple of her kids through college before the company shut down. When times got tough, she would quote her favorite bible verse from Romans 8:28: "God works in all things for the good."

At our house, the important subjects were politics, civil rights, and the church. Emma Lou was a passionate worker for St. Paul's Baptist Church, and one of its biggest fund-raisers. She'd cook and sell chicken and chitlin dinners. She was a Democrat, and worked hard getting people registered and to the polls on Election Day. She was a major supporter of Dr. Martin Luther King, Jr., and a true believer in nonviolent protest. She was a volunteer. With a husband, full-time job, and four children, she still found time to be active in her community and make it a better place. Emma Lou was a very generous soul.

I am her only son. Our relationship, needless to say, was special. We had secrets and stories that only we shared. When I started my career in radio, she was my primary supporter, helping me score small victories on my way to becoming comfortable in that alien world. When an uncaring program director told me that I had little talent, she gave me the strength to continue. "You will meet many more people out there who will want to destroy your dreams," she said. "But if you want to prove this man right, and miss out on this opportu-

nity, I can always get you a job at the factory." Later, she encouraged me to take a job in a larger radio market—a challenge I never would have accepted without her blessing. Her advice to me was to always reach for the stars. Now it's an integral part of me, an attribute I took for granted until her passing in 1997, reminding me of the source of my confidence.

4

A New Playing Field

"When one segment of society, whether it be government or industry or some other, is vested with unlimited authority over radio, then freedom is threatened and democracy suffers. It is diversification and balance of control that we want in American radio." —Paul A. Walker, former FCC chairman

Before we assess the effects of deregulation, let us first review the historical beginnings of federal regulation in radio.

The Radio Act of 1912

After the sinking of the *Titanic*, the government began to regulate marine radio ship-to-ship and ship-to-shore. The act directed the secretary of commerce to be responsible for licensing radio stations and operators, which included specifying the radio wavelengths to be used.

The Birth of Commercial Radio in 1922

When radio began accepting advertising, broadcasters formed their own trade association, the National Association of Broadcasters (NAB). For over seventy-five years this self-governing organization has represented radio in Washington. It's priority is to maintain a favorable governmental, legal, and technological climate for broadcasters.

The First Radio Conference

In 1922, Secretary of Commerce Herbert Hoover convened the first radio conference in Washington, D.C. After two months of deliberations, it was decided that regulation by private enterprise alone would be inadequate; Hoover recommended government control over broadcast frequencies.

The Federal Radio Commission

In 1927, President Calvin Coolidge put pressure on Congress to enact legislation to regulate the broadcast industry, thus establishing an independent oversight organization called the Federal Radio Commission (FRC). The FRC's five members would issue licenses, allocate frequency bands, and control stations' transmitter power.

The Communications Act of 1934

This legislation ceded regulatory authority over radio to the newly created Federal Communications Commission (FCC). The FCC's seven commissioners were appointed by the president, making it a political body. The FCC was given more administrative authority than the secretary of commerce or the FRC.

The Blue Book

In 1946, the FCC released the Blue Book Report, which outlined responsibilities for broadcast licensees. The Blue Book stressed that, in the granting and renewing of licenses, the FCC would look for local programming and the recognition of the public's interest.

The Ascertainment Process

In 1960, to further ensure that the public interest was being protected, the FCC developed the Ascertainment Process, by which stations were required to go into the community, determine what its needs and interests were, and produce programming to respond to those issues.

Late 1970s Recession

With the country in an economic crisis—unemployment, slow growth, and inflation—politicians and members of the private sector began demanding justification for government's regulatory policies. Born of this unstable economy was the conservative political ideology of deregulation.

Ronald Reagan

During his presidential campaign in 1980, Ronald Reagan claimed that excessive and needless federal regulations were overburdening the U.S. economy and undercutting the prosperity of the American people. In a presidential address to a joint session of Congress in 1981, Reagan said: "We must come to grips with inefficient and burdensome regulations—eliminate those we can and reform the others."

FCC Chairman Mark Fowler

In 1981, Chairman Fowler—a self-proclaimed Reaganite—made it clear that he would execute the President's mandate to deregulate the broadcast industry. Fowler said: "For a variety of reasons, the commission has traditionally refused to recognize the undeniable fact that commercial broadcasting is a business... not fiduciaries of the public, as regulators have historically perceived them."

Deregulation of Radio in 1981

The FCC eliminated commercial time requirements, formal ascertainment procedures, and the maintenance of program logs; broadcast applications were replaced by postcard renewal forms. This order essentially gutted the Radio Act of 1927 and the Communications Act of 1934.

The Fairness Doctrine

In 1987, the FCC eliminated the Fairness Doctrine, which had required stations to give airtime to issues of public importance and to present opposing views. The Doctrine was created in 1929 by the FCC's predecessor, the Federal Radio Commission.

The Telecommunications Act of 1996

This legislation lifted restrictions on ownership, allowing broadcasters to own an unlimited number of stations. The National Association of Broadcasters had lobbied hard for this bill, claiming it would start a surge of competition, increase investments, and create millions of jobs. Consumer advocate Ralph Nader argued against the law, saying it would result in less diversity, more prepackaged programming, and fewer checks on political power.

The Minority Tax Certificate

In 1998, the 104th Congress rescinded the Minority Tax Certificate that had been created to increase minority media ownership by offering tax credits and license preference to radio operators who sold their stations to minorities. The incentives that the law provided for minority ownership disappeared.

Comments from the FCC Chairman

A year before Bill Kennard took office as chairman of the FCC, Congress passed the Telecommunications Act of 1996. Kennard, a black telecommunications lawyer, was part of a network of Yale lawyers who helped get President Bill Clinton elected in 1992. Kennard was the FCC's general counsel, principal legal adviser, and representative in court. His predecessor, Reed E. Hundt, stepped down in 1997, leaving Kennard to inherit his polemical relationship with Congress. The NAB is at odds with Kennard because of his proposal to enable thousands of churches, colleges, and community groups around the country to operate low-power FM radio stations. The broadcasters believe that these new stations would be a serious source of signal interference. Kennard argues that the stations "would provide new voices to the traditionally voiceless." Here is Kennard on various issues facing his Commission:

Consolidation

The provisions of the Telecommunications Act of 1996 on broadcast ownership were crafted as part of the overall effort to open up the telecommunications marketplace to

competition. FCC policies implementing the Communications Act reflect core values of competition and diversity.

On one hand, I have concerns about the consequences if more and more media outlets are concentrated in fewer and fewer hands. I have concerns whether large multiple owners can lock up certain demographics in many markets, or whether small entrepreneurs, including minorities and women, are unable to achieve their dreams of owning a broadcast station. In the current FCC proceeding to reexamine our broadcast ownership rules, I intend to consider the impact of consolidation on diversity of ownership and diversity of voices in the marketplace.

On the other hand, with the changing realities of today's marketplace, broadcasters need flexibility to seize opportunities—particularly with the advent of their new digital television channels—and open the frontiers of the Information Age. Consolidation that preserves voices is not bad. And common ownership that provides new voices is good.

The challenge for the industry, and for the FCC, particularly with the opportunities available for the advent of the broadband future, is to find the right balance.

Fairness

The First Amendment is a robust, living document. In addition, Congress and the courts have consistently upheld the notion that broadcasters hold licenses as trustees of the public airwaves and have an obligation to serve the public interest. Government, and the FCC, must not be in the position to be acting as editors or censors of the programs and news decisions of licensees, and I fundamentally believe that it is not the appropriate role of government to micromanage news content. I have confidence in the ability of the public to make their own decisions about the kinds of stations and programs they wish to view. Broadcasters, particularly with the increased competition today from satellite, cable, and the Internet, will ignore the public interest and these marketplace forces at their own peril.

Minority Tax Certificates

For my entire career in communications, I have been a champion of and believer in the important role that tax certificates played in encouraging increased minority ownership. It is a program well-suited to helping minorities and other new entrants surmount the

greatest obstacle to ownership—attracting the necessary capital. This is a particularly important goal in today's consolidating broadcast marketplace. When I was FCC general counsel, I testified before Congress urging it to retain this important program. I regretted the congressional decision to end the program and have recently urged Congress to consider legislation establishing a new tax incentive narrowly tailored to help new, small, and minority tax certificate programs and hope these efforts are successful. I note that many recent mergers between large communications companies have been structured on a tax-free basis, and legislation to establish an incentive to promote small business and minority ownership would, in my view, simply afford all Americans an opportunity to stake a claim to our airwaves.

Low-Power Radio

Low-power radio has the potential to create outlets for an array of new audio services. It can give voice to those ideas not always heard but which many yearn to hear. In the last few months, I've heard from thousands of people who want to use the airwaves to speak to their communities—churches, community groups, elementary schools, colleges, and minority groups. In the FCC's proposal for a low-power radio service, these people see the opportunity to have their voices carry through their communities. As FCC chairman, my job is to ensure that the public spectrum is used to benefit all Americans. However, I have repeatedly said that we must do it in a way that protects existing broadcast signals and which also does not impede the conversion to digital radio.

The Future of Radio

The radio industry is robust and thriving and the prospects for future growth are excellent. Revenues in 1997 were over $13 billion and radio stocks have seen record growth. Radio continues to connect people to their communities, perhaps more than any other medium. Just as the advent of cable television, direct broadcast satellites, and satellite radio did not adversely affect the success of radio, so is the fact that broadband Internet audio distribution will not kill free over-the-air radio broadcasting either. Radio remains unique as a local communications service, one that is the lifeblood of local

information in all our communities and in our culture. To this day, radio stations provide local communities with vital local news and information—weather and traffic reports, agricultural forecasts, and school closings. Radio will continue to play a vital and profitable role in our nation's communities.

Voices from the Radio Show

The passage of the Telecom Bill, as it became known, started a consolidation frenzy. The resulting flood of mergers and acquisitions eventually culminated in the creation of four multibillion-dollar conglomerates that, between them, took control of nearly a third of the country's radio stations. At the end of the twentieth century, the top 100 radio markets are all consolidated and controlled by these four powerful radio groups. The playing field has changed drastically over the last four decades.

Today, radio is an investor-driven business concerned with cash flow and margins. What's been lost is the emphasis on community and personality; the focus is squarely on improving the bottom line, and companies will exercise the most expedient, cost-efficient ways to get there. The concepts of innovation, creativity, and musical diversity—with the exception of the natural fragmentation into niche formats—have lost out to two short-term paths to profits: downsizing and outsourcing.

Since deregulation, broadcasters have disregarded their promise of more airtime devoted to public affairs. As a matter of fact, news and public affairs departments were the first to be downsized or eliminated. With the rules changed, broadcasters no longer have to prove themselves worthy of a broadcast license by providing programming that serves the community.

Politicians who pledge economic rebirth for inner cities through urban renewal rarely deliver on their promises. Their assurances of more jobs and new businesses are analogous to radio operators lobbying for deregulation, pledging that it will engender more investments and create millions of jobs. The invest-

ment part of the scenario has come true, with big media companies swallowing up smaller groups and stand-alones. The investment bankers and stockholders are very happy, but I haven't noticed an increase in jobs. In fact, consolidation has led to the most format changes and downsizing and the fewest minority-owned stations in decades.

Do the architects of deregulation all think alike, or is some subversive synergy leading to mass echolalia among radio consolidators? At the 1997 NAB convention in New Orleans, six radio group heads sat on a panel and agreed that consolidation necessarily meant downsizing and added workloads for managers and employees. The clear objective of all the major companies was to reach investors' and shareholders' expectations at any cost. Scott Ginsberg, then head of Chancellor Media (one of the four largest companies, now called AMFM, Inc.), said, "It's become a performance business, not an emotional business. Performing at higher and higher levels—that's our responsibility."

Randy Michaels, President of Jacor Communications, Inc., met no resistance at that same gathering when he said that perhaps the most critical issue on the table was how companies merged stations and positioned formats. "Big fundamental change is gonna come," Michaels stressed. "We're all just learning how to work with regional clusters." Clustering—a direct result of relaxed ownership quotas—allows a single company to dominate a desired demographic within a specific market by programming overlapping formats, e.g., targeting women 18 to 34 with Modern A/C and men in the same age range via Alternative. The strategy is meant to deliver the greatest amount of dollars to the bottom line by positioning each station in such a way that potential listeners become greater than the sum of their parts. Developing and executing strategies that maximize a company's assets is the goal of all major players with regional clusters.

At the following year's NAB convention in Seattle, Michaels ruminated that radio was not as much fun as it used to be, and that broadcasters should strive to design loose, nonlinear organizations that can attract advertisers and listeners with creativity. Michaels added that fun work environments help employees to explore and exploit their creativity. Why the big change in tone? Because

Michaels had been right; the big fundamental change he spoke about a year be-fore—regional clusters—did transform the dynamics of radio management.

There has been a tremendous shift in radio's internal operational strategies as managers are faced with the new challenges of running multiple stations under rapid company expansions. Many GMs and PDs are not ready to handle this much responsibility, and I suspect that, with the emphasis on a nonemo-tional approach to leadership, we've lost some of our greatest innovators. They've gone to other industries that seek creative decision makers with vision and passion. With the performance expectations of programmers as high as the debt service, corporations are looking for managers with experience.

Surprisingly, consolidation hasn't helped bring talent back to the forefront of our industry. I say surprisingly because other American businesses that have deregulated quickly learned that talent is what separates the winners from the losers. In the new economy, competition is global and smart companies are waging war by hiring the brightest and the best. I believe the radio companies that are most likely to survive merger mania will be the ones that spend the most energy attracting, developing, and retaining talent. Not just on-air tal-ent, but managers and executives who are imaginative leaders. Talent is cre-ativity that turns ordinary radio into extraordinary entertainment in the hearts of customers.

"The radio business," Randy Michaels said at the NAB conference in Seattle, "is too serious now to be taken seriously." Michaels said he intended to instill fun as a major ingredient in his company, and he hoped others would follow suit. But not everyone in radio was listening to the president of Jacor that after-noon in Seattle. Just a few hours later, I was moderating a programming session when a GM reminded me about the bottom line: "In honoring the bottom line, the reality of consolidation is serving shareholders. Programmers need not be creative anymore, but financially oriented; they should take the emotion out of their approach to the new radio business."

What do these two contrasting views mean? They mean that, in today's fast-changing radio landscape, you have to be flexible and versatile to survive.

The days of the program directors whose only qualifications for the job were "good ears" and "people skills" are history. Today's ideal PD must understand marketing and be Arbitron smart, profit-oriented, and a coach who elicits high performance from his or her team players. Even with their ever-increasing responsibilities, today's programmers must find a way to put out an appealing on-air product and be attentive to employees' needs by way of creative leadership, while still finding time for personal growth. How? The best way is to learn by example.

5

Coaching

A friend confided in me that he turned down an opportunity to program two stations for a major broadcasting group because he felt he couldn't lead anymore. He left radio a few years ago to pursue a different career, but has kept abreast of the changes in our industry. He felt that when he was in radio, he had evolved into a "personality-oriented" leader, one who had a great appreciation for the players on his team. He created an open environment where the talent was encouraged to explore their personalities—improvise—while he instilled a heightened sense of teamwork into their consciousness. He feared that he couldn't adjust to the new environment of consolidation and what he believes is a clinical approach to coaching.

Yet in his new occupation, he is still a leader, or, as he likes to call himself, a coach. He claims that in his business (he's a programmer for a televison music channel), they are just as concerned with making a profit and with market share, but they place a lot more value on their employees, on creating value for customers, and on taking a keen interest in the community.

Let me repeat that. Making a profit, controlling the market share, valuing employees, creating value for customers, and taking a keen interest in the community—these are the essential elements of successful coaching. I believe that

all coaches—no matter what their game, business, or level—share common performance standards:

- First, the coach has to embody a value system, one that deals with human relationships within the station and outside, with its customers. Everyone should know the economics and the goals of the company.

- Second, the coach should maintain and encourage a strategy of collaboration and teamwork among people at every level of the station. This will lead to team-oriented, results-seeking, and self-starting behavior.

- The third essential quality is accessibility. The coach must be available for honest, open, two-way communication. The impact of direct communication is enormous. With the help of electronic mail, leaders can be instantly in touch with anyone in their company.

- Last, I believe that coaches need to be good at psychology, starting with self-knowledge. Coaches cannot be manipulators. The days of slick manipulation are history. You have to be genuine to succeed.

I'm a big fan of basketball coach Pat Riley, who embodies the above qualities. I've practiced his philosophy of hard work, dedication, and loyalty as part of my team-building strategy at stations I've programmed. Riley establishes his team's value system at the beginning of the season and preaches his belief in it all year long. You must make a covenant with yourself to be committed to hard work and the constant focus it takes to be great. Programming, like coaching a sports team, takes a complete commitment to the success and well-being of everyone on the team.

You must be devoted to developing your people skills, because they will always be challenged. Let's face it: You're not going to like every morning person or general manager you work with. You have to dedicate yourself to being a fair leader who provides a creative, positive, stimulating workplace for all your players. Be honest, and be a living example of the qualities you demand from your players.

The best program directors are great coaches. Do you have what it takes to become great? Are you ready to make the commitment to excellence, to challenge yourself and others, to reinvent yourself and step up to a lifetime of learning? We all share these qualities to different degrees, though we may need to give some of them a spit shine, or really invest time and energy in improving them.

- **Personality**: The ability to make others like you. If you can't get people to listen to what you have to say, you won't get your team very far.
- **Taste**: Finding, hiring, and maintaining talent. A coach who wants to win has to create leaders at all levels of the company.
- **Flexibility**: There are no bad ideas, no absolute right way to do something. Allow room for creativity and imagination.
- **Salesmanship**: If you can't sell, you can't convince people to do things your way. People who understand language are the best coaches. You don't have to be a world-class orator—what really counts is the sincerity of your message.
- **Writing**: You need to develop the ability to put your thoughts down on paper in a clear and concise manner.

My friend has all these qualities. He is perfectly suited to run a radio station again. In fact, his creative style of leadership is needed more than ever on today's playing field. But he knows what kind of culture it takes to be successful, and if the broadcaster that wanted him couldn't provide that kind of culture, then he was right in turning them down. He knows what we all should know: The health of your coaching career depends on the health of your working environment.

The clearest examples of successful coaching come from the world of sports. Any good coach will tell you there are no real secrets or magic tricks to ensure success. The road to a championship title begins the first day you and your players share an understanding of purpose and begin to visualize your goal. For the rest of the season, the coach must breed confidence, build skills, and most importantly, demonstrate a commitment to succeed. In other words, if you talk the

talk, you must walk the walk. The only way to stay ahead of the pack is to continue to raise the bar, to constantly challenge and surpass your own current skills.

- Coaching, to paraphrase Pat Riley, is all about developing teamwork. You must blend and combine the talents of all your players into an even more striking whole.
- You must demonstrate daily where you want to take your organization and what your core values are.
- You must live up to, teach, and help your team achieve your goals. Facilitating means making things less discouraging and complicated—but not less demanding, interesting, or intense.
- Coaching is a face-to-face style of leadership. You cannot lead through memos or with a closed door policy. It's your choice; you can be worshipped by your team or have them treat you with resentment. Your players want to do their best for you and themselves. Empower them to do their jobs. Guide them, don't dictate. Even more important, give them concrete goals to shoot for; chances are they'll exceed your expectations.
- If you don't have a spiritual connection to keep yourself positively motivated, find one. Remember Gandhi's message that "there is a kind of 'wild card' within each of us, a well of courage and creativity we don't even know... until we learn how to tap into it through spiritual disciplines."

Phil Jackson, one of the most successful coaches in NBA history, created a new paradigm of leadership based on Eastern and Native American principles. His methods led his Chicago Bulls team to six NBA championships from 1989–98. Jackson, a Zen master, directed his players to live in the moment and stay calmly focused in the midst of chaos. His style of leadership is also known as "value-based," enlisting the hearts and minds of players to embrace a group vision that is based on their highest aspirations. "I've discovered that a compassionate per-

spective, trying to empathize with the player and look at the situation through his point of view, can have a transformative effect on the team," says Jackson.

Real Power: Business Lessons from the Tao Te Ching, by James A. Autry and Stephen Mitchell, is a book that offers spiritual enlightenment and alternative coaching ideas. The *Tao Te Ching* (pronounced *dow deh jing*) is a collection of spiritual poems written by the legendary Lao-tzu around the sixth century, but it was unknown in the West until the twentieth century. Next to the Bible, it is one of today's most widely translated books. In *Real Power*, the two authors have successfully applied the meaning of these ancient poems to today's world of business in a fine storytelling manner, offering a stimulating and inspiring approach to solving workplace problems and dealing with issues like competition, mentoring, and downsizing.

Real Power lets you sample deep wisdom as you explore the art of coaching. Autry and Mitchell have gleaned great advice from the Tao (Chinese for "the Way") on how to invest balance, values, and a generous dose of spirituality into your work. The Tao teaches that without the commitment and encouragement of people—not just at the top but throughout an organization—no system can succeed. The power of any idea is expressed only through people.

Taking Control

Our business world is built on command and control systems. The desire for power and the need to control are ingrained in us; our top-down management flowcharts support the needs of our managers' egos. The Tao teaches us a path to become comfortable with a new reality, to accept that noncontrol is the only way to manage things. Change hits us in the face every day. Social, marketplace, financial, and technological change happens every minute. The truth is, with all this change, we don't know what is going to happen next. The Tao teaches us that control is an illusion and that management is an art. If it were possible to control processes and people, computers could do it.

Your first step toward maturity is to realize you are not in control, but to recognize the changes—both positive and negative—that affect your workplace

and respond to them skillfully. In the end, having powerful values is what will give your workplace harmony through all these inevitable changes.

Being Flexible

To become a wise leader, you must remain flexible. The old school admires businesspeople who are "buttoned up" or have a "stick-to-your-guns" kind of attitude. Anyone who is thought of as a soft leader is automatically considered weak. But when you drop these foolish stereotypes, softness also means suppleness, flexibility, and openness of body and mind. Watch a T'ai Chi or Akido master—that is powerful softness in action.

Just as the body and mind stay young and vital by increasing flexibility, an organization that values suppleness stays vital and creative. The Tao teaches that it is an act of strength to let go of old definitions of power and to remain flexible, soft, and ready to yield.

> Men are born soft and supple;
> dead, they are stiff and hard.
> Plants are born tender and pliant;
> dead, they are brittle and dry.
>
> Thus whoever is stiff and inflexible
> is a disciple of death.
> Whoever is soft and yielding
> is a disciple of life…
> —From the *Tao Te Ching*

Putting People First

In *Real Power*, the authors discuss two of today's most popular strategies that have caused a crisis of trust in our business: downsizing and outsourcing. Downsizing has caused workers to distrust their companies and live in daily anxiety about their job security. Additionally, cuts in staff often lead to decreased innovation. The remaining staff is overloaded and some managers have to run two staffs. The

Coaching Playbook

Try to keep yourself in the best physical condition. When you are in shape, your brain works more efficiently and your body can handle more stress. If you're going to compete, create, negotiate, and lead, you have to be in tip-top condition. People who exercise routinely actually think better, remember more, and react more quickly than people who don't exercise at all. The brain is a physical organ. Give your noodle a workout by solving a crossword puzzle or listening to a complex piece of music. It will help neurotransmitters zip back and forth, increasing the blood flow to your brain. The result? A youthful, more creative brain. These exercises can also strengthen your ability to handle tasks that involve reasoning and remembering. Researchers in Holland have found that B vitamins, including B6 (found in oats, tuna, chicken, whole wheat, and bananas), B1, B2, B3, and B12, boost mental energy and repair brain tissue. Keep your brain buzzing.

result is nobody has time to think. This leads to burnout, demoralization, and a loss of creativity. Sound familiar?

The Tao teaches: People are an organization's greatest asset. Wise companies realize they need the energy and commitment of their employees. There might be short-term advantages to your budget through downsizing and outsourcing, but in the end, companies pay a big price and find it very difficult to win back the trust and the commitment necessary to restore growth and instill a feeling of community. Many wise business leaders have begun adopting the principles of the Tao, but call it other names like "value-based" or "grassroots" leadership. They realize that, to become a wise leader, you must be *among* your people rather than *in front of* them.

The Tao teaches: You can't lead people unless they are willing to follow you. To do that, you must inspire them to trust you with their well-being. Your people

will trust you if you bring out their sense of worth and creativity, and the only way to do that is to really know them.

In our culture, this would require a major shift in our thinking. We deal with so much ego in our industry—all managers want to be the hero—but you have to change your belief system and realize that the people you're coaching are the heroes. To become a truly wise leader you must let go of your ego, release the need for authority and control in favor of humility and service. This way, you become fully available to everyone, above and below, leading and following. Then and only then will you discover real power. As the Tao teaches:

> All streams flow to the sea
> because it is lower than they are.
> Humility gives it its power.
>
> If you want to govern the people,
> you must place yourself below them.
> If you want to lead the people,
> you must learn how to follow them…
> —From the *Tao Te Ching*

6

Program Director: A Job Description

I recently discovered a memo from 1992 that outlined my job responsibilities as a program director. Since then, the job, like the industry, has actively evolved. Acquisition fever and corporate restructuring demand more from every department head. Change has become an issue of personal responsibility: You must master and manage it in order to survive.

How has the PD job changed? Look around from small to major markets, and you'll see the same things—the pressures of consolidation and station clustering have caused a massive redefinition of the PD's role. The challenges of added responsibilities and an increasing lack of time have made it tougher to put out a creative on-air product. But even with all this change, several key elements of the PD's job description have remained. So before history rolls over us again and change reconfigures radio-yet-to-come, let's examine these indispensable areas of the job that, if managed properly, will benefit the program director of today—tomorrow.

Achieving Ratings Goals

What is a PD's job? Your most important responsibilities are to attract customers and come up with strategies to boost your station's ratings performance. To accomplish these goals, you need to astonish your listeners. How? The best way is

to connect with them on an emotional level. Be personable and give your listeners a sense of belonging. Care about the community and give something back to the people who help make your station successful. Reward your listeners with unpredictable entertainment. When your listeners are truly astonished, the result is great ratings. You must invest your time wisely, focus on innovation, and pay attention to detail. The following are basic performance areas that can help any PD garner better ratings.

Coaching the Morning Show

Every PD is the executive producer of the morning show. Keeping the morning team focused and on target is a demanding job, but it's essential to your station's overall success. In your daily meetings with the team remind them of the following:

Local: The morning show that weaves itself into the fiber of its community on a cultural, informational, and civic level will produce the best results. Through careful show preparation, highlight community events, leaders, musicians, and trends that will add to the show's overall relevance in the market.

Promotion: Remind the show host (or hosts) to always sell ahead to "top-of-mind" artists, issues, and events. Provide a music book with artists' bios and current information on hits, trends, and industry gossip. Always promote ahead to morning show features and special promotional events.

Pacing: Pacing in the morning show is more critical than in any other daypart. In aircheck sessions, remind your team to keep their bits, interviews, traffic, and news as tight as possible. Plus, keep the flow of pertinent information—such as weather and frequent time checks—in the forefront.

Listener contact: All morning shows need to make contact with listeners on a fun level—not just contests and serious subjects. Producers should always be on the lookout for "zany characters" to develop who call in or whom you reach out to every morning for comic relief. Remember, the new wisdom is to be personal not topical. Talk about things that relate to your listeners.

Music and Research

You must have final approval on each song your station plays. You should participate in all music calls with consultants, the gathering of information from focus groups, record store visits, and other listener feedback sources. You must be accountable for the station's research. You must direct and inspect the work of your research staff. The ability to instantly obtain customer feedback on music and other program features—and to understand and dispense it clearly—is vital to improving your station's ratings performance.

Supervising Staff to Achieve Goals

You have to dedicate yourself to being a fair leader who provides a creative, positive, stimulating workplace for all your players. You should maintain and encourage a strategy of collaboration among people at every level of the station.

Accessibility

Carl Hamilton, VP general manager of KBXX-FM (The Box) told me once, "Just like hit records, your day-in day-out conversations with your staff can lose effectiveness with repetition. In order for your people to win, you'll need to update and reinvent your message." If you want your staff to stay on point and really reach your goals, ask yourself these questions daily:

What can I teach _____ today that will help her/him to perform better tomorrow?

What performance from _____ do I accept today that I shouldn't accept tomorrow?

What's a new way that I can inspire _____ to perform differently tomorrow than they did today?

What detail can _____ pay more attention to that will improve ratings or improve the way we do business at the station?

Reviews

To accomplish company and personal goals, you should conduct formal reviews of your full-time staff at least once a year. You should develop job descriptions and performance requirements for all employees. To keep everyone on the same page about station and individual goals, schedule private meetings. Stay on top of each person's needs. The following is a good set of guidelines to begin with:

1. Performs all shifts with the station's ratings top of mind.

2. Executes formatic fundamentals consistently and fully prepares broadcast.

3. Actively participates in station activities and collaborates with station department heads. Performs remote broadcasts or makes appearances as assigned.

4. Adheres to all station guidelines, practices, policies, and procedures.

5. Demonstrates a high level of positive morale at all times.

6. Maintains proper working procedures and care of all station operating equipment. Follows all procedures for reporting equipment failure, technical difficulties, or other discrepancies.

7. Serves as a station custodian and is protective of all station assets and equipment owned by the station.

8. Accurately and thoroughly performs other duties as assigned.

It's best to rate these areas as being satisfactory, excellent, or needing improvement. All reviews should be written down and communicated in person. You should be very clear and include in each section ways the individual can improve or why they excel. Reviews are very similar to report cards, and everyone's areas of strengths and concerns will be different. Zero in on specific areas that each person executes well and not so well.

Budgets

Your goal is to bring your expense budget home by the end of the year. Every move you make with money is important, and any additional ideas about how to save money will help you achieve this goal. You must be able to handle budgets

wisely; any manager who is not looking at the bottom line carefully is ultimately doing himself and his company a disservice.

Marketing and Market Awareness

With more and more stations being run on a corporate level, marketing lingo has become an acceptable form of communication at radio stations. Understanding marketing is the key to defining and locating listeners for your station. Once you know who your audience is, you'll be able to deliver the best programming and promotional ideas for them. This opens the door to healthy Arbitron ratings.

There are three key elements to marketing: commitment, investment, and consistency. If you're not committed to your marketing plan, it's not going to work for you. Revise and rework your marketing plan until it is powerful and fits your purposes. Consider it a conservative investment that will pay off in time. Last but not least, stay consistent with your message and be prepared to market your product regularly. Consistency equals familiarity.

In his book *Guerrilla Marketing*, Jay Conrad Levinson reveals the ten truths about marketing you should never forget:

1. The market is constantly changing.
2. People forget fast.
3. Your competition isn't quitting.
4. Marketing strengthens your identity.
5. Marketing is essential to survival and growth.
6. Marketing enables you to hold on to your old customers.
7. Marketing maintains morale.
8. Marketing gives you an advantage over competitors who have ceased marketing.
9. Marketing allows your business to continue operating.
10. You have invested money that you stand to lose if you quit marketing.

7

The Disconnect

My wife and I did a lot of searching before finding the right school for our son. Louie is very artistic. He already plays guitar and, by all indications, music will certainly be central to his life. He loves to draw pictures of his heroes—Bob Marley, Ziggy Marley, and Seal. His other favorite subjects include Jamaica, cheetahs, Spiderman, and Michael Jordan.

In the end, we found Aurora, a developmental school that accepts his dreadlocks, will encourage his creativity, and offers a diverse and open-minded atmosphere that has a fun approach to learning. This type of environment is not an easy discovery today, especially in California, which has a state board of education filled with conservative political appointees dating back to the Reagan years, many of whom had little to no experience in school administration.

Recently, the state board changed the language defining a good education, eliminating all references to creativity and replacing them with two words: memorize and solve. With "memorize and solve" as their foundation, they've all but eliminated innovative teaching methods that both encourage children to ask questions and help them begin to make order out of chaos—essential preparations for the real world.

The "memorize and solve" policy is the result of shameless second-guessing from outsiders. It has led to an approach to learning that hampers creative development and social skills. I believe that it also represents the abdication of artistic freedom and judgment—for both students and teachers. What does all this have to do with radio? Plenty.

Teaching, like radio, is a craft. Perfecting your teaching skills—or your radio skills—takes years of experimentation and innovation to direct your creative output effectively. Public and private organizations face a common need to create in order to keep pace with rapidly changing markets. More importantly, humans respond negatively to a lack of creative space. In work or school, we develop strong feelings of frustration, burnout, and anger when deprived of the vibrancy of creation. Memorize-and-solve educational systems are indistinguishable from radio stations programmed solely with a research-and-deploy mentality.

Radio-by-the-numbers is boring, predictable, and formula-driven. Music, news, information, and canned entertainment—are tightly scheduled and modulated. Creative stations, on the other hand, stretch the rules and encourage personnel to play. Like good schools, creative radio stations employ innovative methods to reach listeners (students) and involve them in the process of listening (learning).

America's growing dependence on research disturbs me. We now create by consensus; we're afraid to allow room for what made us great—singular artistic visions. Instead, from the political arena to the Broadway stage, consumer research founded on the old advertising adage—the customer is always right (even if the customer has no experience, knowledge, or taste)—is a primary determining factor.

Focus group results are replacing personal beliefs and creative vision. In Washington, politicians don't make a decision without checking with their pollsters; they're not leading, they're just mirroring the general psyche of the country. Hollywood movie endings are reshot until test audiences give a favorable test score; the result is the same repetitive storyline in movie after movie. In an effort to increase circulation, many newspapers across the country are using

reader-preference surveys to determine what stories—even comic strips—should be priorities. Get your crimes and cartoons right here!

In 1998, Garth Drabinsky, a veteran movie producer, bragged in *The New York Times* about transferring Hollywood research practices to the stage. He hired a polling firm to calibrate audience reactions to find out what "works" and what doesn't. Drabinsky claimed to have altered one play's script twenty times based on these polls. His hit Broadway show, *Ragtime*, has earned more than $20 million, leading other producers and theater owners to become assembly-line manufacturers of art by using similar surveys and exit polls to attract repeat customers. If Broadway—the tightrope where humans step nightly without second chances—won't take the dare on art anymore, where are we headed?

Of course, radio has been dependent on research for decades. And today with consolidation, we're also answering the call of the sales imperative: be popular, be accessible, and get more quarter hours than the other guys. Market research companies tell us what passive listeners want to hear. Every company has a simple process to insure that your station is liked. They systematically exclude music that provokes the strongest reaction—positive or negative—resulting in a music mix that is predictable, homogenized, upbeat, and, most important, safe. When it comes to choosing new music, the rule has become: Stick with the tried-and-true artists, and always be suspicious of newcomers. Memorize and solve.

If all this research really works, why is radio constantly late in picking up on new musical trends? Rap, alternative, dance, or electronic music can dominate retail sales with little or no radio airplay. Underground artists sell out venue after venue without the aid of radio. How? They don't need it. The energy of their creativity has an aura of excitement that doesn't need heavy rotations to reach listeners, because they're already connecting with listeners on an emotional level. That's what creative radio stations used to do.

If polling really worked, people wouldn't distrust politicians and their motives; Hollywood wouldn't fear independent filmmakers and their ability to incorporate reality into entertainment; there would be more hit shows *on* Broadway than off; and radio listening wouldn't continue to decline year after year. We need to end our heavy dependency on research. We should enter a creativity re-

habilitation program, where we can be reminded every day—as I am whenever I look at my son, hear a great radio station, or see an inspiring film—of the richness of the particular, not the abstractions of the general.

❧

The disconnect is real and growing, causing anger and frustration. People are becoming hostile to institutions that take them for granted and disregard their individuality, and radio is no exception. Without flexibility, open-mindedness, and compromise, there is no room for creativity. The flip side of this is that compromise can only be reached when one engages the spirit of creativity and willingness to innovate.

The question is, how do we reconnect with our customers? How can radio reinvent itself as a vibrant entertainment alternative? How can the medium not only show its face, but allow the audience to touch it? I believe the answer is to engage listeners interactively. This means giving control to the listeners. Some programmers will say, "We play what the listeners want," but the reality is, that's just lip service.

Giving the listeners power—being instantly responsive to their changing needs and values—promotes active involvement. Interaction gives listeners a real sense of participation and proprietorship. Active involvement must be an essential element of radio's relationship with its customers.

Active participation could revolutionize this industry, which, of late, has been dominated by a dated and passive approach of numbers, information, and analysis. Being interactive means listening to your customers and tapping into their feelings. Together, you will be emotionally connected. Interaction with the customer would break us of the habit of assuming.

I'm not suggesting anyone should stop using research, because research is important, but let's remove it from its pedestal. Research is just part of the puzzle in the creative process. Remember, radio is a live art form. All the statistics and information must be filtered through an emotional context. People come first, then ideas, then capital, information, and technology. Once programmers realize you can't grow and improve without being connected to your listeners, creativity will once again become a strong ally.

The Reconnect:
Touching the Customer

Forget jingles, voice-overs, lead-ins, and live remotes. Forget, for that matter, the music. The voice of the customer is the most important sound in radio today.

Radio business depends on getting and keeping customers. It is essential that you build an internal communications pipeline that helps create an intimate portrait of your customers, a pipeline that reports good and bad stories from customers every day. But how do you do it? How do you field complaints, solve problems, calm nerves, provide service, and still run a radio station?

When I was operations manager for KBXX (The Box) in Houston, we were competing against a station that was programmed very similarly to ours. The two stations had shared some of the same air talent, sponsored similar promotions, and were musically very close. Our goal was to differentiate ourselves from them and end the problem of listeners confusing us. Our daily research indicated that the stations shared listeners and that this would eventually take a toll on our P1s (primary audience). To avoid this erosion, our programming department began contacting members of our target audience and asking them questions to help us stay a step ahead of our competitor.

We called listeners who had made critical as well as favorable comments about the station. This provided us with valuable insights about our strengths and weaknesses. It enabled us to develop intelligent plans for promotions and, more importantly, to design community activities that the listeners really wanted. It improved our knowledge of how the market felt about specific issues, music, and cultural events. All we had to do was pick up the phone and listen to the voice of our customers.

We can all get research reports filled with quantitative analysis, but the way something is said—what a single customer emphasizes or what is repeated by many listeners—is often most important. Learning from customers means more than just reacting to comments; it means developing the capacity to anticipate and prevent negative perceptions. In my mind, this is better than research data. This is behavioral data.

Don't be a slave to passive research. Don't try to reach your listeners only through advertising on TV or outdoor marketing. Interact with your listeners on a daily basis. When you're actually communicating with your customers, interpreting the slightest inflection in their voice can mean the difference between making the right or wrong decisions in the future. You can't hear a change of intonation or feel the difference it makes in a response by reading research reports. The only thing better than listening to the voice of the people is getting out and touching them. If you have walls of insulation between you and your customers, tear them down and reconnect.

In *A Passion for Excellence*, the best-selling business book that offers scores of practical insights, authors Tom Peters and Nancy Austin discuss a concept they call the "Daily Dose of Reality." This means finding ways to stay in touch with your customers every day. The objective is threefold: to let your customers know they are important to you; to uncover problems before they become major irritants; and to give yourself a daily reminder of what the real world is saying about you.

Every company says it's customer-focused, but do you know who your customers are? Are you satisfying your listeners' needs? Do you have membership cards or e-mail addresses for regular listeners? To really offer good service to your listeners and to begin preparing your station to meet their needs, you should develop a Call Back Squad (see next page).

Keeping Customers

You have to be on top of what the customer wants. Listeners are diverse and dynamic; their tastes and needs change from day to day. The more you customize your product and services, the more marketing becomes part of your customer service—and the more customer service becomes part of your marketing. If you want to do a better job of keeping customers and growing them into P1s, make customer interaction a key aspect of your organization's culture, a part of the way you do business every day.

The Call Back Squad (CBS)

The CBS is an objective vehicle for acquiring information. Its goal is to build bonds between customers and squad members over time. The only way to do this is to think of the customers as individuals. The simple truth is, any company that can't identify its customers individually is going to be history. A great customer relationship gives you long-term business, and in the case of radio, long-term success is based on loyal listeners.

The key to good service is satisfying your customers. Good service solves problems; it delivers what people expect to receive. Great service gets below the surface of a problem and delivers what customers want before they know they want it. This takes listening, assessing, and refining. Great service isn't easy, because each customer and problem is different; it requires spontaneous, sound judgment from knowledgeable people on your team.

Your Call Back Squad should consist of managers (not interns) from all departments who are good communicators; people who can understand and interpret what they're hearing. Meet with them once a week and discuss what is on your listeners' minds. The information our squad gathered from the KBXX listeners gave us strategic advantages and insights into the community our copycat competitor didn't have. The daily input allowed us to create exclusive positioning statements using the language of the listeners, and opened our eyes to pressing community issues from a grassroots level. Of course, this all transformed into ratings, revenue, and a closer relationship with our listeners.

Sometimes stations upset listeners with commercials, musical content, or a personality's presentation, and you then have to recruit squad members to meet with these listeners—especially if the listener is angry or upset. It's always a good policy to answer letters from disgruntled listeners, but if you also call them, it could mean the difference between winning them back or losing them forever. In the fundamental customer relationship, the more a customer teaches you about what she or he wants, the more you can deliver it, and the more difficult it is for them to take their TSL (time spent listening) elsewhere.

Customer Connection 1

The importance of the customer should permeate every department of your station. Keep the customer "alive" in everyone's consciousness by displaying letters or e-mail, both good and bad. Remember: The customer's perception is reality.

Customer Connection 2

Set up a complaint response team that can focus immediately on a problem and give it personal attention. Include top management players in order to involve them directly with the customer and with correcting the issue.

Customer Connection 3

Keep all promises made to customers, regardless of cost. Over the long haul, listeners respect a station's ability to keep promises.

Customer Connection 4

Get out to your promotions and remotes and meet your customers. Invite listeners to the station for tours. Customers should never feel that the station is off-limits.

Methods of Interaction

Of course, the phone is the most cost-effective way to conduct customer interviews. As I mentioned earlier, voice inflection can tell you more than words on a page. The Web offers an increasingly effective way to interact with certain customers. Keep a database of people with e-mail access at work and, of course, of personal addresses. What sets any great radio station apart is how much it cares about interacting with listeners—and how it maintains that intimate relationship.

One Man's View

In 1992 and '93, I was operations manager under Carl Hamilton, VP and general manager of KBXX-FM (The Box) and KHYS-FM (KISS) in Houston, Texas. He taught me the importance of being dedicated to the customers' needs, and he gave me insights into the hidden elements of programming. It was Hamilton who created the Call Back Squad. I recently asked Carl how the program director's job has changed since consolidation.

"They have to be more multidimensional," he said. "Before consolidation, their time was spent on just developing ratings. In today's stacks of stations, there are a lot more marketing kinds of things that a PD has to be very good at—particularly if they're dealing with more than one station.

"They have to be able to motivate and speak in marketing terms. They have to create promotions that move traffic into a store or merchandise out of a store. This type of language is essential when you have to communicate with salespeople about station promotions. It's not like the old days when a PD would say, 'Yeah, we'll show up and do it.' It's marketing savvy for outside the station as well as inside. The inside marketing—sometimes to two or three separate sales staffs—is a tremendous asset a programmer needs to have today."

Carl also believes that a PD's prime responsibility in today's (and tomorrow's) consolidated landscape is to create event marketing that brings in nontraditional revenue. "We have a group of people at our station called the Elite Eleven who are on a huge incentive program based on the growth of our event marketing and nontraditional revenue projects," he explains. "The Elite Eleven is made up of programmers and salespeople who design concepts we can put on the radio and actually make a profit from in noncommercial time."

Hamilton's stations have invested heavily in creating marketing events. "The pressure to perform for advertisers, both through promotions and advertising—and for corporate headquarters—is very demanding," he declares. For example, The Box has an annual car show that nets more than $100,000. But, he said, "Next year, that profit will have to be $110,000 and the year after that, $120,000, so we need to improve upon what's working as well as continue to create new, successful events. Sometimes innovation is sloppy and messy, and sometimes we fail, but we learn a lot along the way."

"To grow every year is difficult," Carl concluded. "That's why the new PD has to be versatile enough to preach motivational values, organized enough to keep everybody flying toward the future, and creative enough to develop promotions and event marketing projects that are new revenue streams."

Credibility

American newspapers and newspaper journalists are facing a huge credibility problem with their readers. A 1998 study commissioned by the American Society of Newspaper Editors, which is made up of 850 top-ranking news executives, has found that the public backlash against newspapers has reached an unprecedented level. "Scary," says Peter Bhatia, executive director of the society. "In the last decade or two, society has become much more cynical about its institutions. And newspapers are institutions."

Radio is an institution, too. We need to be checking our performance level with our customers. There is a lot we can learn from examining the newspaper industry's fall from grace.

The newspaper business has struggled in the last few years with declining circulation and now faces serious competition from the Internet. Attempting to improve its financial health, many experts feel that editors—to be compelling—have forced their writers to overreach in their reporting. Recently, several big city newspapers, CNN, and *Time* magazine have all had to apologize publicly for incorrect and (in some cases) fabricated stories.

Never Underestimate Your Customer

In the search for higher profits, many newspapers have underestimated their readers' intelligence and have made the mistake of thinking that playing up the trivial, perverse, and bizarre could be a winning combination. But instead of holding the readers' attention, it has turned them off.

Trying to give the customer what you think they need, instead of what they want, is a losing proposition. This type of arrogance has led to a loss of credibility and loyalty. Don't fall into this trap. Remember—and newspapers have already found this out the hard way—only through innovation can you continue to serve the needs of your customers.

False Advertising

Radio's credibility has been in jeopardy since the first time someone said, "We play the most music." Our positioning statements are misleading. Most music sta-

tions don't play a large *variety* of music. They certainly don't play fewer commercials. And they don't offer tons of *new* music first. Any listener who commutes knows (whether consciously or unconsciously) that she will hear the same songs in the same hour as she did the day before. Radio has become too predictable. A predictable station is a boring station. A boring station lacks credibility.

We should have honest branding statements that offer the listener a guarantee of services: music, news, traffic, and entertainment. After all, it is our job to give our customers a payoff for listening.

Bad Contesting

Unfortunately, most radio stations overlook the fact that more than 70 percent of their listeners never even attempt to participate in contests. A good contest is designed to entertain the people who *don't* play. *Jeopardy* is a great example. It's interesting, simple to play, and delivers a payoff to viewers who are not going to win anything.

We should stop offending listeners with phrases like "easy to win" and "caller number nine." The challenge is clear: either come up with new contests and alternative ways of winning or don't do any contesting. Try taking calls at random and really having instant winners. Many stations today take fax winners and others are beginning to use the Internet for contesting. It's a start.

The staple of radio contests—the pumped-up winner screaming, "Oh my God, I can't believe I won!"—is a cliché. The high-energy winner promo should have been eliminated decades ago, because listeners are so bombarded with commercial hype that they have become cynical and weary of such advertising. It's time to be real and take an honest approach to protect your station's image. Try to incorporate more mystery, fun, and real excitement in your contest promos. To write a good contest promo, follow these three steps:

1. In your first sentence, tell the listeners what you're giving away.

2. Explain to the listeners how this contest is different and how they will benefit from it.

3. Explain how to win.

Three more simple concepts are necessary to add excitement to any promo: length, pacing, and effective production. Promos should be short and to the point. Anything longer than thirty seconds means you're just repeating the message. The pacing and rhythm of the promo are where the creativity really begins. Through editing and voice delivery, you can enhance or subdue your message to match your station's image. Use cinematic sounds around colorful words to heighten the excitement and add creativity and style to your promo.

Here's an example:

SFX: The sound of a giant's huge feet crashing onto the landscape, shaking the ground like an earthquake. In pace with every step, we hear the Giant's heavy electronic voice say:

Giant: Jam! Jam! Jamuary is here! *(a woman's voice screams in the background)* It will be a monster!

Music: Scary chase music from a horror film fills in the spaces. Then we hear the friendly station announcer:

VO: To kick off the new year right, Q-FM is jamming monster music marathons, commercial free, and giving away Jeep Cherokees during the entire month of Jamuary. All you have to do is listen to the music marathons, count the songs, and when you hear Jamuary step across your dial…

SFX: Jamuary foot crash (Then Giant says, "I am Jamuary!")

VO: …call, fax, or e-mail the correct number of songs in to Q-FM and qualify to win a Jeep Cherokee, all through the month of Jamuary. Only on your music marathon station Q-FM.

Somewhere along the line, the responsibility of producing excitement got switched to the listeners. But in reality, it's the PD's job to produce promos with dynamic words and sound design; it's the jocks who must be unpredictable, spontaneous, and execute contests in an entertaining and personal way.

Echoing Your Community

If you want to remain credible with your listeners, you will have to make a difference in the community. If your radio station shares an interest in improving schools, addressing health issues, or providing mentoring, you are on the right track.

If you really want respect from your community, try to keep pace with the changes in your community's diverse cultures and try to incorporate that vibrancy into your station. If your staff lineup doesn't look like the face of the community, you're not credible.

Keep your community involvement on the front burner and weave it into the fabric of your station's image. Invest a significant amount of time and energy in your projects. Remember, listeners aren't stupid, and if they think your involvement is superficial, your credibility will suffer.

8

Paul Drew:
On Radio's Creative Tradition…
and How We Get It Back

I left WTLB in 1973, when a new program director was hired and changed the station's programming format to News-Talk.

Not long after, I was working for a manpower development organization when I got a call from John Long, program director of WAVZ in New Haven, Connecticut. He had an aircheck of me that had come from his all-night jock, Timothy "Buzzy" Hart, with whom I had worked at WTLB. He wanted to talk to me about a job. I thanked him and told him that I was flattered by the call, but that I was not interested in leaving home. Long invited me to visit the station. Luckily, friends and family convinced me to take him up on his offer.

I'll never forget the first time I came into WAVZ's signal range and heard "The New Waves." A jock named Bobby "Boogie" Rich did a fiery, rhythmic introduction over "Who's That Lady" by the Isley Brothers. I was struck by the energy and magic of the station; in that instant, I knew "The New Waves" was special—it had an enigmatic power, similar to my favorite at the time, CKLW in Detroit.

I didn't know then that both WAVZ and CKLW were consulted by one man: Paul Drew. Or that he had heard my aircheck and thought I was talented enough to join the air staff at The New Waves.

Compared to Utica, New Haven looked like New York City. It was home to Yale University and had a thriving downtown. Of course, this was just before

the mall migration began. When I hit town that day, the city was bright with promise. Buzzy met me and took me to the station to meet Long.

John Long looked exactly like I thought he would: a big guy with long hair that he kept throwing back behind his shoulders every few minutes. He had great eye contact and appeared to be a very honest man. He had a deep, melodious, Southern voice, reminiscent of plantation owners in Civil War movies. I called him "the Colonel" behind his back for year. He told me he wanted a black air-personality who didn't "sound black," but in some way kept that vibe alive. I knew what he meant. He wanted someone hip-sounding, who didn't go over the top, and who spoke the English language. The Colonel said he had searched the country high and low looking for someone who fit that description, and that I was a rare find. This was the first time I realized how few black DJs there were performing on Top 40 radio (in the early seventies, there were only about a half dozen African Americans on pop stations in this country).

The Colonel gave me a tour of the station, which was being renovated. New air and production studios were almost finished. The music on the station was being converted entirely to carts—an amazing achievement in those days. This meant the end of cueing records and the elimination of the scratched or skipping record. This was impressive, but the money he offered me was downright unbelievable—it was three times what I was making.

They put me up in a hotel with Buzzy as my chaperone. He took me out on the town, filled me in on New Haven, and told me stories about all the jocks at the station. He also told me about the mysterious Paul Drew.

Buzzy had never seen Drew, but was proud to be at a station that bore his brand. He told me that Drew could dial in and listen to any of the stations he consulted, and that Drew would call jocks in the control room (it was called "hot lining") if and when he heard them break format. Then Buzzy did an impression of Paul Drew's high, nasal voice, and his slow delivery. I wondered, "Who *is* this guy?"

In my head, I heard Long's whiskey-soaked voice telling me that WAVZ was a Drew-consulted station, and that Mr. Drew had the power to make radio careers. If I took the job and did well, I was sure to get a better position in a larger

market, at another Drew station. He then ran off a long, impressive list of stations (including my beloved CKLW), all under the influence of Paul Drew.

The challenge that WAVZ presented and an interest in Paul Drew compelled me to take the biggest step of my life—leaving home. I had imagined that I might work in radio in Syracuse or Rochester, New York, but I never visualized that I would cross state lines. I was twenty-four years old, in a marriage that could best be described as shaky, with two sons, five and three. I thought maybe a change of scenery would do the marriage good.Who knew? Maybe this Paul Drew guy knew something about saving marriages, too.

I had been on the air for about four months at WAVZ when I received my first call from Drew. I hung up on him, thinking it was one of the other jocks doing his Drew impression. When he called back, the tone of his voice quickly convinced me that it was him. He offered me a job at WHBQ in Memphis, and I did something that people didn't normally do to Paul Drew: I turned him down. Four months later, he called again, this time asking me to do nights at WAXY-FM in Fort Lauderdale. I took the gig. Again, I thought a change of scenery might do my marriage some good.

I learned two important things from Paul Drew. The first was how to break format correctly, and the second was how to focus like an all-star athlete.

After a few months, Drew visited WAXY in Fort Lauderdale and fired our afternoon drive jock/music director, replacing him with me. The only problem was, the former MD was my best friend. It was an awful situation. Here I was, promoted from nights to afternoon drive and given music responsibilities, but I was depressed because I was replacing my best friend. Drew asked to see me and said: "Every time Richie Allen (a batting champion for the Philadelphia Phillies) goes up to the plate, he's trying to knock the ball out of the park. He's not worried about his wife, his friends, or the fans. His job is to hit the ball. He is paid to hit the ball. You are paid to entertain and do great shows. I want you to get up and go in the control room and hit a homerun. And I want you to do that, not just today, but everyday." And I did.

As a jock working at a Drew station, I learned his system of where and when to talk. His format also demanded an economy of words. Once you mastered the

system, there was room for innovation as long as you stayed within the structure. This took a lot of preparation and discipline. Without Drew's early imprint to help polish my act, I would never have been ready for the truly improvisational work that lay ahead of me.

Paul Drew, president of Paul Drew Enterprises, Inc., and USA Japan Co.

As a young man, Paul Drew spent a lot of time by himself, pretending to be on the radio. He began his radio career in earnest before he started high school, on a local station in his hometown of Detroit. By 1966 he'd programmed WQXI in Atlanta and KHJ in Los Angeles, and had risen to vice president of programming for RKO Radio. He was one of the many radio people to be called "the Fifth Beatle," because his power to make or break records made him the only programmer to travel with the Beatles on all their American tours. His stations always got early exclusives of all the Beatles hits. Drew's imprint on Top 40 radio, programmers, and personalities is simply legendary. Today, Drew is the president of Paul Drew Enterprises, Inc., and USA Japan Company in Los Angeles.

Quincy: What kind of effect has deregulation, consolidation, and radio clustering had on our ability to program creative radio?

Paul Drew: Creativity is something that comes from within. I don't know if there's any less creativity today than there was thirty years ago, but there may be less of it getting used today. I think there is always a place for creativity in radio, regardless of whether someone owns fifty stations or six hundred.

Q: But wouldn't you agree that there is a lot more pressure on stations to perform financially and reach bottom-line goals? Has that shift made creative radio less of a priority?

Drew: There is a different model today—a different set of goals—because most stations are part of large groups. The groups have to service their debt and hit certain profit targets. Today's investors *expect* to get a better return on their money from radio than from IBM or government bonds. That's pressure.

Q: You've said that "the sound of a radio station is an extension of the program director's personality." Do you think, with today's economic pressure, that a PD can still get the sound from inside his head on to the air?

Drew: That comes under the heading of salesmanship. If you can convince the powers that be of what you can do, if you can gain their confidence in who you are, you will get the opportunity to pull it off or go down in flames. I still believe that the guys and gals who have great personalities generally have great radio stations—if allowed to do their thing. I hired Jerry Cagle to program WRKO in Boston, even though I'd never heard an aircheck of his radio station. We talked for several hours in Los Angeles and I liked what he said, so I sent him on to Boston. He had as much at stake as I did.

Jerry Cagle (Executive VP/General Manager, Network 40): That's true. I was at KRIZ in Phoenix, and Drew had never heard my station. I had accepted an offer to go to Miami and put Y-100 (WHYI-FM) on the air, but I didn't want to go. So I called Bob Hamilton of *The Hamilton Report*, and told him I had an offer to work at WRKO in Boston. To really pique his interest, I said it was highly confidential, so please don't tell anyone. Of course, he printed that I might not be going to Y-100 but to WRKO instead. Then the general manager from WRKO called me and said, "I don't know who you are but I hear you're coming to work for me." I sent him a letter of introduction and soon I got a call from Paul Drew.

Drew said he'd like to talk to me about working for the RKO chain, but he didn't have time—he was leaving town. This was on a Tuesday and I was leaving for Miami that Friday, so I told him it was now or never. I flew to L.A. the next day and we met. To tell you the truth, halfway through

the interview, I remember getting up and calling my wife in Phoenix; I told her that Drew was never going to hire me, because everything he said, I disagreed with. When I got back to the table, he offered me the job.

Q: Now that the radio station buying frenzy is over and it's time for these corporations to operate all these stations, group philosophies have changed from "Get the emotion out, it's a business," to "Let's put some fun and creativity back in the business." Why the turnaround?

Drew: In the case of any business, whether it's airlines or hotels or radio, the buying part is the easiest part. You get the financing, you buy it, now you own it. Then comes the real challenge: how do you manage it? This is a tough phase for these companies…and the longer they're in this phase, the tougher it gets. If these large companies don't have any transactions within a twelve-month reporting period—sooner in some cases—they're going to have to stand on their record and match this year's results for each facility with the previous year's results. McDonald's does it all the time, but as these companies were growing, and as the gross sales figures were increasing, there wasn't much emphasis on how stations were *really doing*. But if you're not acquiring or trading anything, then the attention turns to the individual performance of each property. That's why people are singing a new tune.

Q: When our industry adopted research as gospel in the late seventies and early eighties, and "more music, less talk" took over, did that kill a generation of air personalities who had nowhere to blossom?

Drew: The only place for personalities to blossom today is college radio, where there's no pressure to raise ratings and make money. Because of satellite technology and the very nature of consolidation's long reach, even the smallest markets don't have the farm teams that existed twenty-five to thirty years ago. There are so few places to practice and shape your craft. The same thing holds true for program directors; there are not a lot of places where you're given the opportunity to make mistakes, learn from them, and get to make more mistakes.

Q: So where are these new personalities and program directors going to come from?

Drew: They will probably come from outside of radio. I've never believed that someone has to be a disc jockey between the music in order to get people to listen. You just have to be an interesting person, and in my case, have an economy of words that fascinates the listeners.

Q: Speaking of an economy of words, your RKO stations in the seventies were tightly formatted, but air personalities were also encouraged to perform in the short time allotted.

Drew: If you start with the premise that, in a twenty-four-hour period, you basically have six, maybe seven on-air personalities, the odds of having seven [all-star baseball player] Mo Vaughns in your lineup are close to zero. In radio, at best, you may be able to afford—and hold on to by contract—a couple of people who are in that stratospheric status. But I think you can build a great radio station with only one or two superstar personalities—the rest are the supporting cast.

Q: Are you admitting that you got lucky with your lineups at CKLW, KFRC, and KHJ?

Drew: It's the equivalent of putting on a Broadway show. Like *Cats* or *Phantom of the Opera*. Did Michael Crawford make the show or did the show make Michael Crawford? We built a great stage, one with a lot of lights and props, so when the personalities stepped onto it, they were surrounded and protected by the atmosphere and setting. Confidence was the natural by-product of all that, and it helped lift the average performer to another level.

Q: Let's talk about the lack of presentation in radio today.

Drew: That's just laziness. Here in Los Angeles, I'll hear a great promo on the air and I'll ask myself, "Will I still be hearing that same promo a week from now?" I've always felt that promos should be changed every two or three days at the least. They're the commercials for the radio station.

They're image reinforcement; they refine the way you deliver your message. Most important, it doesn't cost anything but time to change them. People should be in the production studio knocking these things out, keeping them fresh. It's cost-prohibitive for McDonald's or the Ford Motor Company to do that, but in a case where you own the production studio and the distribution (the station), it's just laziness that they're not dazzling listeners every day.

Q: One of the lessons you taught me was to spend a lot of time in the production room, because that's where you create the sound of your radio station.

Drew: It's not the fault of today's generation of program directors that they grew up with television. If you go back to Rick Sklar, Kent Burkhart, people of my generation, when we were young, we had no choice but to listen to the radio. But we learned the magic of putting together words and sounds. We had a better idea of what that powerful mix can do.

Q: The lack of imagination and production imagery today—does it all come down to laziness? Is that the reason we don't have a lot more unique-sounding radio stations?

Drew: All of the people that had great production skills, who did all those marvelous things you heard on the radio, had to learn them. Either there was someone around to teach them, or they observed and copied someone else. Today with the advanced technology and the use of computers in production rooms, the learning process is less painful than it was in the days of razor blades and two-track Ampex machines. The process should be easier but...those cut-and-paste methods really made you consider each change—each edit—carefully.

Q: What qualities did you look for in air talent?

Drew: I always liked someone who had a good-sounding voice. I like to look at people who are handsome, and that to me is similar to what I look for in the sound of a voice. Not only in the *sound* of the voice, but the *way* the person says things. Do you remember the Sid Caesar sketch from *The*

Show of Shows about the first time a silent screen star had a speaking part in a talkie? He's very attractive, but he has this very shrill voice. It's a very funny bit, but my point is that the voice must represent the good looks and also give good content, no drivel.

Q: How did the RKO corporate environment affect the way you chose program directors?

Drew: General managers and the corporate environment make a big difference when you're making PD choices. I have saved, because he's been more successful than most of the people I've met in life, America Online President Bob Pittman's resume, which he sent me when he was eighteen years old, programming WPEZ-FM in Pittsburgh. I had a nice meeting with Bob one night at the Pittsburgh airport and I would have loved to hire him; same with Lee Abrams, senior VP of content and programming for XM Satellite Radio. They were certainly two of the sharpest programmers of the time. At that time though, my footing wasn't really in place at RKO, and my biggest fear was that the company would destroy them. Or somehow RKO would find a way to keep them from doing their thing.

But when I got to Jerry Clifton, I had been in the job several months and was willing to roll the dice. I put him in New York City right under the noses of the corporate people. Jerry had convinced me that he was going to beat WABC, so I hired him at WXLO (99X) in New York. I used to say that Jerry comes from the terrorist school of programming—you never know what's going to happen next—but I had confidence in him and I was there to protect Jerry.

Let me say something about corporations: Michael Spears had been a very good program director of KFRC in San Francisco; he had a tremendous track record, but against my advice, he took a programming job at our sister station KHJ in Los Angeles. I told Michael he would be offered the job and warned him not to take it, because I knew the situation was unstable. Anyway, I went out of the country and when I returned, he had taken the position. He was only there maybe five or six months when I

received a call from the president of [RKO]. The GM of KHJ had informed him that Michael wasn't working out and he wanted to get rid of him.

I spent the better part of the next day in a restaurant, talking to the GM and trying to salvage the situation. The one thing that kept running through my mind was that Michael had fifteen or sixteen good books for this company in San Francisco, and had made this company a lot of money. They wooed him to L.A. and, because it wasn't working in a short period of time, the thank you they were going to give him was, "You're now out of a job." I've never gotten over that. When somebody says that today's corporations are tougher than corporations twenty years ago, I'm here to tell you they're not.

Michael Spears (Operations Manager, KRLD, Dallas): Drew told me that KHJ would be like starting all over again, that the L.A. corporate culture was quite different from San Francisco. The station was not in good shape and it was under a lot of pressure to turn around quickly. Looking back, the management there had the desire, but not the finesse or skill level necessary to completely reinvent the radio station, and that was what it needed.

Q: What type of impression do you have now of the time you spent working with Paul Drew?

Spears: Drew carried himself with the highest degree of professionalism at all times. But, my first six months at RKO were like Marine Corps basic training; if you could get through that, you could get through anything. He was tough. But once you had his systems down, things got easier.

John Long (Business Manager, Web Designer, and Online Author): Paul Drew taught me that there was only one way to do things: the right way. Programming isn't rocket science. The biggest challenge I faced was getting everyone to work together for a common goal. Drew said to me, "Don't make the same mistake once." Drew believed that people—not systems—fail.

Drew-isms

Here are a few Drew-isms on the basics:

Preparation

Preparation is everything. The team that's going to win the Super Bowl is the team that's best prepared. You can apply that formula to any playing field. On the other hand, even spontaneity can be a planned event, like surprise plays that a team hasn't used all season.

Fundamentals

If you're a very successful radio station, you can make mistakes—not a lot, but you can make a few mistakes—and it doesn't affect things. However, if you're on the bottom and you're trying to climb up, every mistake you make is going to kill you.

Teamwork

It's wonderful to talk about teamwork, but I always considered it high-minded, and frankly a goal I wasn't really trying to achieve. There are so many departments in a radio station, and they all think differently. What I mean is, if someone is missing blocks or tackles constantly on a football team, you would really notice that. If a station is successful, I think a feeling of teamwork is born.

Customers

The customer is God. If you don't have any, you don't have anything. I've said this for years. Take an interest in the listeners and the listeners will take an interest in you. Some people failed interviews with me for programming jobs because they weren't interested in serving the customers. They didn't want to rent a car and drive around, or check out the station's signal, or spend a few days hanging out. They were interested in just getting the job, but if you don't want to know who the customers are, you flunk the test. *(continued)*

I'm not a big fan of focus groups, because you're never really sure of the sincerity of the answers you get from the participants. The profile of the market, in my opinion, should come through the eyes and ears of the programming people—the ones responsible for the product. You're not going to find all the answers by looking at a piece of paper or viewing a group of people through a one-way window.

Awareness

Listen to at least 50 percent of the station as it is presented on the air. Listen to other stations around the country via airchecks, with formats similar to yours. Listen to the competition; he may have a good jock, newsman or idea that you can use. Don't be afraid to borrow ideas. If it's good, it could be great on your station because you can make it better than it is. Be aware and listen to everyone's format across the dial in your market. Be aware of changes in format, no matter how slight, on the competition (change of a jock, a different golden mix, a new news time, a format change in slotting commercials) and make note of how that affects your position in the market. Awareness also means reading…Luckily, you can read and listen to the radio at the same time; therefore, you can kill two birds with one big stone…Read to expand your knowledge of what's going on.

(Paul Drew, RKO Programming Director Training Manual, 1974)

Q: How do you think radio can benefit from all the new technological breakthroughs?

Drew: Maybe we are on the doorstep of a whole new generation of people who can program radio, who are at this very moment, by the thousands sitting with their computers creating all kinds of radio stations out there on the Internet. Mainly because there is no one in the corporate environment telling them they can't do that. I think there is little doubt that the next exciting generation of radio people will come from new uses of the computer.

I also think the five major record companies will wake up one day and realize that getting records played on the radio isn't the beginning and end of promotion. The beginning is really keeping your ear to the Internet and listening for all the new music and groups that are out there. The digital and computer revolution is already underway.

Most of the people I've known in my broadcasting career seem to be people who spent a lot of time by themselves, pretending to be on the radio. And when you first got on the radio, you were usually on the all-night show, alone. Radio is a one-to-one medium, which is analogous to what the computer and the Internet provide—one-to-one communication. It reminds me of young people who began an interest in radio in the forties, fifties, and sixties. Again, I come back to this: The people in the radio companies who are searching for talent need to realize that there is another place to find talented people to do radio with inspiration, passion, and creativity.

Q: I read a presentation that you made about the future of radio. In it, you explore the idea of a place called "Radio Valley." In much the same way Silicon Valley rose up around the computer industry, Radio Valley would be a place where money is made through creative programming.

Drew: Considering all the regulatory, technological, and economical changes our business is still going through, in the future, the possibility of a centralized operation for America's mega radio groups is possible. Today, Silicon Valley is a place where the computer industry's best talent and their support networks are centered. Imagine a super group operating fifty stations across the U.S. from a common facility in Radio Valley. Imagine that group moving top talent from Dayton to Denver by walking down the hall, or better yet, by moving a switch on a console. Imagine having all your creative people in one environment, free from all the things that aren't too pleasant in other American cities, in a comfortable place where they can interact and exchange ideas. The technology makes it possible and it will cost the owners less to do this."

Q: What advice would you offer to program directors of the future?

Drew: If you have some great ideas and you love programming, there is nothing to stop you from doing a lot of tinkering on the Internet. The Internet is your laboratory. You can try things out there before you put them on the radio. It's a great place for experimentation. Because of the computer, it's actually easier to create a great radio station today.

That's what I always liked about WAVZ-New Haven. That station was such a great laboratory. The owners, Dan Kops and Dick Monahan, were sweethearts and didn't stick their noses into the operation. All the program directors there got the same message from me: You can do whatever you want, but don't let me catch you cheating these guys. Give this station your best creative effort, and everyone will prosper and grow.

John Long: Paul Drew arrived to accompany me on my first day as PD at WAVZ. When I joined him for breakfast that morning, he had a tiny headphone stuck in his ear. "Do you have a transistor radio?" he asked. When I said no, he reached in a bag and handed me one about the size of an index card...Of course, it came with an earplug.

"Now you don't have any excuse for not knowing what's going on at the station—any hour, day or night," he said. I sort of chuckled, and he looked me straight in the eye and said, "You're the one that told me you wanted to be a great program director." Then he reached in his bag again and took out a small yellow pad and a pencil. "Always have something to write on, and a pen or pencil. That way you won't forget the things you have to do. Now, take notes." One hour and three full pages later, we went across the street for my first day on the job.

9

Just Like Mike:
Playing to Win

At a news conference announcing his retirement from basketball, Michael Jordan looked like he had plenty of game left. But, he said, "Mentally, I'm exhausted. I know from a career standpoint, I've accomplished everything I could as an individual. Right now, I just don't have the mental challenges that I've had in the past to proceed as a basketball player. This is a perfect time for me to walk away from the game."

On that day in January 1999, Michael Jordan was in great shape. Although, at 36, his body may no longer have been able to accomplish the incredible feats of his youth, his knowledge of the game—and of his competitors—would surely have been enough to compensate for any physical limitations. He could have easily faced the rigors of another season and mesmerized us once again, but he chose instead to listen to his mind. This is a clear example of why Jordan was special.

A lot of athletes and coaches neglect the mental dimensions that are essential for success. They still depend only on physical preparation, skill factors, and technique. Certainly these elements are necessary for top-level performance, but what truly separates the winners from the losers—why one athlete will perform far beyond his potential and another far below—is mental training. Truly great players like Jordan add the mental powers of concentration, composure, and confidence into their competitive drive.

Author Stan Kellner writes in his book *Taking It to the Limit,* "Scan the books and magazine articles that are emerging on today's sports scene, and you'll find a new focus for training athletes…an internal focus. The mental revolution in sports has arrived. The dramatic conclusion is that the power of the mind is the driving force behind all athletic achievement."

Legends establish their reputations by breaking records and setting new standards. What set Jordan apart from other great players of his era, what made him truly rare, was his refusal to rely solely on his God-given gift to sustain him. Jordan's legend began with a dedication to craft, resilience in the pursuit of his goals, and a refusal to surrender to defeat.

Michael Jordan was an overachiever who honed his basic basketball skills to perfection. To be a champion, he did the things that other people didn't want to do; he dedicated a tremendous amount of time to the fundamentals of his craft.

In his book *Playing for Keeps: Michael Jordan and the World He Made,* author David Halberstam describes a social reality that may inhibit the evolution of superstars in basketball; it's a reality that should be noted by the radio industry. Halberstam wrote: "Jordan is a reminder to us of something desperately undervalued in contemporary America: the value of a real apprenticeship for even the most talented people."

Halberstam explains that, as the basketball system has become more predatory, "Players that have ability are not likely to hang around college for more than a year or two at the most, and it is going to be harder than ever to get them to listen to their coaches. More and more, they will arrive [in the NBA] on their own terms, and they will depart on their own terms as well. Then once in the pros, there is simply too much money already guaranteed for most of them to work as hard as Michael Jordan did, year after year, to perfect his game."

The broadcast industry has likewise lost its network of farm teams—or, as Paul Drew called them, "laboratory stations"—that develop the skills of talented young air personalities and program directors.

As the long arm of consolidation reaches into increasingly smaller markets, the financial demands imposed by this rapid expansion limits stations' abilities to nurture new talent. Under the umbrella of group ownership, all markets—large

and small—must raise ratings and revenue; that is the number-one priority.

In response to these new demands, many small-market radio operators have begun using automation systems—simple voice tracking or fully integrated digital delivery services—in less critical dayparts. Many experts believe that the growing use of voice tracking technology, or "virtual radio," is a key component of radio's economic future. The immediate upside is a reduction in payroll expenses—a short-term advantage for budgets—but the drawbacks to outsourcing talent could have dangerous long-term implications.

Remember, radio works best when it connects emotionally with listeners. Machines can't do that. Virtual radio, no matter how well executed, is not live. A canned presentation can't help being cold, detached, and devoid of spirit. The loss of spontaneity, local emphasis, and the stifling of budding talent will eventually leave us totally disconnected from our listeners.

Radio operators should realize that, in the long run, the use of small and medium-sized markets to develop new air talent will bring energy and commitment to their company. I hope megagroups will see the benefits of in-house training of personalities and managers. Moving talent up to larger markets is the best way to improve the bottom line consistently. Investing in radio's greatest asset—its people—should always be the top priority.

Preparation

There are several qualities that athletes and radio professionals share, and preparation is clearly an important one. The only way for an air personality to sound spontaneous and clever is to be prepared; this is the key to any great performance. Professionals are always reading, writing, and gathering information pertinent to their show. This is the difference between relating to your listeners and being out of touch.

"It took me years after I left radio to stop tearing stories out of the newspapers," says radio talent-turned-actor Jay Thomas. To Thomas, being prepared was like breathing. During his fifteen-year career as a top-rated morning man at

*Radio talent-turned-actor
Jay Thomas, circa 1993*

WAYS in Charlotte, WAPE in Jacksonville, WKTU in New York, and Power 106 in Los Angeles, preparation became second nature. "It was a twenty-four-hour search," he says. "I was always looking for that weird story that could anchor the show."

He continues: "By the time I reached the end of my career at Power 106, I had a full-time writer, who I still use for appearances on TV talk shows. When I do a talk show, it's like putting together a mini radio show. I look at what's going on in my life and look at what's in the daily papers. Then I sit down with the writer and hash it out. In radio, I did the same kind of preparation that I do now for Letterman or Leno. I would never go on those shows unprepared—just like I never went on the radio unprepared. I was always afraid I'd open the mic and have nothing to say."

The lesson we can learn from Thomas—and from Michael Jordan—is to be prepared. As an air personality, you must have sound fundamentals; they are the foundation that can help you evolve from air talent to star.

Master the Fundamentals

We all know that Jordan was blessed with physical ability, but without the coaching that he received from Dean Smith at the University of North Carolina, he never would have become a complete player. For three years, coach Smith worked with Jordan on his defensive skills. It was at Chapel Hill that Jordan learned that defense wins close games. Jordan did all the boring drills. The hard work he put into his game, under the tutelage of coach Smith, helped him evolve into a champion. Even after he entered the NBA, Jordan continued to improve on the basics. He was always the first guy in the gym and the last to leave. Add consistent weight training and countless practice foul shots, and the result is a quintessential example of what guided apprenticeship can produce: a perfect basketball player.

Once your fundamentals are well-honed and have become second nature, that's when you can begin to stretch your talents and become an overachiever. I'll take overachievers anytime, because their energy is positive, they energize others, and they set challenging performance goals for themselves. You can't be a winner without that attitude. Great air personalities and great athletes believe that they are special, and they strive to make the world agree.

The job of all on-air personalities is to make the listener stay tuned longer. In order to win, you must have more average quarter hours (AQH) than your competitors. The best way to do this is to give listeners a *reason* to listen; presell upcoming elements of your show, hype outside promotions and concert events, and let your listeners know why they should stay tuned.

If you want to learn the art of creative preselling, watch television. Television promos do an outstanding job of capturing viewers' interest by visually teasing what's coming up. News programs presell with great urgency; they do a superb job of taking their viewers into the next quarter hour. Granted, they have the added advantage of eye candy to engage the viewer, but when radio uses theater-of-the-mind techniques, it can capture the imagination of the listener and keep them tuned in longer.

The basic ingredients of pre- and backselling include call letters, time checks, personal greetings, and the *reason* to be billboarded or teased. But these elements alone are not enough; they should be mixed with strong salesmanship. Great jocks have the ability to produce an air of excitement, interest, or mystery. It's your job to creatively sell excitement.

Great personalities are also involved with the music, and the listeners pick up on that passion. Remember, if you sell the music, the music will sell you. Researchers say that along with talking over music, not revealing song titles to listeners is radio's major irritation—especially for singles-based formats like Top 40 and Country.

There are several schools of thought when it comes to the importance of backselling. I tend to equate it with lay-up drills in basketball: they're fundamental skills necessary to improve your overall game. Talented jocks can transform the mundane "that was...this is" rhythm of backselling music into magic. Listeners

Getting Inside Your Community

There is no trick to getting involved with your community. All it takes is hard work and dedication. By programming specifically to the age group you're trying to attract and focusing on issues that are important to them, you'll succeed. Let's take a closer look at some of the issues I've mentioned and how to turn them into interesting programming and ratings builders:

HIV and AIDS Campaigns

Until there is a cure, radio has a responsibility to inform its listeners about this deadly disease and its prevention. Offer your station to local groups that are working toward constructive results. Set up an information line to answer common questions about HIV and AIDS and to provide information about local treatment programs. Start an association with a health outreach program that has a team of workers who can travel into your community to provide HIV-related services. Go to school assemblies and sign up volunteer teens to be trained in HIV basics so they can share that information with their peers. Create a nighttime talk show that specializes in open discussions with experts on the subject; use the show to raise money and take political action in the fight for more outreach programs.

The old ways of promoting safe sex and AIDS prevention don't work with the generation coming of age today. It will take new ideas and energy to stimulate this group. Reinvent your safe sex promotional campaigns to be street smart and reality-based. Fill your airwaves with artists, actors, athletes, and local heroes who advocate safe sex and HIV testing. Have HIV/AIDS information available at all of your promotions, concerts, and remotes, at your station, and in your station vehicles.

School Funding

One initiative that can provide both immediate and long-term positive results is the adopt-a-school program. In many cities, local businesses join with community development groups to offer assistance and supplies to needy schools. How do you do it? Just pick up the phone and arrange a meeting with your local school officials. Ask the principal, teachers, and students what kind of assistance they need to improve their educational environment.

The answers may include computers, books, art supplies, or free lunches. The kids may need field trips, basketball uniforms, or a career day seminar. Whatever the need, you and your station probably already have the assets, resources, community connections, and fund-raising expertise to get the job done.

I can't think of a better way to help one's community than by adopting a poor school. The support and social interaction you provide will instill pride and confidence in the students. If you truly believe that your station should be a resource for the community and that being responsible means embracing your connection to others, then an adopt-a-school program maybe a perfect match for you.

Battling Violence

Street Soldiers is an award-winning call-in talk show that encourages young people to speak out about crime, teenage pregnancy, and drugs. Normally I wouldn't recommend syndicated programming, because I firmly believe local programming can have a more direct impact on issues facing your community. But violence has become so universal in our country—and this show is so good at addressing the issue—that I strongly urge you to either pick up *Street Soldiers* or emulate it.

The program began in 1994 on KMEL in San Francisco, where it enjoys excellent ratings. Soon after it proved successful, it was added to KMEL's sister station KKBT in Los Angeles, where its ratings are equally strong. Now the show is syndicated nationally.

Joe Marshall, a veteran high school teacher and a MacArthur Fellow, cohosts the award-winning show with celebrity guests and community activists. Marshall is also cofounder of the Omega Boys Club of San Francisco, which caters to at-risk youths. The club and the radio show target two issues that increasingly impact our communities—drugs and violence. "We decided that these problems were everywhere and we had to get more people talking about them," says Marshall. "They can appear anywhere. In your neighborhood, your house, your school, or your music. We ask the kids to keep their eyes and ears attuned for those things that put them at risk."

want music information, enjoy hearing entertaining chatter, and crave showmanship. Creative backselling is like dribbling behind your back, faking a pass, and taking the ball to the hole.

Creative pre- and backselling is becoming a lost art in radio. With the focus on "more music, less talk" and today's heavier commercial loads, programmers are inclined to discourage their jocks from adding more clutter, even at the expense of creating interest. I think stations that don't allow jocks to backsell music are fundamentally flawed. They're not meeting the listeners' needs and expectations.

Get Involved

Great radio personalities get involved with their communities; they have the ability to communicate, strike an internal chord, with their listeners. They work hard to develop an interactive process with listeners that cultivates a mutual friendship, a "human-ness." But personalities can't do this alone; it takes a complete station commitment.

The deregulation of the radio industry has meant less oversight. As a result, stations aren't held accountable to the FCC, and no longer allocate any sizable amount of time to public service. Even before deregulation, radio often neglected the opportunity to use community involvement as a way to interact with their customers. Many programmers today—especially in the top ten markets—believe it's impossible to effectively serve the community, because it's too large and diverse; they would rather spend their money on television and billboard campaigns, direct mail, and contests. Putting money into your community rather than into contests makes more sense.

The first thing a radio station must do is identify the key issues facing its community. This information can be gathered through in-house research, your Call Back Squad, or through focus groups designed to determine areas of concern in your backyard. Today the typical list includes: AIDS/HIV awareness, poor schools, the homeless, violence, drug abuse, and the lack of parks and recreational programs for youth.

Obviously, this entire list is too much to tackle. I suggest you make one issue your own by seriously addressing the problem. Begin by creating an environment in which something can happen. Take a stand and challenge your community to join you in your quest to improve the situation. Invest time and creativity into producing promos and editorials that explain your plan of action, and encourage other community leaders and activists to join in.

If you really want respect from the community, you must show long-term commitment and follow through. A vital part of winning comes from investing significant time to community efforts. Don't fall into the trap of just doing lip service with fancy slogans; really dig into community issues and associate your station with community leaders.

Keep your issue on the front burner and weave it into the fabric of your station's image. This will give your station greater credibility. Remember, listeners aren't stupid, and if they think your involvement is superficial, they tune out.

If your radio station is truly interested in community issues, and is dedicated to providing leadership, motivation, and getting involved on the ground level, your call letters will become intimately associated with your city. Be committed to public affairs, allow civic leaders access to your station, and embrace your community; it will embrace you back. Great personalities are about more than just gaining ratings. They're about making a difference.

10

Personality

To be a great radio personality, you must know how to entertain. It's what people listen for; it's what you're paid to do. You must create an environment that adds enjoyment to listeners' lives. My old dictionary defines personality as "a) habitual patterns and qualities of behavior of any individual as expressed by mental activities and attitudes; distinctive individual qualities of a person, considered collectively; b) the sum of such qualities likely to impress others."

Every great radio station and personality has its own unique sound. You know when you're listening to Howard Stern's syndicated program and you can feel the good vibes that the *Doug Banks Show* on the ABC Radio Network sends out. These two shows couldn't be more opposite in their styles and approaches, but they both achieve great results, primarily because they both entertain. Banks and Stern are personal and relate to people. They wrap their humor around issues that matter to listeners, and that's what counts.

"I've competed against Stern in New York," Jay Thomas says. "I think Stern is a phenomenon. He definitely knows what today's listeners want to hear. He gets personal—straight to your sex life. If I was on the radio today, I couldn't beat him. You can't battle that."

Great personalities today don't use prepared bits and punchline humor. They don't rely on contests or silly wake-up calls as insurance for high ratings. Today, great radio personalities are interested in what's happening in the real world. They talk about subjects that listeners can relate to, such as spouses, family, coworkers, the job, movies, TV, current events, and, of course, sex. Nowadays you have to be unpredictable and never succumb to expectations.

Doug Banks was one of the highest-rated air personalities in Chicago for a decade. He has been named "America's Best Urban DJ," and recently reenergized ABC Radio Networks' Urban radio syndication programming with his nationally broadcast *Doug Banks Show*. Banks is a strong communicator and excellent entertainer who finds humor in everyday life.

"A lot of my stuff is based on things that happen to me," says Banks. "I talk about my kids, about being married…I don't want to be thought of as untouchable. I don't want the listeners to feel that they can't relate to me. I think some personalities make that mistake. I want people to walk away from my show with something. If it's humor, great. If I made them think, great. But I have to leave them with something.

"I was very lucky to come up in an era—listening in the sixties and starting on-air in the seventies—when all the people I worked with had personality. Because right after the seventies into the early eighties we had all these guys reading liner cards. They couldn't *spell* personality, let alone be one. They were brought in to just *do* the format. I don't think I could have survived if I came along in the era of reading cards."

The hardest quality to convey is warmth. It's one of those things that some people have naturally and others don't. In sports, it's called being passionate about the game. In radio, every jock needs to have a high level of warmth to sell music or community issues. This quality demands the real you. No one can convincingly fake passion or conviction.

During my years as a disc jockey, I relied on—and still recommend to other jocks—the book *An Actor Prepares* by Konstantin S. Stanislavsky. Stanislavsky's acting method teaches you to react to emotional, physical, and mental stimuli

in a fresh way, a way that can't be imitated because it is from inside you. There is nothing more liberating than the first moment you are on the air as yourself: You are no longer imitating other voices, and all the trappings of a disconnected performance are gone. You are truly communicating one-to-one. You can communicate any emotion without the listener feeling any sense of deception.

Achieving Greatness

What is the difference between a good jock and a great one? In 1975, when I worked with Bill Tanner, the legendary program director at Y-100 in Miami, he gave me an answer that I've never forgotten. "A good jock is like a small steel ball rolling effortlessly through a shag carpet," Tanner said. "It speeds along, evenly, straight to the end. The shag carpet represents the listeners who fold over for a second as the steel ball passes by, then bounce back in place."

"A great jock," he continued, "is that same steel ball with a piece of gum on it. Now when you roll it on the shag carpet, its path is slower, rougher, uneven, and by the time it gets to the end, it's got pieces of the rug stuck all over it. The pieces of rug are listeners, clinging."

Which type of jock are you? Which would you want on your station?

Personalities—and great radio stations with personality—have something special that draws listeners to them. Think about your favorite station and how important it is to listen every day for the dose of excitement and energy it adds to your life.

In his groundbreaking book, *Understanding Media*, Marshall McLuhan called radio "a private experience." Radio affects people intimately, he wrote, by offering a one-to-one communication between speaker and listener. It possesses a magical power that can touch remote—sometimes forgotten—chords in all of us. Orson Welles' 1938 Halloween broadcast, *War of the Worlds*, about an invasion from Mars, was a classic demonstration of the power of radio. Hitler used radio to take control of Germany; Winston Churchill galvanized his fellow Englishmen to fight the Nazi threat through the airwaves; FDR kept America focused on the war effort at home with his radio "Fireside Chats."

Personality is the heart and soul of radio, and it is also the hardest ingredient to maintain on a daily basis. Buzz Bennett, the highly regarded radio programmer, consultant, and futurist, laments, "The interactive process of the intuitive human is missing in radio [today]. We used to have live copy, liners, concepts, and contests that cultivated an interactive process with the listeners. What was coming from inside you was felt by them. What the listeners found on the radio was a friend. And from that, a lasting relationship developed into TSL [time spent listening]. Today in most cases, radio is so 'surface' that people are hearing only formulas."

Maybe the hardest part of reaching greatness is maintaining the hunger for learning. That means staying in touch with the latest technical developments and concepts, and absorbing every cutting-edge idea from strategic and motivational thinkers. Develop a personal learning plan and fill in gaps in your skills. Smart goals are specific, measurable, and achievable. Your constant thirst for knowledge will keep you topical, local, and relatable. This kind of passion is contagious and will uplift your individual performers, along with your entire organization.

The Three Cs

The three Cs that I mentioned earlier—concentration, composure, and confidence—could easily be mistaken for the three Fs—focus, flexibility, and faith—because they're so interconnected. You can't concentrate without being focused. You can't be composed or control your emotions without being flexible. And you can't have confidence without having faith—that is, being connected spiritually or emotionally to others. Whatever you call them doesn't matter. What's important to remember is that whoever possesses these mental powers is the person with the winning edge.

Concentration

Concentration—being focused on the present—is where you will find harmony between your mind and body and reach a state of extraordinary awareness. When you're really "on," you have heightened powers of anticipation and response.

The Effort Chart

The wise leader understands that even if every person and every piece of work is perfect, there is always room for improvement. To reach higher goals for your team, set individual standards for performance. When people set their own goals, they will work harder to achieve them. This will be the covenant, a moral connection between you and them. Devise an effort chart for each jock. Design it in the style of a report card, but remember that each personality's strengths and concerns will vary. This allows you to zero in on each jock's strong and weak points. For example, one jock might need an emphasis on warmth and pre-selling, while another might need to work on his or her humor or brevity. Plus, each daypart will have different needs, and that will determine what areas should be focused on in each personality's performance.

Here is a list of qualities I believe are essential to any effort chart. They cover the basics that every personality should bring to the table, but since every station and personality has different goals and needs, your specific charts will vary.

☑ **Preparation:** *The only way to sound clever and spontaneous is to be prepared.* This is the key to any great show, and is also the easiest thing to spot during an aircheck. When your people can't turn the weather, a sporting event, or a community affair into an interesting sell, they aren't doing enough homework.

☑ **Consistency:** *The glue that holds every station together.* Jocks who leave their personal problems at the front door, perform at top level, and then pick up their troubles on the way out are true pros. Even if they drop their problems off at *your* door, do a great show, then come back *to you* to work out the difficulty, take it.

☑ **Warmth:** *A natural quality impossible to fake.* Exuding warmth takes work and a lot of practice. Just as great actors have to reach inside and find that inner person to deliver warm messages on stage or screen, the same applies to air personalities. This quality demands the real you; otherwise, it just sounds phony.

☑ **Entertainment Level:** *Smiles and more smiles, maybe even a laugh.*
Again, some people can make you laugh out loud and some can make you smile to yourself. We all have different styles and delivery, so work with your jocks to find their comfort zone and the kind of humor that works for them. When you find it, work at it until it's a natural part of their character.

☑ **Team Player:** *Even Michael Jordan couldn't win by himself.*
We've all marveled at Michael Jordan's ability to take over a game in the final seconds—it became a signature of his career—but like all true champions, Jordan is also a team player. Team players understand that the goal *of the team* is to win, and to do this, *everyone on the team* must be a part of that winning process. For Jordan, it means drawing a crowd of defenders, then passing off to an open teammate.

Jordan learned the ropes of selfless play from his coach Phil Jackson, whose coaching philosophy is grounded in the idea that the power of "we" is stronger than the power of "me." Jackson writes in his book, *Sacred Hoops:* "My goal was to find a structure that would empower everybody on the team, not just the stars, and allow the players to grow as individuals even as they surrendered themselves to the group effort."

Team players understand the goals of the station and encourage others to be a part of the team. A team player is someone who shows up at station events, even when he or she is not scheduled. They creatively cross-promote other jocks on the station. They promote special features and contests as though they're brand-new, and they treat the listeners like they're part of the family.

To make this effort chart work, you have to set it up in the spirit of competition between your players. Offer a prize for best jock of the quarter—a trophy, a free weekend trip, or a bonus package of some kind. Obviously, the bigger the prize, the more enthusiasm it will produce, but don't be surprised at how enthusiastic your people can get over the idea of a good-looking award sitting on their mantle.

Michael Jordan, Steve Jobs, and Howard Stern all reach their peak performance through the power of concentration. For Jordan, it's the perfect pass to a teammate when he's double-teamed; for Jobs, it's thinking differently and creating outside the box; for Stern, it's his ability to inspire his team members to follow his vision and capture the imagination of millions of listeners every day.

Concentration and focus will help you reach that unconscious level where your mind is weighing all the alternatives, picking the right one, communicating that to your muscles, and making things happen. Radio is a live medium; when you're on the air, you need to be in the moment. Once you have a command of your basics, you are less inclined to be distracted by fear or anxiety. As an air personality, I was far more effective when my mind was clear; I eliminated all distractions, and had no thoughts about anything except my agenda— to entertain, one set at a time.

Composure

Earlier, I mentioned the first time I felt completely natural on the radio. What I didn't mention was how *mentally relaxed* I was. When I look back on it, I see how the work I put into basics like show preparation and creative pre- and back-selling had blended with my new improvisational style of performing. I began looking forward to going on the air because I would lose myself completely in the momentum of the show. I would literally mix myself into every moment, beat, and rhythm of the show. To do this, my mind and body had to be flexible and open to all incoming impulses. After four hours I would be completely exhausted, yet high as a kite from the adrenaline rush.

The best way to develop and maintain your composure in today's fast-changing radio environment is to release all notions of control. It is absurd to think that anyone can plan for every contingency. But understand that there is opportunity in change if one remains flexible. To help you through stressful situations, I recommend you take up meditation exercises, Akido, or T'ai Chi classes. I've experienced nothing but positive results since I began T'ai Chi lessons a year ago. My only regret is that I didn't start them earlier in my life. But better late than never, especially if you want to remain open, ready to yield, and responsive to change.

Confidence

Creative people like actors, musicians, and radio personalities put part of themselves at risk every time they perform. Without confidence, the stress of this kind of repeated vulnerability would be almost impossible to take. I suggest that you get your confidence fix from as many areas as possible. Start by being confident about being confident.

Confidence comes from being prepared and having the psychological strength to think positively. All artists need a creative support environment to help maximize their potential and to make them feel safe taking risks. Ideally, a coach offers honest and consistent input, but I suggest that you develop a group of artists and creative people who share the desire to stretch their creative muscles. Last but not least, a spiritual connection is a bonus that can offer emotional stability and endurance.

11

Buzz and Batt
on the Creative Ride

When I joined the air staff of WAVZ in New Haven, John Long, the PD, gave me an aircheck of a station in Pittsburgh, Pennsylvania. He wanted me to listen to it, and he insisted that I pay special attention to a jock named Batt Johnson in order to get a better idea of how he wanted me to sound. I was blown away. The station was called 13Q—so simple, so cool—and there were no jingles. The jocks, somehow, magically tied everything together. They were the catalysts who regulated the momentum of the station, who controlled the flow of energy.

When I returned the tape to Long and told him how impressed I was with Johnson and the station, he told me that 13Q was programmed by Buzz Bennett, a new breed of programmer who was revolutionizing the industry. It wasn't long before I discovered just what he was talking about. Bennett's combination of money, music, and magic altered the radio landscape forever.

"Buzz was a god," says Batt Johnson. A veteran broadcaster, acting coach, speaking coach, and communications professor, Johnson first met Buzz Bennett in 1968 while working for KDKD-FM, an automated rock radio station in San Diego, California.

"My job was to change the reels of tape," Johnson remembers. "Buzz was the PD of KGB, our AM sister station. We became friends, then roommates, and

we spent a lot of time studying Eastern religion and philosophy, reading meta-physical books, and having lengthy discussions about all of it. I knew him as a leader, teacher, and a mystic."

Their friendship transcended business. In fact, Johnson now confesses, "When Buzz left KGB and crossed the street to KCBQ, Charlie Van Dyke replaced him as program director at KGB, and I became a spy for Buzz. Whenever I heard anything about Van Dyke's promotions or programming plans, I'd call Buzz and tell him." Johnson was rewarded with his first full-time on-air job. "I did over-nights on KCBQ, and was assistant production director under Bobby Ocean," he recalls. "I was at KCBQ for a year. Then Buzz and our general manager got into a fracas, and Buzz got fired. About ten or fifteen people quit because he was let go. I've never seen anything like that before or since in my career. It also speaks vol-umes about Buzz's charisma, charm, and leadership powers."

Bennett's programming philosophy began at KCBQ, then moved across the desert to Phoenix, Arizona, at KUPD and KRIZ, and finally arrived on the East Coast in the form of 13Q Pittsburgh. "Pittsburgh is one of my hometowns," says Bennett. "A lot of my relatives lived—still live—there. When I started 13Q, the competition at KQV thought I was just a West Coast hippie. But I knew Pittsburgh."

Buzz also knew whom he wanted on his staff. From WPGC in Washington, D.C., he hired Dennis Waters for middays and Mark Driskill as production di-rector and afternoon drive. From WKBW in Buffalo he hired the fastest-talking mouth in the East, Jackson Armstrong. "I wanted a madman on the air at night," says Bennett. "Armstrong was not your normal disc jockey. When I heard him on the air fast rapping and screaming 'your leader,' I called the re-quest line and hired him on the spot."

The rest of the lineup included Sam Hall from KDKA (the heritage power-house station in Pittsburgh), Johnson, and Dave Brooks. Buzz was now VP of programming for Heftel Broadcasting. He hired Dave Daniels as PD of 13Q.

"We all arrived in Pittsburgh about three weeks before the station kicked off," Buzz says. "We were staying at a Marriott, having strategy meetings every

day. We'd listen to the competition and dissect their format, playlist, and promos. We would also write promo ideas, work on our format, and create visual logos for the playlist."

Johnson remembers helping out on research: "Buzz would send us out around the city of Pittsburgh with tape recorders, talking to people on the street," he says. "We asked them what they thought of Pittsburgh radio. What did it need? What if a radio station came to town and gave away ten thousand dollars? Would you listen if a station was giving away fifty thousand dollars? We'd take all this material back to the radio station and make promos out of it. These 'people promos' were powerful—regular folks talking to regular folks."

"We ran these people promos about this station, 13Q, that didn't exist yet, on WKTQ, which was still operating as an all-news station. We started with a thirteen-thousand-dollar cash call jackpot. All the listeners had to do was answer their phone—'I listen to the new sound of 13Q'—and win thirteen thousand dollars. The phones started ringing at the news station instantly. In other words, we had Pittsburgh's attention before we played a single record. It was a combination of the cash call jackpot and the city of Pittsburgh talking to the city of Pittsburgh."

In its first book, 13Q pulled a 15.7 share of the audience. With the people promos running day and night, the listeners became the stars of the stations. "That was his genius," says Johnson. "Buzz really knew how to take the listeners and use them as the messenger." But Bennett's work was not done. His contract with Cecil Heftel was a package that included two stations. Next up for Buzz was to turn a 100,000-watt FM in Miami into a winner.

❧

The Fort Lauderdale/Miami radio market of the early seventies was fiercely competitive. The marketplace was full of Top 40 AM stations, including the long-standing ratings giant WQAM. On FM, WSHE was playing AOR (album-oriented rock), establishing solid ground with men 18 to 49. But what made this market a real challenge for Bennett's new FM was that he would be competing against one of his own creations—WMYQ-FM (The Q). In 1971, when Bennett was program-

ming KCBQ in San Diego, the Bartel company purchased WMYQ in Miami. Bennett was hired to consult the company's new property. Bennett turned The Q into a hit-oriented station. Lee Abrams, senior VP for XM Satellite Radio, a veteran of the radio wars in Miami and a WMYQ program director, remembers, "A lot of people don't realize that Miami was one of the first groundbreaking FM markets. WMYQ was one of the first Top 40 FMs in the country, and it personified Buzz's hipster vibe."

WMYQ was a very original-sounding station. It took The Q about a year, but it finally scored decent numbers with teens and women in the 18 to 34 demographic. "It was a tough battle," says Abrams. "We beat the other AM stations, WFUN and WINZ, but WQAM was tough. We never beat them overall. I think what made it a little easier for Buzz's return was the departure of the original WMYQ staff. By 1972, the young, hip staff that Buzz had hired had either left or were replaced when a conservative faction of the company took control of The Q. WMYQ still had a presence, but the station's hipness was gone, and Buzz capitalized on that."

In 1973, Buzz Bennett returned to South Florida radio. WHYI-FM was already up and the general manager had named it Lucky 100. Bennett began by dumping Lucky 100 for Y-100 (The Y). The station quickly absorbed the local vibe and replicated the twenty-four-hour party spirit of South Florida. There was always a party going on at 100 on the FM dial. Bennett said at the time that The Y was the next evolutionary step in his programming vision. He staged a fifty-thousand-dollar cash call promotion. In its first ratings book, Y-100 had a 5.6 share. Respectable, but far from being number one. I joined the station in 1975 and Bennett was off to other adventures. We would finally get on top, but not until a year later when PD Bill Tanner brought Bennett back into the fray.

All of us who worked at Y-100 knew that Buzz Bennett was our creator, so when Bill Tanner rehired Buzz as a consultant in 1976, it was like the prodigal father had returned. At the time, Y-100 was being challenged in Miami by a talented programmer named Jerry Clifton, himself a student of Buzz's hip, street-style of programming. Clifton had added new life to WMJX-FM (96X, formerly WMYQ), and Tanner—no fool when it came to winning—sent for Buzz.

As part of Tanner and Bennett's strategizing, each member of the Y-100 air staff had to have an aircheck session with Buzz. I remember mine clearly. Tanner was behind his desk and Buzz sat near me on the couch. My first three or four breaks were applauded, but then a break with a contest winner played. Buzz said, "Play that again." After a second listen, he turned to me and asked, "What happened here? Your energy has dropped several levels. What's going on here?" I was lost.

"Show me how you work the microphone," Buzz prompted.

No one had ever asked me to do that before, but I showed him how I danced, moved a little behind the microphone as I talked. He asked, "Do you dance like that when you're doing contests?"

I thought about it and told him that I just stood and talked to the winner.

"So you're not really comfortable doing contests?"

For the first time, I realized that I wasn't. Buzz smirked the way Sherlock Holmes might have if he were trying to solve Y-100 mysteries. "Try dancing when you do your contest. You're better when you're moving," he suggested.

He was right. I haven't stopped moving since.

❧

I talked to Buzz about radio's past, present, and future.

Buzz Bennett

Q: What's the difference between radio today and radio of the sixties and seventies?

Buzz Bennett: Everybody today is surviving on research. People aren't using their instincts. There's no instinctual movement; it's all rational movement, which is okay in a noncreative industry, but in radio, it takes people who want to drive themselves to create something new.

Q: But in 1972 you used in-depth research at KCBQ in San Diego to beat Bill Drake's KGB. It was a useful tool then. Why not now?

Buzz: You just said it. It was just a tool. Research is cool, but it's only part of the answer. Today nobody's dealing with the second part of the formula: development. Research gives you a blueprint, but you have to build the house with other materials. Remember, in-depth research means more than just waiting for some guys to send me their report. You've got to be in the streets with the people, finding out what's happening, and creating that energy on the radio. I've been credited as the first guy to do call-outs and tabulate requests and record sales, but it is still just part of the blueprint. If you just follow the blueprint, you'll never find your listeners.

I'm a street guy, and I've always believed that most of the answers are in the streets. You just have to go out and get them. When your challenge is to get people to listen to a radio station, the art of looking and listening to the street is essential. The language you find out there—the way the people really talk—is a key to separating your station from the rest.

Q: Give me an example of language from the streets that worked for you.

Buzz: The expression "rip-off" came from the street. I did "The Great Rip-Off" contest on KCBQ and Charlie Van Dyke, who was my competitor at KGB, later confessed that listeners would constantly call his request lines asking, "Hey, when can I rip you off?" He said that [his] station was demoralized and never recovered.

Q: Is it true that you required all your jocks to read a particular book?

Buzz: It's called *The Power of Your Subconscious Mind,* by Dr. Joseph Murphy. It's a very spiritual book, and it gives anyone who reads it a positive attitude. Everybody would come to the jock meetings with their copy of the book and we'd review it.

Batt Johnson: Buzz made everybody read it. The book was about how you manifest what you think about. How you become what you think. The title really says it all. It's about the power of your subconscious mind. Buzz really believes that the subconscious mind is more powerful than the conscious mind, and we're all really driven by what's in our thoughts.

Q: A general manager in New York said to me in the mid-eighties, "Radio is strictly business, not an art form."

Buzz: He was wrong. Radio is a business and an art form—if you're good at it. If you're not good, it will certainly sound like a business. It's art because it's a form of entertainment, and that requires creativity. Unfortunately, the big radio groups are looking for guys who go through the motions of being a PD but just dot the *i*s and cross the *t*s. Downsizing is a good business move for momentary assistance to your bottom line, but when you get rid of good creative minds in the process, that trade-off will be very costly in the long run.

Q: What makes a creative radio station?

Buzz: A cause that requires a team of talented people to blend into a focused unit. Synergy. Everybody in the radio station must believe in the cause with their hearts and souls. The spirit produced by [this cause] is so strong that the listeners can feel it. They want to be a part of something like that.

I listen to stations today and the jocks sound like computers. They don't have a cause; there is no heart involved in it, no passion flying through the airwaves. I have a hard time listening to radio today. I don't hear that spark of creative people who believe in what they're doing. A great jock projects from inside to get inside the listener. That's when you'll hit a responsive chord with the audience.

The objective is to create an original radio station full of excitement, enthusiasm, and charisma. If the listeners feel that positive, good-time vibe, they are going to want to share that; they'll stay tuned longer and they won't even know why. It's contagious. People always want to be around upbeat, positive people. If your station is up, positive, and smoking, everybody wants to listen to it. If your station is bland, vanilla, and mediocre, nobody wants to listen to it.

Q: Do you see any positive side of deregulation?

Buzz: The only positive I see is what they tell you in any twelve-step program: You have to completely bottom out before you can come back. I think we're almost there. What we need is a creative revolution.

Q: You say stations are lacking causes, energy, and synergy, but isn't that the responsibility of the program director?

Buzz: Yeah, but who is the program director today? There are some qualified program directors, but a lot of people have been put in that position and they shouldn't be there. They have to program by committee, and the tendency is to say no to new ideas. That cuts off creativity.

For creativity to take place in radio, you need a leader who expresses the vision of what needs to go on the air. Everybody in the station must believe in that vision, must vibe on it—only then will the audience pick up on the vibe. That's what's missing today with programming-by-committee and cash-flow consciousness.

Q: Where do you see the industry moving?

Buzz: The industry reminds me of the Chicago Bulls management that refused to resign Phil Jackson, who coached them to six championships. That arrogance caused the greatest basketball player in the history of the sport to retire. Then they eliminated all the rest of their top players. But what they took away was the heart and soul of their team. [It left] the upper management in better shape financially, but the spirit of the team was dead and gone. Radio has done the same thing. It's gotten rid of experienced players to save money and basically it's as devoid of talent and spirit as the [post-Jordan] 1999 Chicago Bulls.

Q: Some people are saying that we creative types should grow up and face the fact that this is the way the radio world is now. Big business, no emotion.

Buzz: They would like us to go quietly into the night, but the point is not to take the world the way it is, but to take the way the world is and change it for the better. Creative people need to step up to the plate and change

things. It's sad to watch this industry becoming less than what it was. It was supposed to become better than it was.

Q: Do you believe that the next line of creative programmers are going to come from the Internet?

Buzz: That's absolutely true. We're putting our Internet radio station up right now, Buzz Radio (*thenewbuzznet.com*), because we know that's the future. It's not going to be a big cash flow deal, but there are a lot of creative people prepared to work for almost nothing, just to be involved in the new action. When you offer people money the reaction is so-so, but when you offer them freedom, it's heavy. That's what the Net has going for it: freedom. It will be a cool station…but eventually the money monsters will come and try to change things.

Buzz Words

Paul Drew

I believe in people more than Drew does; he believes in the format a lot more than I do. My philosophy is the rules are to be broken. Here's the format, now break it—but make sure you do something better.

Like Drew, I believe that you have to give your personalities a stage, but unlike him, I let them do their own thing. It's their personality that's going to make it happen. I can't tell you how to be charismatic. Only you can tell you how to do that. All I can do is give you the freedom.

Bill Tanner

Tanner is great at giving his staff freedom. He surrounds himself with intelligent people and lets them do their thing. That's as brilliant as you can get in broadcasting.

Personalities

I don't want to build some type of robotic personality, so I've always looked for someone with a solid hold on their identity—someone who knew who they were, where they were going, and had the courage to go for it. I also looked for people who were hungry. I always thought it was cool to hire guys that weren't working. They would do such a great job for you, because they didn't like being out of work. I like hiring vultures. Give a bunch of vultures a cause and look out!

Program Directors

I've known many people who can do the mathematics of radio—that's a program director. Fill out this form, do a monthly report, schedule people, etc. But a programmer shows his team how to communicate with listeners. How to make them happy, and turn them on. That's what I expect from my PD. To be a great coach. I look at athletic coaches and they look like program directors to me. They keep their team fired up.

In the NBA, Larry Bird is a player's coach. He coaches his team as if he were on the floor with them. He takes in all their input. In other words, all the guys on the team are coaching the team because Bird is never above them, he is with them. It's a good lesson for radio programmers. It's better to work with your people, not have them work for you.

Preparation

During my whole career in radio I've always done show prep. But it seems to me that once I cracked the mic, whether it was for a promo or beginning a show, I never followed the prep exactly. I'm always looking to throw in spontaneity.

With too much prep, you sound automated. Do prep, but don't take it too seriously. I've always believed that when you open the mic, whatever you say should fall out of your mouth—it shouldn't be pushed out.

Fundamentals

Say the call letters this way, or backsell your music this way—all the little tech-

Batt and Anonymity

Batt Johnson

The first thing I noticed about Batt Johnson on 13Q was how hip he sounded. He was conversational, but he didn't talk too much. He talked like people talked; not like an announcer. "The Battman's" content was right on the money—a mix of street lingo and music information. His vast knowledge of artists and songs quickly made me realize that my show preparation needed immediate improvement.

Then one day John Long nonchalantly said, "Batt Johnson may be the best black jock in the country."

That statement caught me completely off guard. I had no idea that Batt was black. I just liked him because of his smooth and cool delivery. Right then I realized two things. First, I was now even more fascinated with the Battman; he became an instant role model for me. But more important was my second realization. John Long's remark solved a mystery that had been puzzling me for years: Why did I love being on the radio so much? The answer was in the anonymity of it, not the celebrity of it.

To be on the radio was to be anonymous. I wasn't black or white. I had the power to be many different things to many different people. It was freedom from the daily trappings of racial stereotyping. Batt Johnson was, simply, an excellent air personality, and I'm sure that, to his listeners in Pittsburgh—in their mind's eye—he took on a variety of different identities. On the radio it didn't matter what you looked like as long as you entertained. I loved that inherent fairness about radio.

I met Batt Johnson for the first time in 1975 when he joined the staff at Y-100 as our night jock. I told him about studying his aircheck and about my initial reaction to him. I told him about my theory about radio and anonymity.

We became fast friends. Batt confided in me about a grudge he had been holding for awhile against a major programming consultant who said that black jocks didn't have the same kind of insight as white jocks, and subsequently weren't as good. He was determined to change that mindset. It was a passion he passed along to me. Years later we ran into each other in New York, where he had made a successful transition from radio to acting.

Batt on Q

"When I first met Q, I thought he was a college intern working on becoming an assistant PD," remembers Johnson. "It didn't take me long to discover that it was Q who basically ran Y-100. He made innovative contributions to the music, phone research, marketing, and programming. This was at a time when there were probably three or four African Americans in Top 40 radio in all of the U.S. None of them were in a management position, except Q. It was clear to me he had something important and creative to offer. Twenty years after our first meeting, I went to work for Q as his morning man at WBLS in New York."

niques that tend to become boring. But without them you're nowhere. Anyone who is new to the industry must learn the basics. Easier said than done today. Best bet is to get yourself a few mentors and learn all you can from them.

I have a hard time thinking of the fundamentals when I'm programming a radio station. I hire someone to do that, because I can no longer communicate with fundamentals. They're innate now. They just happen and I don't have to think about them, which allows me to work at a higher creative level. Beginners have to work hard on their fundamentals in order to reach this level.

Teamwork

To me that's synergy. When everybody becomes one, then you'll achieve whatever your goals are. Synergy is the definition of teamwork.

Listeners

We're lovers. I have made love to my audience through a microphone forever. I learned that lesson from the late great Chuck Browning ("The Chucker"). Every time he opened the mic he had a real personal, emotional exchange with his lover, the audience. You should think of the audience as a mate. I've said to jocks over the years, bring me a picture of your favorite person. Then I'd tape the photo on the microphone and tell them to talk to them. That's the one-on-one relationship you want to achieve. When someone goes on the air thinking that they're talking to a mass audience, they have a problem. They're talking to one person. That one person can be three million people, but there is only one mind that listens to you and fills out a diary.

Advice to Future Radio Professionals

I'd like to see some courage out there. I'd like to see some people step up and take some risks. I see everybody playing it real safe, and they're getting nowhere by doing it. Everybody thinks if they don't make any waves, they'll keep their jobs. I think it's the opposite. When you make waves and change things for the better, that's when you're most secure. And remember, on-the-air is for artists.

12

The Bill Tanner Interview: Conducting Creativity

Bill Tanner's dream was to be a symphony conductor. He wanted to face orchestras, raise his baton to silence the audience, then, with the slightest gesture, initiate the first clear brass chords of *Fanfare for the Common Man*, his favorite classical piece, by Aaron Copland. He wanted to raise the roofs of concert halls around the world. In the real world, Tanner did become a conductor—but a different type. His passion for music, his sense of history, and his ability to lead all came in handy; as a program director and consultant, he guided many radio stations to ratings success and powerful creative achievement. One station in particular, though, will always be the hallmark of his career. That station was Y-100—The Amazing FM.

In February 1999, at the Gavin Seminar in New Orleans, I took part in a session called "The Y-100 Class Reunion." Gathered on stage were several industry veterans who had worked at WHYI-FM, Miami's legendary Top 40 radio station, including former Y-guys Buzz Bennett, Kid Curry, Dr. Dave Dunaway, Tony Novia, myself, and Y-100's current program director, Rob Roberts. Attending via the telephone from his home in Los Angeles was Bill Tanner, who programmed Y-100 in its earliest trend-setting days, from 1974 to 1983.

The session started with a twenty-fifth anniversary video that sent me on a serious trip down memory lane. The first image was of my Gemini brother,

Robert W. Walker (who was recently inducted into the South Florida Radio Hall of Fame), wearing a Y-100 booty shirt in the station's first TV spot. Walker, easily one of the finest air personalities to ever crack a microphone, was sporting the long-haired look of the seventies.

Images of other colleagues passed by—Don Cox, Tanner, the late Crazy Cramer Haas—and I saw news footage of a woman I had given fifty thousand dollars to in a bumper sticker contest in 1976.

The video documented how Y-100 became one of the first FM stations in the country to dethrone a dominant heritage AM Top 40 station. It illustrated how The Y took control of the market with its incredible ability to sell itself as a station that gave away amazing prizes and ingratiated itself with listeners. Y-100 was good-time, good-vibe, uptempo radio that quickly became a household name in South Florida, thanks in large part to a format that PD/morning man Tanner (better known as "Tanner in the Morning") called "predictable unpredictability."

Our goal was simple—to be number one—and we all shared the vision. A vital part of the station's environment was that everyone, from the receptionist to the owner (then Cecil Heftel), was encouraged to contribute to the creative energy of Y-100. Tanner's door was always open, and his rule was that there were no inherently wrong suggestions; everything was worth initial evaluation, at the least. We were a close-knit group that connected to each other and to our audience on an emotional level. We were paid to entertain, we worked hard, and Y-100 became more than number one. It became an institution in South Florida.

We gathered at the Gavin Seminar ostensibly to relive those glory days, but our focus quickly became what made Y-100 different from today's radio stations. The clear answer was that we interacted with each other and the marketplace. Without this emotional involvement, the excitement and ideas wouldn't have flowed so freely at Y-100.

At Y-100, we developed our own methods of innovation; we invested time and money into the community. We listened to our audience and mirrored on the air their feelings and viewpoints. This mutual respect harvested great ratings and kept our creativity alive. Buzz Bennett, the man responsible for naming and putting Y-100 and its sister station, 13Q-Pittsburgh, on the air, has said, "The in-

teractive process of the intuitive human is missing in radio [today]. We used to have live copy, liners, concepts, and contests that cultivated an interactive process with the listeners. What was coming from inside you was felt by them. What the listeners found on the radio was a friend, and from that, a lasting relationship developed into TSL. Today in most cases, radio is so surface-oriented that people are hearing only formulas. We've really lost touch with what we were: personalities that actually communicated and made people *feel*."

During the "Class Reunion," everybody got to tell a Y story or two, and we played a couple of vintage airchecks, including the rare *American Airchecks* complete station composite from 1976. On it were incredible performances by the air talent, but more important were Tanner, APD Robert W. Walker, and GM Bill Cunningham, explaining the station's winning philosophy. Tanner talked about contests and promotions that were fun even for the people who didn't play. Walker added that Y-100 believed in personality first; the goal of the station was to get listeners to take Y-100 personally, and personality was the only way to accomplish that. At the conclusion of the aircheck, Cunningham summarized: "People are always asking me: What makes Y-100 work? The answer is, *we* work at it."

Cunningham was always making sports analogies. He would say: "If we want to be a Number One in our division, like the Miami Dolphins, it's going to take hard work." He preached teamwork and he got it. Everyone at Y-100 worked hard; you were expected to stretch your talents and become an overachiever. The place was full of overachievers in every department, full of positive energy.

My first impressions of Y-100 came as a competitor. I was working at WAXY in Fort Lauderdale/Miami for Paul Drew, and when I heard Y-100, I listened with envy and wanted to be traded immediately to their team. It's the only time in my radio career that I remember feeling that way. Lucky for me, the radio gods were on my side and I soon got my chance to join The Y.

I'll never forget the first time I visited The Y. Before I could step off the elevator, I could hear the hum of energy and excitement that awaited me—it's something that I've never experienced before or since. The image that always comes to my mind is of the little boy in the film *Close Encounters of the Third Kind*, opening the door until the bright yellow lights from the alien ship cover

him; he's not afraid, he's curious to discover what is out there. That level of curiosity and a desire to create was part of the natural environment of Y-100. It didn't matter if it was 7 A.M. or 10 P.M., the energy level never dipped below 100 percent at The Y.

Raised in the small southern town of Vicksburg, Mississippi, Tanner started his broadcasting career at the age of thirteen as an announcer at WQBC in his hometown. From 1957 to 1970, he worked as an announcer for several Mississippi and Louisiana radio and television stations until he got his first PD position at WNOE-FM in Monroe, Louisiana. Tanner quickly moved up to running Mississippi's largest AM/FM signal, WJDX in Jackson.

Between 1974 and 1983, Tanner was the program director/morning man at Y-100. In 1975 he was promoted to national PD for Heftel Broadcasting Corp. and added 13Q in Pittsburgh to his roster. When Y-100 was sold in 1978 , Tanner was promoted to VP of programming for the new owners, Metroplex Communications. In 1983, Tanner relocated to the nation's capital as PD and morning man for WASH-FM. After two years he returned to Miami as the first morning man for HOT 105. Then he moved across the street as PD/morning man for WPOW (Power 96) and VP of programming for Beasley-Reed Broadcasting.

Since 1992, Tanner has been a programming consultant for: WPOW, WQAM, WXDJ, and WRMA in Miami; 100 JAMZ in Nassau, the Bahamas; Cox Radio, Inc. (WAGG, WBHJ, WBJK, WEDA) in Birmingham, Alabama; WBLI in Long Island, New York; and WPYO in Orlando. Tanner is also the VP of programming for Heftel Broadcasting Corp., overseeing stations KLVE and KSCA in Los Angeles.

I've known Bill Tanner for over twenty-five years and have worked for him twice in my career. Tanner is a leader who is committed to learning and teaching. He understands the concept of working together as a team, and he is analytical enough to realize that stations need a winning strategy both on and off the air in order to win. But the most important ingredient of his coaching menu, which I have incorporated into my coaching style over the years, is his effective use of storytelling to make his point—maybe it stems from his southern

roots. Tanner is a master of this powerful teaching technique that intimately engages people. Here's an example of a story Tanner told me to illustrate the concept of theater of the mind:

Bill Tanner, legendary former PD/morning man at Y-100.

> *The morning man on WSLI worked there for fifty years. He called himself "Farmer Jim Neal." This was a fanatically successful morning show that had numbers in the 30-share range. His whole bit was based around an imaginary dog called "the old feist dog"—a very Mississippi-type of thing. The feist dog never uttered a sound; it was total radio imagination. Neal would say, "I've been talking to this feist dog. He ain't got much to say, but he's been sniffing around over here, he must think I been out all night." He did his humor mostly in the body of a live commercial. They used to play one live and one recorded commercial an hour on his show from 5:30 A.M to 10 A.M.*
>
> *Here's another example: "Farmer Jim here for First National Bank. You know when me and this dog got to town, we had about four dollars in our pockets—dog had most of it. Dog took his money and put it in the First National Bank. And you know what? They never lost a quarter of it...not even a quarter. Me? I didn't do that and my money is all gone."*
>
> *The dog was personified. In other words, in listeners' minds, the dog knew if he was out raising hell all night, or that putting your money in the bank was the right thing to do. But the dog never barked, spoke, or was pictured. But the audience, once they got hooked on it, they just tuned in every day to hear what was going on with that dog.*

At the end of the Y-100 Class Reunion, Tanner left us with a lingering thought, a haunting refrain, if you will, about how radio must marry art with commerce. "How does research marry art? How do you do it? How do you get your well-researched ideas to come out of the radio sounding good? It is here where a good programmer's sense of the art of radio can produce the winning

edge. Your magic, your concept, your dazzle can combine with what you've learned and interpreted from what your market says about your station. The challenge today, like it was at Y-100 twenty years ago, is to win. The answers still come from the artistic and creative side of programming, as much as from the computerized statistics. It is what you *do* with research that will make your station great."

Play on, conductor....

Q: What radio stations had an impact on you, and who were your mentors?

Tanner: In the late fifties, the station I admired most was WLS-Chicago. I also admired WHBQ in Memphis, which was consulted by Bill Drake, and there was a third radio station—one that almost nobody ever talks about—WSLI in Jackson, Mississippi, that was just excellent. They were probably the best business operation of any radio station I've ever worked for. They were what we used to call an MOR [middle-of-the-road] station. The on-air people there were not called "jocks," they were called "announcers." They taught me a great deal about how the radio business runs.

One of the announcers, George Florence, was a huge inspiration to me and Cramer [Haas]. He was an excellent radio man. He taught me precision—things like hitting the network on time and how to do everything by the book. He was just a role model for doing things right. More than any other single person, he was the biggest influence on me.

Q: How important are the radio fundamentals?

Tanner: Putting fundamentals into KLVE in Los Angeles in 1994 took the station from a 3 share in the fall to a 5 share in the winter book. We made sure the music was right and rotating properly and that the frequency and call letters were given in prominent positions. The station just rocketed.

I'll never lose my respect for the fundamentals. These basics are the foundation that the building is built on. Now you just don't want a foundation sitting there, you want a thing of beauty…and the thing of beauty is the individual creativity that stars like Robert W. Morgan and "The Real" Don Steele can bring to a station.

Q: What is the key to a successful morning show?

Tanner: There are many keys. First, you have to be more than just a disc jockey; you have to be an entertaining personality. I'm not a funny person— and I don't consider myself a wit or anything in that regard—but I had the good sense to surround myself with people who look at life with a cockeyed, goofy attitude. I believe that is essential, because people who listen in the morning are driven by routine. At Y-100, my morning show partner, Jim Reihle, paraded through a daily list of zany characters on our show. The use of imagination by really talented people has a lot to do with making habitual listeners in the morning. That's why I think you need to have personality.

Q: What kind of preparation is necessary for a morning show?

Tanner: The show itself has to really be prepped. You can't just go in with everybody and wing it. For example, at Power 96 in Miami, it was Mark Mosely who did the lion's share of the preparation. That's the way he is; he wants to hit the door with a lot of things ready to do. He's still doing that on Bo Griffin's morning show there. On the other hand, some people can wing things pretty well. But if you're too lazy to prep, like me, then you have to surround yourself with people who are much more entertaining than you. I wish I were as talented as a lot of the people who have worked with me, but I was fortunate enough to have the talent to pull all the elements of the show together.

Q: Buzz Bennett says that you were a genius at surrounding yourself with talented people and getting the best out of them. How did you do it?

Tanner: I believe the job of a program director is to find the strengths of his people and reinforce those strengths, encourage them and bring them

out. Everyone has a positive and negative side. Your job is to shore up their negative side and keep it under wraps. The truth is, you must have a genuine interest in each person as an individual. A blanket, one-size-fits-all attitude doesn't work.

Q: What do you look for in a radio personality?

Tanner: Originality. A lot of times I hired people right off the street or who didn't have a lot of previous experience. Jim Reihle, for example, had been a switchboard operator at WOPT-TV in Jackson, Mississippi. I think what you have to do is look for an original spark. Look for something that shows that they are interested in doing something other than playing a record and saying the time and temp. I knew that Reihle had this whole world of character voices in his head trying to get out—plus he was hilarious just standing around talking.

Q: Why is there a lack of imagination in radio today?

Tanner: Because everybody has decided that everything can be researched down to a fine point. They believe that as long as you say the positioning statement over and over and over, they will win. And it may win, until somebody comes along doing something better—and that's the problem. You need to have an imaginative approach to the things that you're going to sell. You have to use research wisely. You have to research your songs and have a limited playlist, particularly for hit-oriented radio.

I do think that anybody with imagination and brevity is going to win. A great example of that was the morning and afternoon guys on KHJ and most recently K-EARTH, Robert W. Morgan and Don Steele, God rest their souls. Those people really illustrated entertainment with brevity.

The people at Y-100 were another good example. We were doing Top 40 radio—just playing the hits—but with a little variation, which made it sound fun; we detracted from the boredom factor, which can be high in hit radio. I think people like Robert W. Walker could say more in the least amount of words than anyone. Robert brought the Drake format disci-

pline. He had worked at two Drake stations and knew you had to get on and get off without a lot of bullshit. He taught us all by just doing.

Robert W. Walker (member of the South Florida Radio Hall of Fame): It was Tanner who taught me how to do that. Drake taught me how to be brief and how to basically do liners, how to communicate with inflection instead of a quantity of words. Bobby Ocean had the quote of my life: "It's not what you say, it's how you say it." That still gives me goose bumps. But it was Tanner, who came from MOR radio with a real showbizzy, razzle-dazzle entertainment background, who added the final touches. When he put that high entertainment quality on top of the Drake brevity, that was it! *That* was Y-100.

Tanner: Y-guys like Cramer Haas, who had a small-town Mississippi attitude, worked very well in Miami. Jo Maeder (The Madame), Doctor Dave Dunaway, Don Cox, Earl the Pearl…I should stop naming names because I'll miss somebody. All those people knew their mission, which was to be absolutely brief, but at the same time say a lot. We knew it was the right thing to do when we heard Robert W. on Y-100. It was like the radio jumped up and ran away, because he was so electric. He taught us all by example every day.

Q: Why did you call the Y-100 format "predictable unpredictability?"

Tanner: The great analogy of predictable unpredictability is *The Tonight Show*, which started in the fifties with Steve Allen, then Jack Paar, then Johnny Carson, and now Jay Leno. For almost fifty years, the format on *The Tonight Show* has remained remarkably constant: The host walks out to the audience's applause. The host always talks to the audience, not to the camera. They tell some bad jokes and the host makes a face. He sits down behind the desk. Talks to his sidekick. Then he brings out the most important guest of the evening. They use to have live commercials to have fun with, but, like in radio, they've disappeared. They bring out an assortment of singers, actors, celebrities. At the end of the evening the dullest guest

comes out. All of that stuff has been a constant. That's the predictable. The format.

The unpredictability has been when the dog doesn't eat the Alpo, when the Mighty Carson Art Players had a great bit, Leno has funny material on Monica Lewinsky; they're topical and right on point. But it's still within the format.

At Y-100 the predictable was: the person tuning in for music got hit music along with a sense that something was always going on at Y-100. Unpredictable: outrages from the jocks, craziness, full-blown personality radio.

I always liken the format to a foundation of a great building. The only person really interested in the foundation is another architect. But if the foundation isn't strong, the whole building will fall down. The building is the unpredictable beauty we erect on top of a consistent format.

Q: The Y-100 format was demanding…

Tanner: We were all personally challenged by the way the other jocks on the station performed. If you got on there with nothing to say, you knew that on either side of you, you were going to get your ass kicked. That was the type of daily pressure you had to measure up to. It was always that way.

The other thing about the Y-guys was that most of us came from smaller markets. Jackson, Mississippi, was the 129th market; you came from lovely Utica, New York; Cramer was from Mississippi; Robert W. had worked in Miami; and Don Cox had worked a short time at CKLW in Detroit for Paul Drew. What I thought we brought was that *need* to be entertaining on every jock break. To paint mind pictures for the audience.

I believe that success in this business usually has to do with setting standards. Radio stations function by standards, but we didn't even know that we were setting a standard at that point. For example, at Y-100, you either talked up the commercial intro or you didn't—but everybody who was good did it. That's just a tiny example of it. Cramer Haas, our production director at Y-100, was a nut about quality—the way the processing sounded, commercials were carted, anything that had to do with the sta-

tion's sound. The disc jockeys knew if they carted a commercial or promo that was distorted or the levels were too hot or too low, they would get a call from Cramer telling them to come in and fix it. He set high standards at Y-100, and we've never done better than that.

Robert W.: We used to produce promos with all the effects loaded up on carts, two turntables, three cart machines, another reel-to-reel machine, and then voice it live straight to the cart. Mixing it on the fly. Now they have Pro Tools and you can do all that stuff, and it doesn't have to be in real time. But that was good experience, because it taught you timing. It was like playing an instrument. The studio was your instrument.

Q: Buzz Bennett said this about your coaching style: "Tanner and I have had the same philosophy for years. You can't be uptight and win. If you're working under a heavily policed format, everybody on the air will sound stiff. Y-100 was just the opposite of that. We had a goal, with a loose structure that allowed hip guys to go in the control room and do their thing."

Tanner: He's exactly right. I remember being in Jackson, Mississippi, after I saw how much money Buzz had given away at Y-100, thinking, "I wonder what fool will take his place." Then there I was. I arrived in January of 1974 and felt we needed to pledge allegiance to Buzz's format. Robert felt the same way. The Y-100 fun, good-time attitude was established by Buzz. We kind of got off the vibe for awhile, but then in two or three months with Buzz's help, we got it back where it should be. Then we took it to another level.

Robert W.: Buzz Bennett was a huge influence on me. Buzz was an old Drake guy, but he was also a rebel, a real maverick. I learned a lot from him about putting a touch of the mystical, a drop of magic, and a little wink-wink in your voice.

Tanner: Buzz is as close to a genius as you get in this business in terms of the vibe of a radio station. At one point at Y-100, when I got depressed and down in the dumps, I had Buzz come in and basically consult me. We were

in a tough battle against Jerry Clifton's 96X. It was one of the most productive things I had ever done in my career, because I have never worked for a program director.

Q: You've both competed against and worked with Jerry Clifton over the years. What's your take on him?

Tanner: Clifton is crazy like a fox. He and Buzz Bennett share the ability to distill what's out on the street and get it on the radio. That is an extremely effective thing, especially in the area he specializes in: hit-oriented radio. Clifton can be maddening when he falls out of the sky and wants to change the radio station, but most times he's right. He has instincts, perceptions, and depth that few programmers have. He is not one to sit in front of computers and overanalyze research. He does believe in all that, but there is a unique perspective that he has that becomes very entertaining on the radio.

Another thing about Clifton that I've always admired is his stunning voice work on promos. I've had some great people who have done promos for me—Robert Walker comes to mind immediately—but the person that the audience has reacted to the most is Jerry Clifton. He has that goofy way of talking to himself from channel to channel, and he sounds like he doesn't take anything seriously. Clifton has this manic personality on the air...and he is more like that in real life then he would care to admit.

Q: Robert, what made Y-100 work?

Robert W.: We were all emotionally attached to the listeners; that's what came across on the radio and that's why we kicked everybody's ass. We played with passion. We were like the championship Chicago Bulls—we got out there and we were *on* for the people. What was there not to like about the gig? You had all the adulation that you could stand. Getting paid, whatever, it really didn't matter; it was being able to blast music and show people how much you loved it. I was happy but I don't think I quite realized the magnitude of what we had. We didn't think of it in those terms.

Q: Tanner, you have worked in radio for individual owners and in several corporate environments. What do you find are the pluses and minuses of each?

Tanner: The plus of working for an individual—or a benevolent dictator like Cecil Heftel—you can do great things on the spur of the moment. I do believe that my experience working for him both at Y-100 and here in Los Angeles at KLVE and KTNQ (10Q) are some of the highest professional experiences I've ever had. It was a great opportunity to have a team of people, from the manager and the owner to the program director, people in production, sales, and promotion, all focused on one or two radio stations.

Since consolidation, I have heard many talented programmers say they just don't have the time to spend on individual stations. That's why I think you have a lot of "Format Freddies" today. You just don't have the same number of people offering the expertise and hovering, coaching, and working like you did in the old days.

On the other hand, radio had gotten to be a depressingly small business. This consolidation is the result of radio needing to have more dollars to make it a real investment target. Insuring that investors get the value for their share holdings; that is what has made radio grow so quickly.

Still, I'm not sure we're well served by having one regional guy trying to deal with multiple numbers of radio stations. In my experience, that's less successful by far than people who can concentrate all their energy on one or two stations.

Q: Do you think the cluster idea is working?

Tanner: That's debatable, too. Obviously they're taking a lot more money out of the market—and I'm sure that's the overall goal—but in a lot of instances, I see examples like this: two stations that are billing ten million dollars, when combined instead of there being a synergy, you wind up billing fifteen million, because one gets neglected and sold at lower rates.

I think the issue here is, if you can take two and two and get five, fine. On the other hand, if you're taking two and two and economizing on the

operations and the programming and you wind up with three, I think you have to seriously question it. Some of these corporations have so much debt rolled up that it's affecting their stock, so they're hardly in a position to make offensive programming moves.

Q: Which leads us to the increase in commercial loads.

Tanner: I think there is a limit after which people regard the radio as less of an entertainment source and more of a nuisance. I was instrumental in getting Y-100 down to two stop sets an hour. I once got fired from a radio station, which will remain nameless, because the first thing they wanted to do was put in three more stop sets. The listeners called and complained so much that the owners had to change back to two stop sets. The audience remembers interruptions, especially if your interruptions are long. We don't have research on how long is too much, but we know this: When a station takes to running eighteen to twenty minutes of commercials an hour—which I have seen on FMs—the ratings go down. Go figure.

Q: Where are the new programmers and personalities going to come from? As Paul Drew put it, we've lost our "laboratory stations."

Tanner: I do think that there are talented people out there. I'll throw a question back at you: Who are these people who come up with all these brilliant television commercials? Look at TV. How could you not be impressed with the commercials? They keep getting better. They have attitude, they're funny. I think that's where a lot of people who might have been programming radio stations wind up, because it is another frontier of the imagination.

Who gets inspired by coming into a radio station to just read liners? It's counter to what we need as human beings. We want to be known for something; we want to put our stamp on something. That's the kind of people I want to come to my radio station. I believe when a radio station and an individual who comes to work for it are on a parallel track—when each meets the needs of the other—you have radio greatness. I would use

Y-100 of the mid-seventies and early eighties as an example. We all had a hunger to make it work. That produced great joy.

Robert W.: Y-100 influenced people's lives in a positive way. It makes me want to cry, because that's the highest thing you can do—lighten up people's lives, man.

Q: A lot of people feel that we creative types should grow up and realize that the radio business is strictly about the bottom line now. What's your take on that?

Tanner: I think the issue is perhaps that those people don't know radio too well.

A good, emotional radio station—one that draws emotion from its players and affects its listeners in a one-to-one way, which is what we strive to do in radio—is very good for business. I do believe that emotion lends itself to passion, and passion is the key ingredient to any ongoing relationship between the radio and the listener.

I think people who say it's all clinical now are making a mistake. I'll give you an example: KHJ was probably the best Top 40 station that was or ever will be. KHJ and WLS in the John Rook era are right up there on top—they were just brilliant. I've heard and read so many times that the Drake format stifled creativity, blah, blah, blah. *Nothing* could have been further from the truth. What it did was abbreviate the live disc jockey, and make sure they complemented whatever the promotional thrust of the radio station was. They only focused on one thing at a time. Just stunning results.

Q: What advice would you give to radio professionals of the future?

Tanner: Strive to be a great performer within the limits that are set by the format. If you think the format is overly restrictive and you can't do it, go find a station where it's not. You have to have personality with brevity. And you have to be memorable. Understand that you have to get it done in ten to fifteen seconds tops, and regard the format as just a framework that will take you to greatness. As an old-timer who has been around for

Bill Tanner broke an old Top 40 radio taboo when he hired a woman to do middays. Jo Maeder was the first female DJ in South Florida to do a daytime shift and the first woman to fly on The Y.

Jo Maeder (The Madame), the first woman on Y-100.

The Madame: Jo Maeder

"I started at Miami Dade Community College, where the radio station tried to mimic Y-100. The student running the station wouldn't let me on the air. He said, 'Chicks can't do this type of radio.' It wasn't even a real radio station, it was a PA system that broadcast to the vending machines. This still caused a controversy, because a lot of the students agreed with him. Finally the instructor intervened and I got on. Later I went off to Syracuse University, where the station was very free-form.

"My first job in Miami was at 96X doing a Sunday night talk show. But they wouldn't let me do anything else, so I made up a bizarre tape of my answering machine messages, wrapped up in a box of candy, and sent it to Tanner. He hired me to write commercials for Y-100. I had no idea that I was going to end up on the radio. Two weeks later they started training me to go on the air. Mark in the Dark (Mark Shands) trained me on his all-night show. I began doing the weekend overnight shift and was called the Midnight Madame. I think Tanner knew all along that he was going to make me a disc jockey. He created a position just to get me in.

"I think being the only female on Y-100 protected me in a way. Plus having a name that was obviously made up gave me the freedom to say things that I probably wouldn't have said if I was using my real name. I was this character. I also liked the station's high level of sexual energy. There was a lot of flirting, subliminal and outright that's politically incorrect today. But it made Y-100 stand out.

"Y-100 was a very emotional experience. It's interesting for me to hear that

the guys there were as emotional about the place as I was. I guess we all took it very personally. I loved the change-overs; they had such a cohesive effect. It made us sound and feel like one big happy family. Which was genuine. Everybody did get along. Because if it isn't genuine, the listeners know it.

"I think what attracted the average listener and what attracted me—a hardcore hippie at the time—to Y-100 was they played the long versions of songs like "Whole Lotta Love." The heritage AM station continued to play the three-minute versions of songs. That alone made such an impression on teenagers. It made those who listened and the people who worked at Y-100 hipper somehow. The presentation was very Top 40, but outrageous, and the prizes were over the top. I loved it because it was so exciting.

"I remember the energy of Y-100. When you walked in the buzz was on. I think chemistry is essential to any station winning. You can feel it when people like each other and support each other.

"The battle between 96X and Y-100 was also exciting. The two stations always tried to outdo the other. I regret that there aren't those types of battles anymore in radio. Today, in most markets, all the stations are owned by the same company. You don't have the street fights anymore that forced you to be at the top of your game creatively.

"I didn't realize how much Tanner had taught me until I was doing morning drive against him. I wrote him a letter and thanked him. When Tanner put me on, it was a huge risk. There weren't any women doing daytime shifts in Top 40. He felt that it would make the station stand out even more if there was a female. I really owe a lot to him for taking that gamble.

"I tell my NYU students to pick the station you really love and get any kind of a job there. But it's good to know how the whole thing works, how all the different departments interconnect. And how the business itself runs today and how it compares to other industries. I remind them that it's all attitude. You have to be thrilled to be there. You don't have to be a major talent really, it's all enthusiasm and just being who you are.

(continued)

"I was thinking the other day if radio hadn't stopped being creative, I never would have started writing. But there was just something I couldn't get out on the radio anymore."

Jo Maeder teaches "Inside Talk and Hit Music Radio" at the New York University School of Continuing and Professional Studies. She is a voice-over talent, most notably as the female voice of the Showtime Network. Maeder is also a writer who recently sold her first novel. She lives in New York.

awhile, I tell kids coming up, search for passion on the radio; take the enthusiasm of it and make it sing for you.

Robert W.: It's like my Dad says: "The important thing is to do something that you really love to do. Because if you love it, you'll do it well." I feel sorry for people who have to work for a living. How much of a drag is that? I think people in radio today don't appreciate what they've got. Every since I was eleven years old I wanted to be a DJ. And I got to be one. That's amazing!

Radio Improvisation:
Creativity Is the
Real Music of Radio

A mastery of the fundamentals and a clear artistic vision are essential ingredients for a creative work environment. The difference between success and failure at a radio station—or any organization, for that matter—is determined by how well the leader brings out the positive energies and talents of his or her people. How do you help people find a sense of direction, shared purpose, and teamwork? By communicating a cohesive vision about the ultimate mission of your station.

Without a clear mission, even the best-run stations have no chance for unity of purpose; instead, players will drift, reacting to every nuance of change, simply because they are not aware of the station's ultimate direction. Like a symphony conductor, a program director's job is to make sure all his players know their part.

The world of music—and of jazz, in particular—offers several lessons for all radio people. As stations consolidate and become clustered, it becomes imperative that employees, and entire stations, be on the same page. Here is where radio can learn from jazz. Programming departments need to play together like a jazz combo; they need to listen to each other and improvise freely, but always under the direction of a focused leader who is communicating a vision.

The same is true for individual personalities. Think of them as musicians. Once they've decided to collaborate, they have, in essence, agreed to believe in

each other. Once mutual trust is established, the players gain the confidence to improvise.

However, as Gary Burton, a jazz vibraphonist and educator, reminds: "There's a need for vision and concept, and only one person can effectively establish and define a vision.... I want my piano player to have as much input as I can stand—as long as it doesn't bump into the vision."

As a player—not in a jazz band, but in radio—I've had the good fortune to work with Buzz Bennett, Bill Tanner, and Jerry Clifton, all programmers of vision; men who challenged and inspired me to do my best work. And a lot of it was improvised.

Jazz, after all, means improvisation: the ability and freedom to invent. "Improvising in jazz is expressing your individual personality and sound while at the same time reinforcing the strength of the total ensemble," says Stanley Crouch, the jazz and cultural critic. "What the most creative people in radio do is create a dialogue between themselves and their listeners. When this is done well, the records they play connect with each other and enhance the overall relationship between the personality and listeners."

Improvisation is a sweet blend of two opposites—discipline and spontaneity—that involves listening and playing in the moment. "Improvising is hard," says saxophonist Branford Marsalis, "because you have to have an expansive vocabulary in order to have something to say. It requires hours and hours of listening, studying, and analyzing other great musicians. Very few people are willing to pay those dues."

The same applies to radio jocks, who must master their fundamentals before attempting to cross formatic guidelines. At a creative radio station, the format is just a road map that shows you the direction the station is headed, but it shouldn't limit a personality's choices on how to get to that destination. In other words, liner card information, station positioning statements, and format basics must complement the programmer's overall vision, but like a jazz soloist, each air personality must have the freedom to put his or her signature on those elements. Like jazz, radio is a performer's art form. The in-the-moment nuances are the difference between the mundane and the unexpected.

The concept of improvisation poses a real challenge for today's radio stations, most of which would first have to go through a process of *un*learning before real creativity could be tapped. Before any of us can learn new things, we must challenge current assumptions about how radio stations should be run. I'm talking about the deeply held belief that creativity is no longer necessary to produce a competitive station. For too long, radio has been caught in the trap of rationality. "We've becomes slaves to research," says Len Schlesinger, a professor at the Harvard Business School. "Just because something is 'right' analytically doesn't mean it's the right thing to do."

Creativity is being hammered out of the radio industry by researchers and bottom-line operators, who believe—wrongly—that radio is a business, not an art form. Why is creativity treated as a worthless quality? In high school, I was indoctrinated by Counselor Bob to believe that, if I involved myself in occupations like music, writing, or radio, I was going to be broke and have a rough road ahead. I'm sure it was done with the best of intentions, but what Bob didn't realize was that without creativity in my work, I would live a life of spiritual poverty.

Mediocrity has contaminated the airwaves, and it's time to change the music. Let's throw out this oppressive, status-quo way of thinking that has stifled radio's creative growth. Let's replace it with revolutionary ideas that create magical moments for the listeners. Become an advocate for new ideas. Give permission for people to pursue innovative thinking; you will always learn more from taking risks than from playing it safe. As Somerset Maugham once said, "You'll win some, you'll lose some. Only mediocre people are always at their best."

Radio must be willing to break the rules. Radio needs to respect creativity as a mainstream asset. To progress, radio must educate its ranks and be willing to rethink and revise the safe formulas and rules of old-school, suit-and-tie managers. The future of creativity in radio is up to us.

❧

Out of the 1980s' radio mentality of scripted liners and predictable music came Howard Stern. Just when radio had tucked itself into bed for a continuous

music sleep, Stern came along and pulled off the covers with his unnervingly honest, totally unpredictable, and scathingly funny style. He single-handedly reincarnated personality radio.

Stern has broken all the rules—he plays no music and has no standard news and traffic reports—yet he has the top-rated morning show all over the country. Why? Because he is a pure entertainer who relates to his listeners. Stern talks about things people in the real world talk about: husbands, wives, family, co-workers, movies, current events, and sex. Stern's style is to be personal, and his wide appeal (his nationally syndicated show has strong ratings with both men and women 18 to 54) proves that people relate to people, not topics.

As Brian James, a veteran broadcaster at WCLZ in Portland, Maine, notes: "There is no emotion in 'Here's another twelve in a row,' and nobody in line at McDonald's is going to turn around and say, 'Wow, you're the guy on the radio that says, Best mix, best variety.' Radio is missing the humanness—real people talking about relatable issues. Like him or not, Howard Stern is the best example of relating and real emotion."

There is a lot to learn from breaking the rules and taking risks. When everyone is doing one thing, you should try something else in order to stand out and gain an edge. Stern's leap from cult status to mass acceptance is a great example of what happens when creativity meets the power of radio.

Another eruption of creativity came when rap music exploded on the scene and scared the hell out of complacent radio programmers—and society at large. Rap music had been percolating underground since the mid-seventies in uptown clubs and hip-hop parties in New York City; its vital sound was created in the streets, because there was no room for this type of expressive, experimental music on Urban stations that had jumped on the "more music, less talk" bandwagon. The jive-talking air personalities of R&B radio—many of whom were known for their rapping skills and crowd-pleasing rapport—were by then off the air or handicapped by strict format rules. So listeners turned elsewhere: to clubs, concerts, and the streets, and found themselves being entertained by a new generation of turntable-spinning DJs.

Most black music stations fought hard against playing rap, insisting that the music was "too far off the beaten track," but the creative energy of rap music had captured the interest of listeners, who were bored with formula radio.

In his book about black culture, *Buppies, B-Boys, Baps, & Bohos,* Nelson George writes, "Unfortunately the rapping DJs are looked down upon by older and more middle-class blacks, who see them not as a continuation of tradition, but as perpetrators of old stereotypes. The rappers make no claims that they are artistic or are presenting positive images to black America. They talk about what they feel and know, simple as that."

Rap has transformed the language, and it has invaded fashion, advertising, and media. Rap has taken root as a universal youth emblem.

"What you have with rap music is no formula," says Buzz Bennett. "There is a cause and a belief that you can feel. It is an art form that people can react to. Young people today can relate to rap and alternative music because they have an attitude. Amazingly, young people today move back and forth between the two genres. Color is irrelevant. Whatever makes them feel good is what they're going to go for."

Radio in the early 1990s showed signs of a creative rebirth. It had no choice, because rap music and the hip-hop culture had spread around the world. Rap music and DJ mix shows have since become an essential part of all mainstream Urban stations. And while radio is still using facts and figures to provide the foundation for its music decisions, rap music is no longer frowned upon or dismissed as a passing fad. Change can be powerful.

Another positive indication of the power of creativity is the success of strong personalities like Tom Joyner, Doug Banks, and Don Imus. (Take note, though, that all of these personalities worked in radio for years, perfecting their craft before the liner-card mentality's hostile takeover.) By the sheer force of their personalities and strong ratings—not unlike rap music—these performers and a few others were able to survive the hostile uncommunicative takeover of radio. Of course you'll notice that all these performers and most shows with any latitude to create are still limited to morning drive.

A Shared Vision

In his book *The Creative Edge,* William C. Miller, principal consultant with the Global Creativity Corporation in Mill Valley, California, offers these essential guides to fostering innovation at work:

- Everybody in the business should understand the company's big-picture plans as well as the CEO does. Everyone needs to know the economics of the company and the industry. Create a process map showing how costs are incurred and where the money comes from. Make sure everyone knows who the customers are and what they need. Share an appreciation of industry themes and the company's strategic direction.

- Everyone must have a shared vision of the company's goals. It's the principles of the people in the organization. This must be an ongoing conversation between individuals as they are creating an environment for learning and working together. The more you allow each person to grow in terms of information and power, the more you grow the entire organization.

- Don't erase your white boards or blackboards after each meeting. "Information persistence" helps learning to continue before and after formal meetings.

- Don't keep people chained to one area or function. You need mobile people acting as explorers, carrying ideas into different departments of the workplace. This will lead to changed behavior—to the kinds of customer-focused, team-oriented, results-seeking, and self-starting behavior that are the ultimate source of modern business success.

- Changing behavior: When people resist what we consider an obviously compelling plan, we need to read between the lines and "discuss the undiscussable." Those who are particularly sensitive and defensive about preserving the old must open up to new ways of thinking and listening.

Barry Mayo, a former programmer, GM, and station owner who is now the Urban programming consultant for ABC Networks, agrees. "In the late seventies and early eighties, I was one of the PDs who was in the forefront of the 'more music, less talk' format," he admits. "While it worked for ratings, I think we killed a generation of up-and-coming air talent—all the really successful jocks today were in the business prior to 1980—but I think the success of Tom Joyner and Doug Banks could be attributed to the radio listeners' increasing appetite for zany entertainment. I've apologized to the industry for the stand I took. Back then, I was into research. Today, everybody's got the same research, so they're all playing the same music. So what's the difference between two stations that are both playing the hits? Personality."

The human appetite for creativity and innovation is demanding in both business and our personal lives. Creativity is energy, energy is life, and radio needs a daily transfusion of creativity. In order to feed this demand, radio needs to start exposing itself to new perspectives—cultural, organizational, and personal. I realize you can't force-feed creativity, and you can't transform people who don't have the internal drive or desire to create, but this industry has been stagnant for years and frankly, it needs a revolution to spark new thinking. I suggest that radio begin by changing its culture.

Preach creativity and offer the tools to help your people begin thinking out of the box. Hire creative teams that generate daring ideas and feed off each others' energy. Foster a return to a healthy collaborative work environment. Radio operators must take a leap of faith, must go beyond the positioning mantras and formula formats and enter the creative process and the emotional vibrancy of improvisation.

14

Branding and Creative Promotion

"Radio was yesterday's Internet."
—*Gerald Nachman,* Raised on Radio

In his book *Raised on Radio*, Gerald Nachman describes how radio as a cultural phenomenon flourished in the thirties, forties, and fifties—an era collectively known as the Golden Age of Radio. Although confined largely to family living rooms, radio "was the first information superhighway," writes Nachman. "But it began as a dusty one lane road that, within a decade or two, had become a sprawling, coast-to-coast entertainment turnpike."

Radio began as a local resource, offering blocks of news, talk, and music to communities bonded by region and day-to-day reality. Every day, across the country, millions of listeners tuned in to their local station for news and home-grown entertainment. But once the big networks began to form (NBC was first, in 1926), radio's days as a strictly local concern were numbered. By the 1940s, network radio was at the forefront of the entertainment industry. Nationally broadcast variety, comedy, and mystery programs enjoyed huge, double-digit ratings.

Then came the 1950s and the advent of television. Despite radio's tremendous hold on the country's imagination, television quickly replaced it as the dominant entertainment source. As Nachman writes, "TV absorbed radio, sim-

ply gulped it whole—its personalities, formats, sponsors, and most important, its audience."

Radio, although badly beaten, survived: To do so, it had to go through a complete makeover. The days of big-budget shows with live orchestras were over. Network programming lineups became more magazine-style. They included housewives' shows, serials, and music shows, with announcers playing records. As television's popularity increased, DJ shows began to make up the dominant mainstream radio format.

Radio today is again in need of a reinvention. Consolidation within the industry has resulted in an unacceptable level of sameness on the airwaves, and it is up to radio professionals to find ways to reach out to new listeners and reconnect with those who have abandoned the medium. Today, from market to market, stations have the same names (HOT, KISS, POWER, or LITE), use the same slogans and canned TV spots, and do the same contests. I'm not saying they all sound exactly the same, but taken together, they do create a predictable impression. Radio has become a copycat industry, a consumer of passive trends that prefers to languish in a status quo based on conventional and outmoded thinking.

Most radio operators still believe—simply because radio is free and available twenty-four hours a day, seven days a week—that its consistency gives it a respectable position as a background art form. But if radio remains immobile and static, if it doesn't evolve while everything around it is changing, then radio is going to lose the interest of even more listeners. Even stations with heritage brand names must stay in transition, must keep trying new ideas to keep listeners interested and loyal.

In his book *Disruption*, Jean-Marie Dru, cofounder and chairman of international advertising agency BDDP Group, explains how a brand is an asset. Yet he also stresses, "If a brand rests, fails to question itself, and builds only on its past, before long it will come to appear complacent. People need to sense that it is attentive to the times and that it knows how to remain contemporary."

Today, radio's competitors are more responsive and interested in customers' needs. Radio already faces stiff competition from CD and cassette players and

the distraction of handheld computer games and telephones; soon a unique adversary will take center stage: satellite-delivered radio. The competition for car listening will surely intensify in the year 2000, when digitally delivered music starts fighting for dashboard space in every car. Last but not least is the allure of thousands of Internet radio stations and hundreds of cable television channels already in millions of homes. You can't compete with that if you're a "background art form."

Radio has to do something—*something different*—to stand out. Through creative promotions you can give your station perpetual makeovers that provide support for your brand, give it new vitality, and keep it fresh in listeners' minds. But before we explore how to design creative promotions, let's spend a little time on what makes a great brand.

Branding

In earlier chapters, I've explained two ingredients that go into a great brand: credibility and vision. Branding is your station's identity, a distinct attitude through which you can bond with the listeners. Your brand should make the listener feel they are a part of the station.

In the business world, brand marketers like Nike, Apple, and Virgin have connected with their customers on an emotional level for years. But it's only in the last few years that branding has become the radio industry's buzz word for a winning strategy. That's good news, because it may mean that operators are ready to take a leap of faith back into the world of emotional imaging; maybe they're really ready to leave behind the prosaic positioning mantras like "more music, less talk."

Why now? Because as radio stations consolidate, they must also diversify (it simply doesn't make sense for one company to own multiple stations broadcasting the same format within a market), which means programmers need something to keep their image cohesive and strong. Branding provides a clearer picture of what a station is all about, and in today's world of consolidation, it is critical for stations to be unique in the minds of the listeners.

Radio is late to embrace the concept of branding—it is, in fact, still grappling with whose role it is to play brand manager at a station. For years, otherwise good program directors have faced tremendous difficulty assuming that role at their stations. While branding ultimately is the GM's responsibility, I think, ideally, it is the PD's job to develop the personal relationship between the station and its listeners. It's the PD's job to identify what the audience wants and establish a strong identity with the target demo. Great brand marketers like Steve Jobs, Phil Knight, and Richard Branson have discovered that it's not so much the brand as the relationship *between the brand and the customer* that matters.

In radio, a brand manager is responsible for how the station is perceived by the listeners. The general manager, on the other hand, is concerned with establishing and maintaining corporate equity within a market by working with advertisers and agencies. In the past, programmers with a street feel—who could interpret information and research into brand names like "Boss Radio," "Music Radio," or revolutionary call letters like 13Q and Y-100—were taken seriously by visionary broadcasters.

Over the years, though, the program director has lost jurisdiction over the station's identity, and this role is now most often handled by GMs and consultants. And since their focus is squarely on product and clustering solutions (instead of the listener's desires and how they use radio today), many stations have lost their emotional attachment to their community. The radio industry traditionally has focused more on what *owners* want it to be rather than on what *listeners* want it to be. But all that seems to be changing as GMs and operators around the country are realizing that, in order to compete, they must become proficient in the art of branding.

Branding in radio is crucial if you want listeners to remember your station when it comes time to write in their Arbitron diaries. Branding is about top-of-mind awareness. There is a direct correlation between a brand's vision and the awareness of the brand. Listeners remember with greater clarity brands that know where they're going. If you remember anything about branding, remember what Jean-Marie Dru says about it in his book *Disruption*: "Brands with vision don't just address the customer, they address the person behind it. That's why we like them."

Radio still has plenty to learn as it experiments with branding. Many operators remain well behind the curve; some are still vehemently skeptical when it comes to developing brand images. An informal survey conducted by *Gavin GM* magazine in 1997 found that many broadcasters perceive branding as primarily involving 1) the identification of a specific niche within the market, 2) developing programming that fulfills specific needs identified in research, and 3) creating a personality that gives their station an identity. While all these elements are necessary, none gets to the core of branding—emotional attachment.

In an article on branding in the same issue of *Gavin GM*, Lew Dickey, president of Atlanta-based Stratford Research, stated why he believes that radio is clearly behind the curve when it comes to branding. "It entails a lot more than just coming up with a slogan and deciding how many [songs] in a row you're going to play. To develop a successful brand, it's vital to begin with the end in mind...and possess a solid understanding of your brand. The people at Nike know the value of their brand—how to enhance it and reinforce it." The message is clear: In order for radio to compete in a branded world, it has to become more proficient with the concept.

Radio functions differently than other industries in that there is a two-step process involved in reporting customers' behavior: The listener not only has to use the product, they have to *report* that they have used it. That's why branding for radio is so critical. A station brand must carry an additional psychological value that makes the listener think, "I like this station, and I'm proud to say I listen to it." The station has to find a place in the social context of each listener's life, a place where they connect on an emotional level.

All good branding takes time. It takes effectively executed marketing and promotional plans; this, along with the station's on-air sound, will allow listeners to begin to know you, giving you a foothold in their world. From there, you build on their confidence and create an emotional connection. Remember: A brand is always in transition. It needs to evolve. It must reinforce itself day after day.

Hopefully, branding will allow street-smart programmers to reenter the meeting rooms where the important decisions are made about a station's image. Once programmers show that they have vital information about their listeners—

Branding Recap

- **A great brand taps into emotions.** The common denominator among companies that have created great brands is not performance. A brand reaches out beyond the product and connects emotionally with the customer. Great brands transcend the product.

- **A great brand is a story never completely told.** A brand must evolve all the time. The story never seems to end, because the brand has a rich history, a dynamic present, and a bright future yet to be revealed.

- **A brand is relevant.** A lot of stations try to brand themselves as cool, but more often than not, this will fail. A station might play the right music and know the current hip vernacular, but that's not enough to sustain a brand. The larger idea is to be relevant. Ask your listeners; they'll tell you.

- **A great brand reinvents itself.** A great brand continues to raise the bar— it adds a greater sense of purpose to the experience.

- **A great brand knows itself.** The real starting point is to go out to your listeners and find out what they like or dislike about your brand; learn what they associate as the very core of the brand concept.

- **A great brand is in for the long haul.** You have to remain true to your original long-term vision. The vision is the leap of imagination that the brand will travel from the present to the future. It may evolve, but the core value has to remain the same.

socially, culturally, and even behaviorally—GMs will listen. Good programmers know that they are in the entertainment business, and that it's easier for personalities to excite, energize, and create loyalty by having a close rapport with the listeners. A background art form can't do that.

Promotion

I still find it hard to believe, but promotion directors are a relatively new position in radio. In my twenty years of programming, I've worked in seven major markets—including twelve years in New York City—and still have only worked with four promotion directors. For years, promotions were handled by the programming and sales departments, or assigned as additional duties to a jock. But today, with the economic pressures brought on by consolidation, stations (especially those in large broadcast groups) need promotion directors to help generate more revenue.

Radio stations should be a place where novel ideas are sparked and brought together. It's not easy to explain how ideas are born—sometimes they jump out of the blue and other times they're produced after long hours of careful thought—but I can tell you that an association of ideas can create something new and unexpected. The more this happens, the more creative and successful your station will be. The role of a promotion director is to maximize this potential.

The ideal promotion director knows everything about the market they live in and the station's target customer. She or he should be a curious and attentive listener who is always on the lookout for the next trend. Just like the program director, the promotion director must be able to breathe life into inert data and to protect the station's branding message. But most important, the promotion director must understand that listeners don't just passively absorb messages, they react. What counts is how a station's promotions make the listeners think and feel about the station. In other words, promotion directors have to know how to interact effectively with listeners.

Promotion directors must be creative in their own right; they should constantly be encouraging different directions for the station's brand to travel. It's the promotion director who has to generate ideas that will fire up other members of the station's creative team. A promotion director should never settle for what the rest of the market is doing. They must have an insatiable desire to do more.

Good promotion directors are hard to find. When pressed, most programmers will confess that they probably lose more sleep worrying about keeping their pro-

motion managers happy than about losing their morning drive personality—especially if the promotion director serves as a catalyst for developing creative ideas, knows the customers and the clients, and stimulates other staff members.

"Excellent promotion directors are very rare," says Paige Nienaber, VP of Fun 'N Games for consultant Jerry Clifton's New World Communications. Nienaber also heads up CPR, a radio promotion consultancy. "A promotion director is everything to everybody," Nienaber continues. "You are always being pulled in opposite directions. First, you are responsible for giving the program director the tools to achieve his or her goal for the radio station; the program director relies on the promotion director to keep the station visible in the community and to help give the jocks something cool to talk about.

"There is also a responsibility to sales. You have to give the sales manager and his team the resources to realize their goals. The job description would also include helping the station make money. The job is different at every station because each one has different priorities."

Nienaber oversees thirty stations under the umbrella of Jerry Clifton's New World Communications. Clifton has an axiom about promotions that clearly indicates how important he thinks they are to a creative radio station: "No one ever notices the cautious person driving safely and doing the speed limit. The person you remember is the guy driving the wrong way at 100 mph, hanging out the window of his car, naked. That, my friends, is the basis of all good radio promotions."

"It really is," agrees Nienaber. "Most radio promotions are like baby food. They're spoon-fed to people, they digest really quickly, then they're gone—and they don't even leave a taste in your mouth. When I look at some of the great radio promotion directors, one thing that many of them have in common is that they're former class clowns. Class clowns always want to be the center of attention. They'll do anything to get people to stop and react to what craziness they're creating. That's what radio promotion is about—getting people to stop, look, and listen...then go to work and tell somebody else about the cool thing they heard on the radio. A radio station that constantly gets people talking is unbeatable."

I was lucky enough to work with Nienaber in New York City, and learned firsthand why he is one of the industry's best promotions minds. His ability to read what a station is lacking in street vibe, his fresh take on basic contesting, and his knack for transforming mundane sales promotions and programming concepts into strategic packages is exceptional. At the time I was programming a heritage FM that the listeners perceived as out-of-date, and Clifton assigned Nienaber to assist me in reinventing the station's image. He was supposed to stay two weeks. I kept him for six months. In that time, we turned that tired old station back into a vibrant part of the community.

Nienaber is a self-described "radio lifer," who began his career in 1981. After learning the ropes as a promotion director in Charlotte at KISS-102 and WILD-107 in San Francisco, Nienbaber signed on with New World Communications in 1992.

*Paige Nienaber of
New World Communications*

Q: How has consolidation affected promotions departments?

Paige Nienaber: One of the most progressive things to happen [in the wake of consolidation] is the creation of the sales promotion position. Sales departments are really under the gun—scratching for bucks, looking for nontraditional revenue (NTR), and needing added value on almost every promotion—but now, instead of getting 50 percent of the promotion director's time, they have an individual who gives them the service that they really need. I also think that sales promotion is a monster that we created ourselves. Radio has trained its clients to think they can demand a promotion.

Problem is, with consolidation, we have promotion directors who direct promotions for multiple stations; it's a huge strain. To remain sane and do a good job under those circumstances, I suggest delegating responsibility to the specialized people who can handle different job aspects.

Give excited, enthusiastic, young people duties that really interest them, like club or street promotions.

Q: Why are programmers leery of contests that originate from sales departments or agencies?

PN: Unfortunately, a lot of contests that are generated by clients don't actually benefit them—and certainly don't help the station. They're usually the brainchild of someone who's not terribly creative, but it's their account and they had to come up with *something*. For example, a fast food chicken chain wants a promotion so the salesperson comes up with "Chicken Trivia..." and the client thinks it's great!

They're not in radio. They don't see the problems [we see] in their idea. On the other hand, I would never go into McDonald's and say, "Hey, this is what I think you should be doing with your hamburgers." That's their job. I would never assume to know more about selling hamburgers, yet fast food chains will come to radio and tell us how to do a radio promotion.

You have to have the fortitude to redo it and send it back to them. Be positive and highlight the benefits of your revisions without critiquing the original effort. There is always a way to make it work; you just have to make the effort. It's a balancing act.

Sometimes you have to make programming deliver a promotion they hate, and sometimes it's your job to tell the sales department that you can't run a certain promotion because it's poorly structured. Someone will always be unhappy if a promotion director is doing the job right.

Q: How does a promotion director get their own ideas on the air?

PN: The first thing you should do before coming up with a promotion for programming is make sure that you have people involved in the creative process who are in the target demo. Get people who listen—or should be listening—to the radio station and run your ideas by them. I've always worked with an in-house focus group before I take any idea to the program director.

A good promotion director needs to be very close to the program director. If you have that type of relationship, you'll quickly learn what their likes and dislikes are. As a promotion director, that is usually your first line of defense when a salesperson brings in something that the PD is not going to like. You have to work with that salesperson to make it better before you take it to the PD. If a PD rarely has to say no, they will have a much better attitude toward all promotional ideas.

Q: You've said that a promotion director has four different jobs; they need to 1) help the PD realize his or her vision, 2) provide the sales staff with tools and resources to help them do their jobs effectively, 3) keep a buzz about the station on the streets, and 4) give the air staff something cool to talk about. But how do you get the cool stuff from the streets on to the air?

PN: Fortunately, there's lots of resources. First, there are the listeners; a good promotion director is always talking to the listeners to find out what's on their minds and discover the latest happenings in the community. I've always used the staff and rewarded them for tipping me off to cool things. For example, a barbecue to raise money for a sick twelve-year-old kid. Well, that's a good thing for the station to tie into. It's something cool to talk about.

On any given day in any given market, there are three or four things a station should be talking about. The promotion director needs to know what those things are and prioritize them.

The job calls for you to be away from the station a lot. The promotion director is always out at remotes, festivals, and other events. If you're sitting around meeting with salespeople, filling out forms, and e-mailing the corporate office, how can you know what's happening in the community?

Q: Speaking of the community, how do you win them over?

PN: One of the best experiences I ever had was filling out a Nielson diary. I went into the process determined to be as honest as I could. But what I found out was that loyalty and emotion played roles. Even though I watch

the Channel 11 News only for ten minutes, I wrote down all thirty minutes. Why? Because years ago when I was an intern at the TV station, the anchorman, Paul Majors, treated me like a human being. Years later, he'd always remember me when we saw each other at events. Paul Majors will always get the extra twenty minutes in my diary.

It's all about emotion. Most stations just go through the same routine every day, not caring or taking a stand about what's going on in their community. They don't get emotional about anything. They're not bonding with the listeners. One of the best promotions of all time was what Power-106 in Los Angeles did during the 1992 riots. They stopped playing music and let people call in and talk. Their listeners had emotions they needed to voice, and Power gave them the forum to do it.

If your basketball team is going to the NCAA championship, be the cheerleader and get people excited. When a promising twelve-year-old junior high athlete gets hit by a stray bullet, don't hesitate to get on the air and be angry. Get people emotional and you have a winning promotion.

Q: You're being modest. You and Jerry began one of the most emotional radio campaigns in years with Stop the Violence Day. How was that created?

PN: Stop the Violence Day was modeled after such one-day campaigns as the Great American Smoke Out. It all started at a brainstorming session at WPGC in Washington, D.C., in 1989. The community was fed up with all the violence in the neighborhoods. The radio station took a stand against it, worked with community leaders, and shared ideas and resources in order to make a difference in the community. It had such a great impact that many of our stations across the country began participating. Now it happens every November 22, the anniversary of the Kennedy assassination.

Q: I guess that's why you're such a big fan of brainstorming….

PN: Brainstorming is a missing ingredient at most radio stations. The emphasis on creativity and new ideas has been lowered in favor of quick fixes and the tried and true. But to ensure better promotions, you need lead

Brainstorming

Creative people find brainstorming sessions very useful for finding new ideas. Experts suggest that the earlier brainstorming occurs in a process, the more productive it is. Why? Because when brainstorming takes place weeks or months before any final decision has to be made, it takes place in a more relaxed atmosphere, where all ideas are welcomed and creativity flows freely. The following are Nienaber's Brainstorming *Dos* and *Don'ts*:

Dos

• Do it away from the station.

• Include everyone. This imparts a sense of ownership to the entire staff. Include interns, because they haven't been in radio long enough to be screwed up; plus, they're usually right in the heart of the demo the station is targeting. For them, any idea is a good idea, which is the basic idea of brainstorming. Receptionists are usually more aware of the vibe of the radio station than many of the sales staff or the jocks; they talk to your listeners and clients daily. I've heard brilliant ideas come from receptionists.

• Play some games to get everyone loosened up mentally. The mind is a muscle that needs to warm up. Professional athletes don't just jump into a game. They stretch out and warm up first. Bring squirt guns and blast each

time—and nothing is better than brainstorming to give you the necessary ideas. Brainstorming is really important. It's more than just a bunch of people thrown together in a conference room with a note pad; there is a correct way, a process that has to be followed.

All departments prefer to have a three-month jump on a major promotion. When you know months ahead of time what you're going to do, programming, sales, and clients are all much happier.

other. Pass around a joke book and make everybody read a joke. Or break the big group up into smaller groups to write a joke—it's hard, but that exercise will really jump-start your creativity.

- Make an agenda of things that you want to create ideas for. Then open a free-for-all session, with people throwing out ideas. Someone should emcee the event, and someone must be writing all the ideas down on boards or another place that everyone can see. As you progress, people will naturally start fine-tuning ideas already written down. It should be loose and everybody should stop thinking like "radio people" for a day. What a concept.

Don'ts

- Never use the word "can't," as in, "we can't do it because it is not allowed."
- Negative staff members (you know who they are) should be kept busy at the station and as far from the brainstorming session as possible.
- There's no such thing as a bad idea. Don't criticize any ideas put forth by your staff.
- No suits allowed. With the possible exception of swim or birthday suits.
- There is no hierarchy. Everyone at a brainstorming session is on the same level.

What you have at most radio stations is a creative clique that is in charge of coming up with most promotional ideas. The program director is always in the clique, but there are a lot of uncreative program directors out there—and that's fine. You don't have to be super-creative to be a program director, you just have to be a leader with vision; you have to be detail-oriented and able to implement the stuff that someone else comes up with. I know a station that's never had a creative promotion director, but

they have twenty people on the staff who are very inventive and always come up with interesting stuff for their task-oriented promotion director.

Q: What advice would you give new promotion directors?

PN: They have to find out where the listeners are. Ask staff members where your listeners are: What mall? Where do they go after work? Where do they go on weekends for recreation? Then you need to go to these places and just hang out. You need to meet people and ask questions. The best research in radio is not from a research group that has just called five thousand people, it's from hanging out at record stores, talking to people in malls, and frequenting TGIF bars. That kind of interaction gives you a broader portrait of what your listeners want and expect. Interact with the listener, let them know that you and everybody else in the station are accessible and human. It's all about emotion.

Radio has lost its emphasis on innovation. There are too many other immediate issues on our daily calendars that money dictates take precedence over the creative product. But there are still stations out there that haven't lost sight of the importance of delegating time and energy to the process of creating new promotions, marketing, and features. In an era of dramatic technical changes and an evolving ownership landscape, one of our greatest weapons remains a pad of paper, four or five creative individuals, and a half hour of uninterrupted quality time to think, scheme, and dream.

15

Putting Time on Your Side

I've long equated being a PD with being a firefighter. In fact, in my office, I used to hang a red fireman's helmet on the wall. At a radio station, emergencies constantly flare up, keeping you distracted from your work. Program directors are always putting out fires.

When I was a PD, I rarely ate lunch outside the station, because crises always produced in me the nagging anxiety that I didn't have enough time to get all my work finished. As a result, I built a proud reputation for not going to lunch. In retrospect, I never would have had to go hungry if only I had managed my time properly. I wasn't skilled in time management, and whenever a spark ignited into flames, I would have to spend hours putting it out. And while I was stomping out small fires, I was not getting to the work that really needed my attention.

To be a good PD, you need to be able to deal with surprises and to handle unexpected problems quickly and creatively. But you also need ways to manage your time to increase productivity—especially in today's corporate culture, in which PD responsibilities have increased dramatically, and in which they often have to handle two or more stations.

With stations stripping away management layers, in order to stay competitive and keep their bottom line healthy, it's ultimately up to PDs to redefine their position in a way that allows them to meet their company's goals...without

working themselves to death. The only way to become more efficient and productive is to get organized. If you're a PD, here are some suggestions.

First, you should do what more than seventy thousand people have already done: purchase *Time Management for Dummies* by Jeffrey Mayer. Dubbed "Mr. Neatnik" by several Fortune 500 executives, Mayer has written several books on getting organized, and has sold more than five hundred thousand volumes. *Dummies* has quickly become the definitive book on time management because it isn't just about getting yourself organized. It offers another layer of information about e-mails, voice mail, computers, and software to help keep you on top of your projects.

"The most important tools for productivity," Mayer writes, "are a master list, well-defined priorities, and a follow-up system." Stop rummaging through the files, faxes, and memos, and create a master list of to-do items. Use it religiously throughout the day. Keep paperwork down by immediately filing documents you need to keep, and throwing away everything else. Your master list should be rewritten at the end of each day, to reflect your accomplishments and lay out what needs to get done the next day.

Check your master list and evaluate the status of each item to ascertain your priorities. Usually a priority is related to adding ratings or revenue to the station. This brings us back to interruptions, the most aggravating time management problem. Sometimes, to get your priorities straight, you have to close your door, turn off the telephone, and bluntly tell people that you have to finish a project.

I suggest that you block out two hours every morning to work on your most important tasks. Book appointments with yourself to get specific jobs done when you have the most energy and enthusiasm. It's critical for you to have a clear head in order to prepare meeting notes or gather information for monthly reports.

Mayer says the most important thing to have today is a great follow-up system for projects and paperwork. With a system in place, you can be proactive and take control. Always ask yourself: 1) What do I need to do? 2) Who do I need to do it for? and 3) When does it have to be done? Then take action.

Last, give yourself a weekly review. Take thirty minutes every Friday afternoon and update your lists, process loose papers and notes, and think about upcoming events. If you're still short of time and feel overloaded after learning to work smarter, maybe some of these ideas I've gathered over the years can help:

Delegate

Review your responsibilities and turn some of them over to an assistant. Look for someone in your department who can get the job done better or quicker than you. You should always be on the lookout for rising stars in your station. Besides allowing you to work smarter, finding talent makes you more valuable to your organization.

Negotiate

Whatever your predicament, there are usually more solutions than you may come up with at first. For instance, most deadlines can be altered, even though your boss won't readily admit it. The next time you have to deliver something on a tight schedule, decide when you can realistically deliver it. If you can't produce in the designated time frame, suggest an alternative deadline. Of course, emphasize your goal of producing quality work. Then deliver the goods.

The best reason to get organized and be disciplined about it is that it allows you to operate with a broader vision. When the alarm goes off and another fire starts, not only will you be able to deal with the surprise easily, you'll have the advantage of time on your side.

Creative Time

Radio is a creative industry that provides entertainment to the masses. Do a mental time check: How much of an average work day is dedicated to creating?

Time Tips from Mr. Neatnik

- Look at each piece of paper that comes across your desk and ask, "What am I going to do with this? Is there work to be done?" If not, toss it. About 60 percent of what's on most desks should be thrown out.

- If the paper is needed, create a file for it. Any time you're confronted with an item that will take less than two minutes to complete, do it immediately.

- Date every piece of paper. Then if you file it, you'll know the chronology of events.

- Get to the bottom of your in-box once a day. Take just one thing out of it at a time. Never look at a second item until you've determined an action for the first.

- Put all phone numbers in a Rolodex or other file and throw away scraps of paper.

- Store paper, pens, tape, stapler, and paper clips in one centralized location. Always put them back.

- Keep only a phone and needed file on your desk. A clean desk isn't necessarily the sign of a sick mind. It's the sign of an organized person who's in control. You'll get used to a spotless workplace.

Kind of a numbing thought, isn't it? When you add up all of the mounting tasks being piled on managers and the occasional crisis thrown in just to keep things exciting, there's very little time left to sit down and come up with the next batch of great ideas.

I suggest you budget at least a half hour every other day to sit down with other creative thinkers to drum up new ideas. More often than not, stations

that understand the importance of budgeting time to generate ideas produce unique products.

The best way to generate ideas is to ask questions, and the simpler, the better: How can we improve our relationship with our customers? How can we reach the at-work listener without using the telephone? Don't be afraid to expand the realm of possibility; throw off the shackles that bind your imagination and give yourself the freedom to access diverse ideas. Remember: creative time is for generating ideas, not making decisions. The goal is to maximize creativity.

Better Meetings

Meetings are the most despised part of any business, and radio is no exception. But bad meetings do more than just ruin your day—bad meetings make bad radio stations.

Meetings matter because they're where an organization's culture perpetuates itself. Meetings are where you bond with your players so they come away feeling like a member of the team. Meetings are where your goals are developed, and they're your first step toward victory.

As radio continues to consolidate, stations continue to downsize; as a result, we're running leaner and leaner staffs. Radio has always been about teamwork, but now, with fewer people to do the work, your number of meetings is likely to increase. The following are a few steps on how you can make your meetings less painful, more productive, and maybe even fun.

Meetings Are Real Work

One problem with meetings is that most people don't take them seriously. They arrive late, leave early, and spend most of their time doodling. You have to alter the mindset from "the meeting's over, let's go back to work" to a shared conviction of all participants that meetings *are* real work.

Some managers reprimand latecomers or punish them with a fee, but these techniques address the symptoms, not the disease. The real solution is to make

your meetings *uptime* rather than *downtime*. The best way to improve your meetings is to start with the basics. First have an agenda, clear goals, and paths you want your people to follow. Let your people know what's expected from them in the meetings and what their role is.

Open every meeting by clearly stating the goal of your radio station. This constant reminder keeps everyone on the same page about the direction of the station, making all discussions more constructive. This goal should be clearly posted in the meeting room. Use it as letterhead; I used to put the station's mission statement on the top of every memo.

No Long Meetings

Meetings are too long...and time is money. Almost every productivity guru says meetings should never exceed ninety minutes. Long meetings usually lead to more meetings. You need to keep a tight schedule to move your agenda along. Most importantly, don't allow participants to violate the first rule of good meeting behavior: *Wait your turn to speak*. This way, discussions tend not to be repetitive. If you must have a long meeting, schedule breaks into your agenda.

The agenda is the starting point for all productive meetings, so stick to it. Get the agenda out a day in advance so everyone is clear on the planned direction of the meeting. The challenge is to keep your meetings focused without stifling creativity or insulting those participants who do wander.

Ameritech, a regional phone company in Chicago, uses a technique called the "parking lot" to maintain its focus. When comments come up in a meeting that don't relate to the agenda, they record them and store them in the "parking lot" to be dealt with at a later meeting.

Converting "Meeting" to "Doing"

Meeting experts agree that most people leave meetings with different views of what happened and what they're supposed to do. The simplest way to get everyone on the same page is to print up a summary of the meeting. Don't worry about taking detailed notes; instead, use a dry erase board or a computer with a large monitor to help you create the document as the meeting moves

along. Focus your follow-up document on three categories of information: decisions reached, action items that people need to follow up on, and issues that remain open.

To help people concentrate, you may want to get away from the sterile and uninviting atmosphere of meeting rooms. Don't hesitate to change your venue occasionally. To emphasize the importance of the spring book, why not have your prebook jock meeting outside? A meeting around a picnic table in the sunshine with pizza could go a long way toward helping your team feel the spirit of the season.

Finally, don't try to cover too much ground. Stick to one or two big issues, such as the station's Arbitron goal, target demo, contest execution, special music, or motivational points. It's better to solve one problem than to address many inconclusively.

Individual Jock Meetings

Group meetings are necessary, but nothing replaces the need for face-to-face communication with each team member. The rules for individual jock meetings are different, because each jock is different. Each has strengths and weaknesses, and the best way to monitor and develop them properly is through one-on-one critique sessions.

Always provide air personalities with positive feedback about their performances. Pick out examples of excellent bits, format execution, and especially good content. To get great performances, you must emphasize the good stuff.

When criticizing, always remember to use the word "we." For example, "We need to improve on this." The last thing you want your jock meetings to produce is a feeling of you-against-them. If you don't have a solid suggestion on how to fix a problem, then don't bring it up. Using vague generalities (either negative or positive) does nothing but confuse performers and lower their confidence levels. You must be honest and straightforward in all communications with your jocks. Your jocks will trust you more and will be more likely to take your advice when they know you have their best interests at heart.

Try to protect your talent from criticism from upper management and listeners. Always discuss problems with them openly, and be receptive to their side

The Fun Stuff

- Toys are a great stress reliever and creativity enhancer. Have something in the meeting room for your people to play with. You'd be surprised at the joy a few little squeeze balls can produce.

- Have an endless supply of snacks for your team. If there are hungry people in your meeting, their focus will be on eating rather than thinking.

- Music helps the mind work better. I suggest you take breaks in your meeting and play a little jazz or classical music.

of the story. Performers who feel that you support them will feel freer to experiment and push their creative potential.

Meetings are just like any other part of business: you get better at it only if you commit to it. Meetings shouldn't be just about work; they should also be fun and motivational. A good meeting is a collaboration; the goal should be to allow your people to become involved creatively.

Meetings at a Glance

Even if you have one meeting a week, many of your employees may feel, "All we do is meet and meet and meet and nothing ever gets done." Here's a checklist to help make your meetings fast, focused, participatory, and decisive.

1. **Take your agenda seriously.** The agenda is the script; distribute it in advance. If all the participants follow it, you will stay on schedule and limit distractions and digressions. A well-structured agenda adds discipline and gives a meeting direction.

2. **Solicit participation from the group.** This isn't easy, because most people won't speak their minds in a meeting. Establish an environment of trust,

reach out to quiet members, and keep a clock on those who like to dominate. Always give people credit for good ideas.

3. **Keep your meetings as short as possible.** People will always have a lack of interest for meetings—even well-structured ones.

4. **Arrange for a good place to meet.** It should be clean and well-lit, with comfortable chairs and minimal distractions.

16

The Future of Radio:
Up in the Air?

When I entered radio in the sixties, the technology was crude and clumsy compared to what's available today. It took a juggler's skills to handle the clunky control boards, reel-to-reel machines, three or four turntables, and the newfangled cart machines, not to mention the piles of records and carts. Back then, being on the air meant balancing a lot of mechanical elements. It took a lot of effort to create a smooth-flowing show. I was lucky, though; I had Lou Gazitano as a teacher.

I met Lou at WTLB, where he was the night jock while working his way through Utica College. He had been on the radio for several years, and was an excellent jock. His skill at running a control board was amazing. I marveled at his ability to cue records, play jingles and prerecorded commercials, and read live copy with warmth and believability. Gazitano taught me how to run a control board and use the limited equipment to my best advantage.

Let me offer a typical break sequence from back in the day: While a two-minute song was playing, Lou would cue up his next two records, then search for the thirteenth spot on a tape containing twenty Coca-Cola commercials—counting them off as they fast forwarded by on a reel-to-reel tape machine. Once found, he would cue it up. Then he'd have to reset a pot on the board to play the tape machine (instead of a cart machine or turntable). Then he would

load the jingle cart, take the hourly transmitter readings, and, as the song began fading out, he would give the call letters, backsell the record, give the time and temp, do some schtick, then begin reading—flawlessly—a sixty-second live commercial.

This was a common scenario for a station running about eighteen minutes of commercials an hour, many of them live. There wasn't much time to fool around, because all the records were short and we didn't have a lot of equipment to make transitioning from one element to the next easier.

The technological changes radio has gone through since the 1960s have been astounding. If someone had predicted that one day we'd never have to juggle tapes and records, deal with large copy books, pull carts, or take transmitter readings again, we would have laughed them out of the station. Boy, have things changed.

Today, most radio stations' air and production studios are computer operated, equipped with integrated service digital network (ISDN) lines and computers for digital editing. In the seventies, the advent of stereo sound set the stage for FM to become the dominant band for broadcast music. In the eighties, radio coped with major deregulation, acquisition fever, and corporate restructuring. But as we streak toward the twenty-first century, radio is in for more than a change; it's headed for a full-blown revolution.

In recent years, many broadcasters have begun to lobby against satellite radio because they are reluctant to pursue digital audio. To them, it's an unnecessary expense, since listeners are satisfied with the status quo. Lee Abrams, senior vice president of programming at XM Satellite Radio, and his group of creative players are a marked contrast to the radio industry's conventional thinkers.

Abrams has always been on the cutting edge. When he broke into the radio business, he was called "wonder boy"—a reference both to his age (he was still in his teens) and to the wisdom of his decisions as program director of WMYQ in Miami, one of the country's first FM Top 40 stations in 1971. As a programmer, Abrams can lay claim to inventing some of the first successful FM radio formats. At age 19, he was credited with starting AOR (Album-Oriented Rock) radio at WRIZ-FM in Detroit. Along with AOR, Abrams also developed the

Urban/Dance format for the original WKTU-FM in New York, and in 1982 he flipped KFOG-FM, a "beautiful music" station, into the first "upper end" (25+ share) AOR format in San Francisco.

In 1972, Abrams joined with Kent Burkhart to form Burkhart/Abrams and Associates, one of the first radio-oriented consultancies, which went on to work with more than two hundred stations. Many of those stations were part of the Superstar Stations, the first commercial AOR format. The Superstar format borrowed from the Top 40 playbook and was "as commercial as possible," Abrams says, without losing a progressive identity. Over the years, Abrams helped launch the TNT cable network and redesign *Rolling Stone* magazine. In 1989, Abrams joined ABC Radio Networks and helped spread Z-Rock across the land as a satellite-delivered twenty-four-hour Active Rock format.

So why does Abrams think XM will fare better? For one, General Motors will offer satellite receivers as a standard option for car audio systems. XM Satellite is partially owned by Hughes, a GM subsidiary. Besides, Hughes is providing financing for XM's $550 million worth of satellites. XM is co-owned by the American Mobile Satellite Corporation, which provides wireless service to businesses, and World Space, Inc., which plans to offer satellite radio service outside the United States.

Satellite technology is a perfect fit with Abrams' passion for new ideas. He seeks to change the radio landscape. He believes that traditional radio has become complacent, stodgy, and unresponsive to its listeners. He thinks it's the perfect time to start a revolution.

"The similarities between radio in the seventies and what we're trying to do with satellite radio are unbelievable," says Abrams. "What was happening with AM versus FM back then—the migration of listeners from the AM dial to the FM dial—is exactly like what will happen in the year 2000. The headline will read, 'XM Does to FM What FM Did to AM.' I think that's a pretty powerful statement."

In a memo to his XM staff in January of 1999, Abrams outlined the advantages FM had over AM thirty years ago, and paralleled how satellite radio would have similar advantages over the FM band. As a survivor of the radio wars of the 1970s, Abrams remembers, "Back in the early days of FM, a lot of big AMs—and

legendary AM programmers—were in denial about FM. The net result was, they were driven out of the business." Here are a few bullet points from Abrams' memo:

In 1970, AM Radio…

- Did not address the emerging mass-appeal music styles. For example, hard rock (Deep Purple), folk rock (Crosby, Stills & Nash), or progressive rock (Emerson Lake & Palmer); FM came along and embraced it.
- AM did not meet the audio standard for music, which was then the 33 rpm stereo album; FM transmitted in stereo and sounded as good as the home stereo.
- AM did not play anything other than the hit single from any given album; FM played several cuts from the albums of important artists. It was the beginning of the album era. FM radio was part of a more general technological retooling. People were buying component stereos like headphones; FM was part of that and AM wasn't.
- AM did not update its look for the times. AM DJs looked hokey—still wearing blazers with tigers on their lapels; FM jocks were hipper and in sync with the times.
- AM was running eighteen-minute commercial loads; FM came on with low spot loads.
- AM was tired. Its playbook was written in the mid-fifties and was updated in 1965 by Bill Drake. Other than the odd KCBQ station here and there, most AM stations sounded cliché; FM came in with a fresh, no rules sound. They were relatable and honest.

In 2000, FM Radio…

- Is not addressing most of the mass-appeal music styles (hard rock, jazz, reggae); XM will embrace these styles.
- FM no longer meets the audio standard for music, which has progressed from stereo to digital; XM will deliver digital quality.

- FM doesn't play anything other than the hit single from any given artist; XM will go deep into a CD.

- FM doesn't reflect the look of the times. Its logos are too corporate and DJs look tired; XM will look, feel, and breathe modern culture in every way.

- FM is not part of the technological retooling; XM is an integral part of the digitizing of America.

- FM is making money, but listeners are suffering; XM will cash in simply by pleasing and exciting listeners.

- FM sounds hokey and cliché; XM will be real, honest, and relatable.

As senior VP of programming, Abrams is in charge of providing content for the one hundred channels that XM Satellite Radio will debut in the year 2000—and he swears that his music channels will be nothing like traditional radio. "Our whole mandate here is not to do regular radio," insists Abrams. "We have the opportunity to hire the most out-of-the-box, creative people on earth. In FM radio, the playbook hasn't been rewritten in years. You still hear things like 'the ninth caller wins,' which was great at the beginning of the touch-tone era, but that was thirty years ago."

Abrams recalled a recent drive he made from Dallas to Washington, D.C. "The radio," he said, "was just appalling! Every station uses the same slogan, I think it's the same guy who does the voice for all of them; it's all one big cliché. XM, by design, is going to rewrite the playbook for radio. We want each of our formats to be noticeably different from the way FM radio is structured, even to Joe Average-Radio-Listener."

Abrams sees gold in the many music styles that FM radio doesn't play or even acknowledge. "I think if we offer the same old thing as traditional radio, we'll be in trouble," he says. "For example, there is a lot of New Age music that sells. Yanni was the fourth-highest grossing artist last year [1998] in total sales, but he can't get *arrested* on the radio. B.B. King closed the Olympics in front of nine hundred million people; he's the voice of Wendy's, the voice of Northwest

Airlines…Blues is a hot genre, but *he* can't get arrested on the radio, either. There are opera singers who sell millions of CDs, and the *Riverdance* thing sold twenty million copies. There is a lot of music that FM won't touch. XM is going to come in and embrace these styles."

But the world of radio has seen satellite-delivered music programming come and go already, including Abrams' own Z-Rock format, which had an impressive eight-year run from 1989 through 1997. It was originally part of the Satellite Music Network. Z-Rock was the first national superstation that affliliates didn't try to localize. But, says Abrams, what hampered digital radio before was the lack of in-car listening access. XM's partnership with General Motors vastly improves its chances of reaching an Arbitron-estimated hundred million American motorists. I asked Abrams for his take on the future of radio.

Q: It seems you have many of the former stumbling blocks of satellite radio delivery well in hand, but how do you plan to combat complaints of not enough local programming?

Lee Abrams of XM Satellite Radio

Lee Abrams: We are going to maximize the value and vitality of national radio. Instead of trying to hide it, we're going to be proud of it. We want the typical listener to think that our studios are cool, exciting—with celebrities and stars always dropping by. Besides, on a recent drive across the country, stations I heard weren't doing anything local. Once a year these stations do a blood drive or some generic community service stuff. We're going to be passionate as far as embracing new music styles, old music styles, and every imaginable artist.

Q: Hugh Panero, chief executive of XM, says that deregulation has concentrated ownership of the nation's radio stations into fewer hands, and that owners are

intent on only programming proven money-making formats. He thinks that people want a wider selection of music and are willing to pay for it. I assume you agree with that?

LA: Absolutely. People will pay for their passions. If somebody's passion is jazz, we're giving them four great twenty-four-hour, seven-days-a-week jazz channels. Our programming mission statement is "reestablishing listeners' confidence in the music mix." In other words, we want to reclaim the core artists. Radio used to own artists; now it very rarely does.

We want to be musical leaders without sacrificing the integrity of the playlist. When a new release comes out, instead of just adding it, we're going to celebrate it. We might have a guy down at the Lufthansa airline hangar at five in the morning to meet the jet coming in from Germany to get the German pressing of the new Aerosmith record. We might have the manager on the air, talking about the album. We might play it once an hour. We'll be bringing back passion, treating new releases and tours like major events.

Q: You obviously feel that programmers today aren't passionate enough about music and are out of touch with listeners.

LA: Again, it's back to 1970, when so many AM PD's were out of touch with the listeners. The same thing is happening now.

When the first *Beatles Anthology* album was released in 1995, ABC Television did a special that was top-rated five nights in a row. There were full-page ads in *USA Today*. There was tremendous awareness about that CD. At the time, I was working for a classic rock station that will remain nameless. I asked the PD what he was going to do, the Beatles being a big core artist. He said they were going to play only one cut, the designated "new" single, "Free as a Bird." He said that [the Beatles] were too unfamiliar.

I would have played *nothing but* that album for the entire five days! FM now is in the same situation AM was in. In doing research for our formats, I went back and listened to radio airchecks from 1964. Back then,

when, say, Herman's Hermits came out with a new record, they treated it like Elvis. It was a *major event.*

Q: In 1986, you wrote to your AOR Superstar stations: "More music, less talk, more variety…enough already. The same songs over and over again…enough already. I believe it is a strategic point to inject freshness into traditional radio."

LA: One of our mission statements at XM is to be eccentric all the way to the bank. We believe that doctors and airline pilots can't be eccentric, but we're radio people—hey, let's get nuts! We are going to create a twenty-four-hour morning show. People are always asking me, "You're national. How are you going to deal with mornings?" It's always going to be morning on XM. Other stations may believe that there is an FCC law that says radio must become boring at 10 A.M., but we're not willing to shut down creativity. We're going to be always on.

We will be cliché busters. We will actively look for clichés in radio and get rid of them. We think in stereo and will create cinematic radio—theater of the mind—with a real emphasis on amazing production. Great radio stations must always reinvent production, always sound different, fresher. That's very important.

If you're going to survive in the upcoming battle of the [radio] bands, you've got to do what I call "amazing radio." It's a way of thinking, an attitude and energy within the building. It's the magic between the records and out on the street.

Q: In 1986 you said: "The bottom line is to understand the intricacies of our audience and then program to it. Too often we use research techniques as a cop-out rather than a guideline." Which it should be.

LA: Research has taken over, and so much of it is flawed. I was talking to a research guy who said he couldn't test certain music over the phone, like dance mixes. I've been doing a lot of research that is totally different from phone testing. One of my favorites is exit polls, talking to people coming

out of concerts. You get such a fix—particularly with the upper demo of 35 to 50-year-olds. For example, if I stop a guy coming out of a Jethro Tull concert, his answers can be really telling:

> **What do you think of Jethro Tull?** *Oh, they're gods.*
> **How long have you been listening to them?** *Since college.*
> **How old are you now?** *I'm 45.*
> **What do you do?** *Financial analyst for Dean Witter.*
> **What radio station do you listen to?** *Radio News 1080.*
> **How about the classic rock station?** *Why—so I can hear "Freebird" again?*
> **How about the light rock station?** *It's depressing and schmaltzy.*

If you *listen* to these people, they will tell you what's wrong with radio. A traditional radio guy's response is, "Hey, I'm in radio, you're not; you don't understand. 'Freebird' is good for you."

We're listening to concertgoers instead, and they have given us some great ideas for new formats. I think it's not necessarily AM or FM radio's fault, but there just aren't enough frequencies for them to cover all these exciting new musical genres. That's our greatest advantage; we have a hundred channels.

Q: What's your take on today's deregulated radio landscape?

LA: I think the owners, senior executives, and stockholders are doing great. But for the rank-and-file broadcast and programming types, it's horrible. I also think the listeners are really suffering. When I go to conventions and hear people talk about deregulation and how good it is, all I can think about is how it has such a dark side to it. The reality is, in the daylight, everything is great; later, over a beer, they all complain about how they don't know who to report to and how confusing it is. A typical cluster mentality is to get a morning show, throw up a few billboards, adjust the music library, and everything is fine. It's a nightmare out there, particularly for listeners.

Q: You have always been a believer in teaching and mentoring young, aspiring program directors. Since deregulation, the time and resources necessary to develop new leaders seems to have all but vanished. What do you think?

LA: The one thing we did at Z-Rock was train new talent. The key is to hire people that get it. A lot of our Z-Rock talents were weekenders from Top 40 stations who just hated the boring formulas and rules. We put them through Z-Rock boot camp. They learned the Z-Rock mission, the Z-Rock attitude, and the Z-Rock spirit. When they came out, they were amazing.

The boot camp approach means finding people who have the right stuff and giving them really intense training. It means providing them with a creative philosophy and opening their horizons. We played them great Top 40 airchecks from the fifties and sixties, which they certainly had never been exposed to. Next thing you know, wow, you've got a fired-up team!

At XM, we've also brought back the art of guerrilla staff training. We have meetings that start at 6 P.M....and end at 6 A.M. with forty yellow pads full of ideas. These staff meetings are a combination of teaching and inspiration; we learn how to cleverly take our competition apart by capital-izing on their weaknesses. Right now, a typical radio station staff meeting is at noon in a fluorescent-lit conference room; it ends in a half hour, and all they did was review the memo about the new procedures for booking the production room. In our meetings we have a cliché buzzer; if someone comes up with three clichés ("the tenth caller," for example), they're fired.

Q: David Kantor, president of AMFM, Inc. (formerly Chancellor Media), said in The New York Times *in 1998, "even if your services are able to attain a sub-stantial number of subscribers, your listener base will not be anywhere near the size of a national radio network." He goes on to say advertisers are interested in measured audiences, not the number of subscribers.*

LA: First of all, we will be measured. In a few years, the Arbitron diary will have AM, FM, or XM. I have a lot of respect for Kantor, I worked with him and I think he's great; but he's got to know deep inside that, when this

thing takes off, it's going to be a legitimate competitor. It's not going to happen in six months, but in a couple of years. Our goal is to be the band of choice.

Car radios will soon have the AM, FM, and XM. They'll be listening to XM unless there's some major traffic tie-up and they need the local update. Of course FMs will have more listeners in the early days, but it's just like in 1970 when FMs only had two shares—by 1978, things were quite different.

There's plenty of room for radio stations and XM satellite radio to coexist; we're nothing more than another radio band. In 1920 there was AM, in 1940 FM, and now, there's XM.

What You Don't Know Can Help You

Important adjustments must be made if radio is to improve its connection with listeners and compete with technological and social changes certain to affect our industry. Programmers need to challenge themselves; take off the blinders that limit creativity and resourcefulness.

Radio cannot move forward without eliminating its reliance on traditional market research that merely extrapolates current trends. Radio must end the pattern of jumping on the bandwagon of whatever format is hot. It's time to take a longer look into what the future holds.

How can the development of "oldies stations" be the newest innovative format in our industry as we approach the new millennium? How can radio operators and programmers plan for the future when they don't know what change tomorrow will bring? What will future customers want?

No one knows what great radio will sound like in the future, but we can be sure of one thing: it will resemble creative radio of the past and present; it will be developed through a combination of research, detective work, and performance. Research keeps you on target—focused on what your listeners want—but then you must employ detective work (pounding the streets) to get at the

passion and emotional context of your listeners' desires. Find out where they gather and learn how to speak their language. Then entertain your listeners with strong performance. Your research and detective work will lead you to what your listeners' shared interests are; use this information as jumping-off points for humor and humanistic connections.

Radio must learn from businesses and institutions that plan for the future, from oil companies to the White House. These organizations spend millions of dollars hiring futurists and creating "think tanks" to develop scenarios of what the future will bring. The scenarios aren't predictions; they're ideas, recognizing the changing aspect of the present environment, presented as stories about how events *could* play out. These scenarios help managers make informed decisions.

My first experience with scenario building was at KBXX in Houston. After each ratings period, VP/GM Carl Hamilton would call together department managers to try and forecast the future. We would fill up white boards with information that we knew about our station and our competitors, and then we would write down things that we *didn't* know about ourselves and the competition. For example: Would our morning team leave? Would the competition finally hire someone better for afternoon drive? Will they do a million-dollar giveaway? What if our main competitor is bought and added to a cluster targeted to take our audience?

These "what ifs" helped expand our vision, made us consider possible situations the station had to be prepared for. Scenarios built on questions like these helped prepare us to take action.

Socrates once said, "I know nothing except the fact of my ignorance."

I think what the great philosopher meant is that we should respect our ignorance, because we can learn by paying attention to what we don't know. If you learn to pay attention to what you don't know, you will learn to probe, to question, to analyze, to challenge, to debunk, and ultimately to grow. For this to happen, you must begin to practice new ways of thinking.

When you think about the things that still make radio exciting to you and your listeners, you'll realize that it's usually the unexpected that keeps us entertained. Unpredictable, happy accidents excite listeners and have led to format

changes...and even new formats. We've forgotten that the true excitement of radio starts with what we don't know rather than with what we do.

Here, in more detail, is the exercise we used at KBXX in Houston:

1. Under the heading "I know what I know," make a list of central issues and facts about your station. The list should include key items like your ratings and your ratings goals, plus any strategic moves you're planning inside the station, any outside marketing plans, and what you know your competition is doing.

2. Under the heading "I know what I don't know," make a list of guesstimates about what your station plans to do in the future.

3. Use these two lists to set up different scenarios—like an increase of competition, or the loss of your morning show—and speculate on how that would affect your market position. Of course, surmise similar perspectives for your competition.

I'm continually amazed at how naive most radio people are about their competition. I subscribe to the Paul Drew school of paranoia: You should know your competitor and their product inside-out. Pay as much attention as possible to their shortcomings. It's your opportunity to get a leg up.

This exercise will provide you with strategic options that will assist you in positioning your station for all foreseeable—and unforeseeable—actions. This "What is–what if" guessing game puts you to face-to-face with your weaknesses (and those of your competitors). It will help you see your listeners, your strategic plan, your air talent supply, and your station's infrastructure in an entirely new way. Plus, it helps you develop peripheral vision to scope out latent competitors. Never rest on your laurels, and always invest time and energy into what you don't know.

I asked AMFM's senior vice president, Tom Poleman, and Helen Little, the company's Urban format director and operations manager of WUSL-FM in Philadelphia, to look into the future, past, and present to find answers that can

help radio become more creative and vital in the new millennium. The follow-ing array of interesting answers may provide some guidance as you prepare yourself for the unexpected.

Q: Are there any lessons to be learned—successful programming techniques or innovations—from creative radio stations from the sixties, seventies, and eight-ies? Or is radio today all about radio today?

Tom Poleman: Steve Rivers (chief programming officer for AMFM) and I were just talking about this. There are absolutely great lessons to be learned from the past. Some of the most innovative radio contests and for-mat concepts were invented decades ago. Many would argue that radio was far more creative back then. I'm very much in favor of listening to old airchecks and talking to our industry's legendary programmers to get inspi-ration for today. Some of the most effective contests that we run on today's Z-100 were invented thirty years ago. It's all about recognizing the brilliant ideas from the past, and repackaging them for today. If something was truly fun and entertaining in the seventies, chances are it still is now.

Helen Little: Before radio became gigantic corporate entities, it was com-prised of much smaller businesses, so the freedom to create wasn't as risky. Programmers could experiment more and the things they discovered worked have become the programming rules of today. The stations that operate from this type of creative point of view will be the standouts of the twenty-first century.

Q: Has consolidation helped or stunted the growth of creative radio stations?

TP: It's helped from the perspective that we now network and share ideas much more effectively. Smaller market program directors get exposure to major market perspectives on a more regular basis. We also have a lot of cross-format brainstorming sessions in Chancellor. Nothing helps the cre-ative process more than a fresh perspective from someone outside of your format. It's amazing the ideas you come up with when put into a room

with great programmers. At Chancellor, our new programming structure has also been designed to make sure we have the best resources on call at all times in order to supplement the creative talents of the local staffs. We've made it cost-effective for smaller stations to have higher-quality research, marketing, and programming ideas. It's really raised the bar, making for stronger individual radio stations.

Q: What is the biggest obstacle that keeps you from being your creative best?

HL: Working for people who are not open-minded and don't support creative efforts.

TP: Pressure and lack of time.

Q: If you ruled the radio world and could make everyone do one thing to make their stations more creative, what would it be?

HL: No one would be allowed to do the same promotions over and over again. No more tired, cliché names like "Family Four Packs" or "Win It Before You Can Buy It." Everyone would be required to use their imaginations to come up with something new and different, even if it's just the *name* of the promotion. Use other people on the staff to pull ideas from somewhere besides the program and promotion directors. Present the product in a theatrical way. Get the audience to *feel* the station as opposed to just listening to it.

TP: Take the time to brainstorm and utilize all of your resources. It's always hard to find the time to have a quality brainstorming session, but the rewards are always well worth the time investment. I'd also like to see more programmers maximize their resources, instead of trying to do it all by themselves. The strongest program directors know they don't have all the ideas; the best know how to tap into the creative resources of their entire staff.

Q: Do you view Internet stations as the enemy? If so, how do you plan to compete against them?

TP: I look at the Internet as a potential ally. Let's face it, technological improvements are inevitable. Those who embrace them to their advantage will succeed. Those who try to fight [them] are setting themselves up for failure. Recognize that the Internet is part of your listener's life. We're coming up with ways to integrate Z-100 into their Internet use. Whether it's audio streaming, e-commerce, or a visual representation of your station, it can only enhance the listener's experience with your brand.

HL: The Internet can and will be used to complement and expand our listening audience. It offers an opportunity that further defines your radio station in a personal way. A Web site should look and feel like the station sounds. It's a chance to experiment and find new ways to connect with listeners.

17

Jerry Clifton:
There Are No Rules

Jerry Clifton, a consultant and radio station owner, fills entire rooms with his presence and charisma. I'm a little over six feet, and he's maybe five-foot-six, but he has always seemed to tower over me. Then there is his unique voice—a mixture of the toughness of Humphrey Bogart, the swagger of Jimmy Cagney, and the power of Edward G. Robinson. He could have made a fortune doing radio and television voice-overs, or as the star of his own animated TV show. Fortunately for us, he decided to create great radio stations instead. I'll never forget the first time we met....

In 1975, Paul Drew, then RKO's VP of programming, reverted WAXY in Miami to its original automated oldies format. He made the move after RKO's attempt to transform the station into a Top 40 that could compete against Y-100 failed miserably. The format switch was doomed from the start; RKO spent no money on marketing the flip to Top 40, so it was inevitable that we wouldn't succeed. The mistake quickly became an embarrassment of sorts for the chain; it was over in a matter of months. Drew flew in and fired the entire programming staff, except me. I probably made the cut because I worked eighteen hours straight, dubbing oldies and cutting promos and station IDs to fill up the Schaffer automation machine—in addition to a DJ shift.

After the station's successful transformation back to oldies, Drew sent me to WXLO (99X) in New York to interview for the overnight position. I arrived on a Friday afternoon in the middle of rush hour, and was feeling quite anxious about the prospect of living in New York City. It had always been a dream of mine to work in the Big Apple, but I wasn't sure that I had the experience to do the job. Also, something else had recently caught my imagination, and I was having trouble shaking the idea: I wanted to work at our rival—and conqueror—Y-100.

At 99X, the station receptionist pointed down a long hallway, toward the office of PD Jerry Clifton. She laughed a little and said, "You can't miss his office, it's the one with the...oh, you'll see."

What I saw was a stuffed dummy about five feet tall, with a cardboard cutout of Paul Drew's face attached to it and wearing a replica of Drew's signature straw hat. Hanging from a rope around its neck, the figure loomed over the doorway to Clifton's office. I couldn't believe my eyes. I knocked on the door and was greeted with a loud, "Who the hell is it?" I said, "McCoy." He asked which one. I answered, "Quincy," and was allowed in.

Clifton, his morning man Jay Thomas, and several members of his staff were having end-of-the-week cocktails. I was introduced around. As soon as my behind hit the couch, a man came into the office and knocked everything off Clifton's desk, flipped it over on its side, and walked out. Clifton and the others began laughing—probably more because of the shocked look on my face than what the man had done.

Clifton laughed, throwing his head back and sending his shoulder-length salt-and-pepper hair flying behind him. He excused himself. Seconds later, there was a tremendous crash; I again heard things breaking and a desk being turned on its side with a bang. Clifton reentered his office, followed by the other man. Both were in hysterics.

"Where do you want to go for dinner?" the man managed to ask.

"How about Chinese tonight," said Clifton, seemingly out of breath.

"Great, we'll go to Chinatown."

The man, I soon learned, was the station's sales manager, and every Friday, he and Clifton would go through this ritual of clearing each other's desk.

This was a perfect example of right place/wrong time for me. I had just stepped into a no-holds-barred atmosphere that I wasn't prepared for. My limited history of dealing with program directors had not prepared me for anything like this. Most of my PDs had been fun, but *conservative*. At that moment in time, I was convinced that Jerry Clifton was crazy.

I was taken to dinner as part of a large, rowdy group of sales and programming people. Of all the extraordinary moments, one stood out. Just before the food was served, Clifton jumped up on the table and began to do the twist. This didn't seem to faze the others, so I wondered if that was another one of his rituals. At some point during the meal, Clifton said to me, "Hey, you should take the job, you'll have fun here, and I'll make you a better disc jockey."

I listened as he talked about the station's goal to beat WABC; how the station would make radio history. Once in a while, he would move and talk to someone one-on-one for a period of time. I didn't realize it until a couple of years later, but that dinner was really a staff meeting in disguise—a technique I would borrow and find very productive.

That night I ended up sleeping on Clifton's girlfriend's couch. I got up early the next morning, left a thank-you note, and caught a cab to the airport. I'd had fun and was certainly intrigued with his outrageous style of leadership. But he was crazy, and I didn't think I was ready for crazy. I didn't take the job.

I next saw Clifton a year later, in 1976. I had achieved my dream, working as music director and doing the noon to 3 P.M. airshift at Y-100 in Miami. Clifton had recently become national PD for Bartel Broadcasting, and was programming 96X (WMJX, formerly WMYQ) a crosstown station that, until his arrival, had been barely a blip on our radar screen.

He had inherited a complete mess at 96X; the station was nearly bankrupt, and morale was at low tide. But Jerry Clifton, with his passion, contagious enthusiasm, and street intellect, found a way to compete...and he was determined to destroy our beloved Y-100. We despised—or feared—him so much that we called him "Hitler" and "Charles Manson." We thought he was the devil, but deep down in our radio hearts, we admired his creativity and his tenacity.

Clifton found music that was sacred to Miami listeners—music that nobody else was playing—and used it to brand his station. To my knowledge, he was the first guy to put on a commercial-free quarter hour of music. Called "Power Quarter Hours," these were followed shortly by full "Power Hours" of all music, no commercials.

Clifton instigated a brilliant billboard campaign that employed hieroglyphic images to spell out the station's new slogan, "I X IN MY CAR." The X, of course, symbolized many different things—including the most obvious, naughty reference—and struck a responsive chord with young South Floridians. So did his imaginative radio promos. A Clifton promo was always uniquely constructed, produced, and delivered. His distinctive voice had a mysterious quality—some would say a wise guy attitude—that made listeners feel as if they were involved with something cool.

Add a hungry staff totally mesmerized by his personality, who became true believers in his David and Goliath vision of taking down the mighty Y-100, and, with precious little money and a guerrilla-style marketing campaign, he gave us a fight that ranks near the top of all the legendary radio wars. We would crash each other's station events, put each other down on the air, destroy each other's billboards, and damage station property. Finding the station van's tires slashed in our own parking lot was not an uncommon occurrence.

One day, I drove our consultant, Buzz Bennett, to a mall where 96X was doing a live remote. Buzz and I entered the mall and immediately saw the station's setup; Buzz marched right over to Clifton. Unfortunately for Clifton, his back was turned and he didn't see Buzz coming. Buzz walked up behind him, put an arm around Clifton's neck, and pulled him close and squeezed. He whispered something in Clifton's ear, then he let go. It took all of ten seconds. When we got back in the van, I asked Buzz what he had said. It was, "This is Buzzy Bennett, and I'm gonna kick your ass, man."

Years later, when I worked for Clifton in St. Louis, I reminded him of the incident. He said: "Buzz was my hero. To have your idol tell you he is going to beat you in a war is devastating. It broke my confidence, and that's why I never

beat Y-100. Buzz broke my concentration and I never recovered. But I've never let that happen to me again."

In St. Louis, Clifton and I lifted Amaturo Broadcasting's KMJM (Majic 108) from a 5.5 to a 7.0 share 12-plus, a third-place ranking in the market. Despite this, I was fired by the company's VP of programming—not because of my performance, but because of a personality clash between me and the executive. You see, by this time my style of programming had been shaped by the creative talents and techniques of Tanner, Bennett, and Clifton. I was viewed as unorthodox, uppity, and crazy by the conservative, "more music, less talk" VP. What was truly remarkable about the incident was that Clifton not only objected to my dismissal, but left the station in protest. I've never forgotten that act of loyalty.

I've worked with Jerry Clifton three times in my programming career. He likes to say that I'm a glutton for punishment, but the truth is, I'm a sucker for a creative environment. Clifton's charm is in his enormous capacity for fresh ideas and his willingness to challenge the status quo. His ability to uncover unseen market holes or a station's identity problem is amazing. His storytelling always leads to a lesson about serving the listener or igniting your own creativity. He pushes programmers to put their own stamp on a station and make it their own—breath for breath, you and the station living off the same air supply.

Radio is his passion. In fact, it consumes him, and not even the smallest element of the business of programming escapes his scrutiny. Veteran personalities and coaches are drawn to his insights; he is always teaching and inspiring. He was everything you needed if you were a PD, like myself, who liked to try new things. He is a man of his word, who encourages others to stand behind their own arguments with the knowledge that he will support them.

Most consultants today are nuts-and-bolts, driven by formatics and playlists. Not Jerry Clifton. For Clifton, the playlist is just the beginning; creativity is the major part of what he offers, because he believes that's where the greatest rewards lie. "My style of consulting is old-style," he says. "Each of my stations is custom-made. I go into a market and find what the hole is and build a station that will win there."

Clifton fell in love with radio in his hometown of Portland, Oregon. He says his career in radio was preordained. He became a successful PD in San Diego, Detroit, New York, and Miami, where he was national PD for the Bartel Group. Today, his New World Communications company consults more than twenty stations, and his New Planet Radio owns stations in Honolulu (KRTR "The Crater" and Oldies KGMZ,) and Phoenix (KPTY).

I interviewed Clifton in Washington, D.C., in a place where you find most consultants, a hotel room. In the background, he had the radio on.

Q: Here is a headline from The Hamilton Report, *dated May 16, 1983: "McCoy-Clifton, Out at Majic in St. Louis in Surprise Move." What surprised me back then—still does, in fact—is that you left after I did. Do you still stand by your people like you did for me?*

Jerry Clifton: Yeah. It's a disease I have. I'm not saying I'm a wonderful person or anything like that, but I can't deal with stupidity when I see it. I don't like decisions when they're made based on ego. I don't have the ability to just swallow and say, "Well, I can put up with this." So the only other thing I can do is to follow my instincts and intuition.

Q: In that same article, you were also interviewed, and you said that there is a lack of talent in programming. "I think it is almost impossible to find someone capable of being a good programmer." Do you still think that's true?

JC: I wish I had some of the talented people who were available back in 1983. The [talent] development part of the radio business has gone away. Today there are very few people out there who make it through the maze and figure out how to become high-powered program directors.

Basically, what I do for a living is called "consulting," but it's really mentoring young programming talent; my job is to teach the tricks that I was lucky enough to learn or discover during my career. I've been blessed with the ability to pass this information along very effectively.

The trouble is finding anyone today who even has the desire to program. When I find them—even the ones with limited experience—I'll put them in a station and teach them the nuts and bolts. If they have desire and talent, that's enough to get them jump-started.

Q: Paul Drew says that one of the biggest problems today is that there aren't any laboratory stations where young personalities and PDs can make mistakes.

JC: He's right about that. The station that I own in Phoenix is a laboratory. I've been experimenting with different formats. People tell me that I'm being ridiculous by not playing the repetition game. It reminds me of when I went up against you guys at Y-100 and everybody thought I had gone crazy. It took about two years to figure out what to do. I don't think people should always do the popular thing. You have to go out and blaze the trail or eventually you're just like everybody else.

One of the positives of owning a couple of stations is that I can screw around with them until I figure out how to do it right for the new millennium. If I do what I've done before—eliminate all the things that are wrong—the only things left on the air are the right things. Then we'll have another unique format that will take over the world. [*Laughs*]

It's just a matter of time. We're doing everything we can to figure out how to serve the audience that we've identified as not being served. So far, the ratings say we haven't figured it out, but you don't lose the game until you quit playing it. I know from doing this a hundred million times before that we're getting closer.

Q: Buzz Bennett says that stations today lack causes, energy, and synergy. What do you think about that?

JC: I agree. It's all business and no pleasure. On one hand, it's a lot better than it used to be. We used to find ways to use the English language that would allow us to appear to be doing things that we weren't actually doing, because we didn't have the budgets. Now we have the budgets, but we're not using any sort of creativity or magic to blow these events up and

make them outstanding. When operators say they want to bring attention to their stations and you come up with an outrageous idea, nine times out of ten, they decide to reach into their promotional budget and just throw cash at the listeners.

Seldom do you hear a station doing anything that tugs at your heart strings...but *those* are the things that cause people to pay attention to your station. In Phoenix, there were three young children raped in the same part of town. Instead of going on the air with our big spring money give-away, we're offering a ten-thousand-dollar reward for information leading to the capture of this criminal. The positive response from the community is unbelievable, and the TV stations have actually used our call letters on the air, instead of the usual "a local radio station" tag.

Q: Paige Nienaber, your VP of Fun 'n Games for New World Communications, says it's important for stations to get emotional votes from their communities. With all the problems out there, isn't it odd that more stations don't do community-oriented promotions?

JC: It's because they're harder to do. They work better, but they don't work as quickly. Promotions like "Stop the Violence" give a station a tremendous emotional bond with the audience. It's like having a deep bench in basketball; if you create a radio station that has lots of magical things going on and that is soulful, then when a competitor comes into the market playing the same music, you will have the edge. After the initial blast of energy from the new station—they'll always get a lot of attention simply because they're new—your history of emotional connections to your listeners will bring them back. Eventually, they'll realize, "You've done us well and we're not going to turn away."

Q: What radio stations had an impact on you when you were young?

JC: Growing up in Portland, and listening to KISN, I believe it was pre-ordained that I would end up in radio. KISN was owned by a guy named Don Burden. It was the all-time radio promotional giant. Many jocks that

ended up being recognized as the great DJs of the sixties and seventies came through that station. Most of the Drake guys, most of the KHJ jocks—including "The Real" Don Steele—went through that station. That station was a stunt a minute. It was the old style of radio, running twenty-two minutes of commercials an hour and every client had a disc jockey hanging from the rafters doing some sort of promotion. That's what I grew up on. That's the kind of radio that works.

I got a good education from my early radio listening. I learned what to do on radio in addition to playing songs. From the beginning I found that I had a talent for putting on promotions that people remember. Over the years I've developed my own systems for creativity, pushing the envelope, and keeping my stations operating outside of the box all the time.

Q: Explain your system of creativity.

JC: Magic is the showbiz and the art of radio. We do strategic brainstorming sessions at all our stations on a regular basis. When I was a PD, my stations were a twenty-four-hour, seven-days-a-week brainstorming session. I didn't realize it, but they were. We had a chalkboard in my office and I would write something on it, then everybody would add to it during the day. It was total insanity, but by the end of the day, we usually had something that was totally bizarre but usable. I wanted something that would stick out, not something that would fit in.

I've done a lot of brainstorming sessions. I've practiced the trial and error method of bringing the best out of creative people. We do exercises to start out the session and then we go crazy. The idea is to loosen people up like they've had fourteen cocktails, only they're not incoherent. Back in the day, we would get incoherent, but we never could remember any of the good stuff we talked about. [*Laughs*] Now we get crazy, and it's all written down. Giant ideas have come out of brainstorming sessions, including the "Stop the Violence" campaign.

The essence of radio has always been to capture the moment. And the moment is different in each market. If you can capture the moment for

your market, your station can become a superstar. You lose the emotion and the feel of the local market if you steal great ideas from Chicago and put them on in L.A. It won't feel like L.A.; it will feel like Chicago.

I spent a lot of time talking with psychologists about how to enhance creativity. I've developed a way to take away inhibitions so people can create ideas tailored to their markets. Those are the ideas that really make stations happen.

Q: I've worked for you in three different markets, and it's always been a mystery to me how you could come to town and immediately know whether the station was connected to the vibe of the city. How do you do that?

JC: It's a gift. I used to think that everybody had it, but now I realize that they don't. I can listen to a record in one market and declare it a stiff, then get off an airplane a thousand miles away and hear the same record and declare it a hit; that is not changing my mind; that is, in fact, what's happening. The vibe is different. I don't know how I get it, but it happens immediately when I step off the airplane. Particularly in a market that I've worked in for a long time. I understand the vibe, and all of the research and information I've gathered in my brain seems to come to the surface. I begin to think like a local.

Q: Also in that 1983 interview, you said, "I find now that radio stations tend to look at research as gospel, rather than use it as a tool. There is no gut feel, no human touch. I think that is very unproductive and is going to cause a stagnation that could be detrimental to all of us." How do you feel about research today?

JC: That stagnation has happened. That may sound strange coming from me, since I was one of the early believers in research. I realized when I was the music director at KAFY in Bakersfield, California, back in the sixties, that I didn't really know if I was playing the hits or not. You always know when there's a smash. The thing that happens to people who are really plugged into the music is, they get ahead of the audience. I realized that not everybody was listening to new songs seven hours a day like me.

It registered that I needed some type of discipline to keep me on the right level—in touch with the audience.

Stumbling along, I read articles on market research and applied the techniques to radio. I learned that in reality, the songs you think are powers today are usually the powers of tomorrow. By the time we're sick of songs, they're just becoming the listeners' favorites. The only way to keep in touch with that information is to have constant communication with the listeners.

Today, everybody does the same type of research; everybody has bought into the philosophy of playing the hits for their format. The only place where you can make a difference is in marketing, promotion, and other areas of creativity. The kind of research I like is getting out and connecting with the listeners. You must have relationships with music outlets, do impromptu focus groups with listeners, be attentive to what's happening in clubs and on the streets—you have to do all of those things if you really want to be a great radio station. Clinical research is like buying an atlas. It will show you where the roads are but it won't show you the scenery. You need to see the scenery to make it happen.

Q: You have worked for small owners, corporate operations like RKO, big consolidated companies, and now you're an owner of radio stations. Which one of these roles offers the best route to creativity—or can creative radio be found in all of them?

JC: My desire when I started out was not to make money. I just loved music and I couldn't sing. I loved comedy, humor, and showbiz—all the things that make up radio. I wanted to be a part of it. I wanted to play. To me, it was the place I could tell my stupid jokes and put a smile on somebody's face. Radio was the perfect place for me. My goal was to make a contribution, *not* to make a lot of money. I'm still that way today. But I was lucky enough to figure out that you can get enough money to make yourself comfortable if you have something to contribute to the success of a station.

When I got involved in ownership, again it wasn't to make a lot of money; it was because I was really frustrated with the consulting business. No one would let me experiment anymore. Too much money was involved and no one was willing to buy into my concept that, by experimenting, you will have the number-one radio station, custom-made for your market. Everyone is looking for a format-in-a-box. I bought my own radio stations so I could experiment with them.

Q: Has consolidation had a negative effect on creativity in radio?

JC: It's not a small business anymore. You can't buy a radio station by mortgaging your house anymore. It's not so much the effect of consolidation, compared to the effect of the large amounts of money it takes to buy and operate a station today. The difference is there is a lot of pressure—a lot of Wall Street, a lot of accountants—and they're all convinced that the reason we're on this planet is to make money. I don't agree with that. I believe we're here to have a good time and create great radio. The money will follow. That's why I do creative radio.

The first part of consolidation, the buying up of all the radio stations, was easy and profitable. The stations' worth increased based on the laws of supply and demand. Now the trading game has slowed way down. There are very few fish left for the sharks. Now they have to operate the properties and generate a profit. Thus, big companies' goals are more business-oriented and less product-oriented.

Q: So we have the increase in commercial loads.

JC: It has the potential to be very dangerous. From a competitive standpoint, if everybody is running fifteen units instead of ten, everybody should be making about 50 percent more profit. But if companies get greedy—and some people have already gone insane—the commercial loads will continue to grow. That will drive the listeners away from radio…probably into the waiting arms of the Internet or satellite radio stations.

I've always thought that by being an innovator, there would be no way to be backed into a corner, because people would always need programming. People will always need a show. It's the business types that have to worry whether they're going to have a place on this planet or not. The creative people, the artists, are always going to have a place, because there's always going to be a need for entertainment.

Q: Lee Abrams and his XM satellite radio people believe that FM is ready for the takedown. He says FM radio is making similar programming mistakes to the ones that AM radio made in the seventies; that FM radio is in denial.

JC: I agree with him 100 percent. I made a name for myself in the radio business by taking a job on an FM station and taking advantage of over-confident AM operators. Today's FM operators have their backs turned to this reality. They remind me of the AM guys who were always joking how nobody had an FM radio. Then all of a sudden, everybody did. The same thing goes for the Internet and Lee's satellite radio—everybody saying it's a long way off, or that you can't listen to it in a car. Well, have you ever heard of cellular? The cost of cellular today is practically next to nothing. Very soon you'll be able to get all your computer hookups in your car, and then there will be ten million radio stations to choose from. *Hello!*

Q: Paul Drew and Buzz Bennett believe that Internet radio is where the new radio talent is going to come from. What's your take?

JC: They're right. The Internet-only stations have a lot going on. Cyberspace offers a great opportunity for young people. The Internet is probably going to do to FM what FM did to AM. As a matter of fact, I'm in the process of creating an additional studio in each of my stations that will broadcast on the Internet. This is simply an experimental place for the jocks to go play around when they want to do something that is completely outrageous. The concept is that there are absolutely no rules. If you want to go on there and make weird sounds or talk backwards or something, well, do it. Just like the experimentation in the early days of FM, people are doing things that have never been done before. I think this experimentation will

allow us to have a research and development department, which we haven't had for years in the radio business.

Q: How important are the radio fundamentals?

JC: Basics help, but formatics are just rules of thumb. If you're a football player, you practice the plays all week. But on game day there's something more important than executing the plays, and that's scoring the points. If you have to use your talent and break a few rules to catch the ball in the end zone, you're probably gonna do that. The basics, like the rules, should be a part of your talent. Not something that gets in the way of your talent. We spend so much time trying to teach jocks the basics that we forget to teach them how to be showmen.

Q: What do you look for in a radio personality?

JC: I seem to be able to identify people who can become personalities. Working with a jock or a PD who's moving up through the business, I can identify what their strengths are and build on them. People who want to become entertainers need to find out what they're good and bad at, and then do more of what they're good at.

Some of the most creative people are also the most insecure. A requirement of being creative, I think, is to be wacky. But when someone's wacky their whole life, they're looked at by parents and teachers and everyone else as being a little bit off, and that creates insecurity. As a PD, I encourage and protect those people, let them know they have the freedom to create. They need to know there are no good or bad ideas: "I believe in you. Go for it."

Q: Let me read some notes I took when I was the operations manager at The Box (KBXX-FM) in Houston in 1993 and you were the consultant. We sat in my office just talking and I wrote these things down. The notes are titled "What Is Our Job?": 1) Music for the people; 2) Entertain; 3) Be in contact with the community; 4) Be plugged in. You must have the vibe; 5) Interpret the streets; 6) Mirror the listener's mind—use their language on the air; 7) Be their social director. You have to be first with trends, clubs, concerts, first with the 411.

You could hand that out to any up-and-coming PD, don't you think? Those are the basics of programming any creative station.

JC: Those are the basics. I still say a lot of those same things exactly the same way today. It's interesting how I remember coming up with some of those explanations. I've never been good at sending out a one-sheet like that one. A piece of paper is easy to read, but living it and coming up with the ideas in your own words is a real important part of the process.

Q: What advice would you give to radio professionals of the future?

JC: Be a pain in the ass and believe in yourself. Just because somebody tells you something, don't believe it's true. There are people out there who will really try to help you, but they're few and far between. The rest are trying to manipulate you to do what *they* want you to do; they'll tell you any-thing to get you to do it.

The problem with becoming a real personality in radio today is that the first thing you're told is not to be one. You're taught to fit in instead of to stand out. But if you don't stand out, you'll never become a major per-sonality. It's a tough road to become a high-powered radio personality, because you have to learn enough of the rules of the road so you won't be ramming into everyone, but at the same time you have to keep your own identity in order to stand out from the crowd.

I remember when I hired Mancow in San Francisco. He had just been fired from a station in Monterey. I was talking to him on the phone and he was just about to begin the standard "I'm not really hard to work with" dance, when I stopped him and said: "I guess I don't want to hire you. I was calling you because I heard you were impossible, radical, that you were completely outrageous. That's what I wanted. I don't want somebody that fits in, I want somebody who stands out."

When Mancow did the Bay Bridge stunt, which I think was one of the best stunts in modern radio, we stood behind him. *[In 1994, Mancow, doing mornings at KYLD, tied up commuter traffic by stopping two station vechicles on the Bay Bridge while a staffer got a haircut. The stunt was staged in response to*

erroneous reports about President Clinton tying up airport traffic while having his hair cut.] He didn't get fired or kicked around for that. Instead he got patted on the back and told not to answer the phone for a few days to avoid attorneys.

We were trying to knock off KMEL, and we knew we had to be outstanding. That meant we wouldn't necessarily play the game conservatively. I remember, after the bridge thing, walking into the GM's office and he was holding up a video tape. He asked me how much money I thought six hours of news broadcasts about the incident was worth in advertising time. We got the ratings and ran.

That kind of support is rare in the business today. Most GMs and PDs don't have either the confidence or the power to operate like that in today's business climate. Most operators are watching out for their own ass, and are concerned with paying their bills. These people will not have the balls to be doing the kind of radio they need to be doing in order to survive in the new millennium.

<center>❧</center>

Clif(ton) Notes

Preparation

Preparation means living the lifestyle. You can't sit down and plan a show effectively without living the lifestyle. Basically, the people who are really great are the ones who are completely involved with the people they're broadcasting to. When we started WPGC in Washington, D.C., years ago, somebody asked me what I attributed our success to. I answered, "We are plugged in." It wasn't because we sounded slick or had the right jingle package; it was because when somebody in the D.C. market looked into a mirror, they saw WPGC. The station looked, felt, sounded, and did all the things that people in the market wanted to have done.

Jerry Clifton, owner/founder of New World Communications.

*Research is just a part of preparation, reading the newspaper is just part of prepara-
tion, going to the opening day baseball game is just part of the preparation. Whether you
work at a hip-hop station or a rock station, you need to go to concerts. You can't really
relate unless you are there. Otherwise, you're missing out on an opportunity to be
plugged in. Eventually, missing those events will catch up with you. You will be out
of touch.*

Buzz Bennett

*One of the true innovators of our business. There was a time when I truly thought of
him as being the most talented programmer ever. His stations were a pleasure to listen
to. He stepped in and replaced Bill Drake as the king of radio in the early seventies.
Buzz really contributed a lot to our business. I wish for the industry's sake that he
hadn't burned himself out—or burned his reputation out—to the point that he wasn't
able to participate effectively at the level he should have, because he was really special.*

Teamwork

*Teamwork is the whole deal. If you don't work together as a unit, your station will im-
plode. It isn't the individual players who make things happen as much as it is the syn-
ergy created by them working together. Too often, you see a team with a superstar on
it who scores all their points, but they still can't win. A perfect example of that was the
1998 World Champion New York Yankees. They were a baseball team with no super-
stars, yet they won it all. It takes a whole group, pulling together, to make things hap-
pen. Everybody standing behind one guy who's carrying the load, patting him on the
back, telling him how great he is—it doesn't work.*

Paul Drew

*He is a man of his word. You can't say that about too many people in this business.
The first thing I said to him when he offered me a job at 99X in 1975 was, "I don't
think I can work for you, I've heard the stories." He said tell me how you like to work.
I told him that I had to be my own man. If RKO Radio wanted to operate my format,
I would teach them how to do it. He promised me that he would not get in my way,*

and if I told him to leave the station that he would do what I said. I took the job and he absolutely was a man of his word.

At one point, I got mad at him and told him not to come to the station anymore. Weeks later, he called me to ask if he could come by the station to make some copies. I had forgotten the incident and asked what he meant. Drew said, "Well, you told me I couldn't come to the station anymore." I said, "Of course you can come make copies, and you can come to the station again!" That tantrum was long over. [Laughs]

I think I was one of the few people to realize that Drew was one of the best straight men in the world. He was hilarious! He came off to people like a geek, but in reality, he got it all. It was his way of playing the game. To those who had the courage to step forward, Drew gave them the room to shine. He didn't get in their way. If you had thin skin, he could say things that would make you nuts, but I didn't have thin skin. His personality was so dry that, if you didn't have self-confidence, he probably scared the hell out of you.

He was one of the few guys that really cared, who championed his hires and stood behind them when they made fools of themselves—which we all did from time to time. He was way ahead of the crowd as a radio programming businessman. He should go down in history as somebody who made a tremendous contribution to the showbiz of radio.

Today's Programmers

It's hard to get programmers to focus on giving the listeners what they need. There's too much of a business attitude around the programming departments today. Getting the job done—shuffling the papers—is more important than entertaining. One of the things I've always said is: We're not looking for perfection, we're looking for entertainment. Too many people are trying to make it sound perfect instead of making it entertaining.

Listeners

There are two types of customers in the radio business: There are the customers of the sales department and the customers of the programming department. In your mind, you can't mix these up. That's where much of the tug of war occurs in radio stations. People on the sales side always point out the customer as the guy who buys the advertising and therefore pays everybody's salaries, while people on the programming side say what really pays the bills are the ratings.

The Yankees: An Example of Teamwork

Jerry Clifton points to the 1998 New York Yankees as a perfect example of teamwork. He says: "It isn't the individual players that make things happen as much as it is the synergy created by them. They were a baseball team with no superstars, yet they won it all." Let's take a closer look at the '98 Yanks and see how their team chemistry produced a world championship.

The Yankees tied an American League record by winning 114 games in a season, moving them past the legendary 1927, Babe Ruth-era Yankees. This amazing accomplishment was largely overlooked, however, because everyone was caught up in the homerun race between Mark McGwire and Sammy Sosa. Both McGwire (with seventy homeruns) and Sosa (with sixty-six) broke Roger Maris' record of sixty-one homeruns in a season.

At the beginning of the American League playoffs, Yankees manager Joe Torre was asked by a sports writer whether his team's 114 wins were meaningless unless they won the World Series. "That's absurd," he answered.

The "all or nothing" theory is a curse in sports and in business. The spotlight in America, all too often, has shined brighter on star performers than on contributing players. McGwire's seventy home runs could do little to help his struggling St. Louis Cardinals, nor did Sosa's sixty-six break the playoff jinx that is part of his Chicago Cubs' team legacy. But the Yankees, without a single star on the squad, set a record for victories and became models of ensemble performance.

It's a fact in business as well as in sports: No individual can lead—or succeed—alone. Sharing success sustains success. The critical part of winning is helping your teammates perform better. By sharing and looking out for others on your team, you'll win more often…and experience greater joy in your achievements.

What really separated the Yankees in 1998, besides their 114 victories, was the way they rallied around teammate Darryl Strawberry. When Strawberry

was diagnosed with colon cancer and taken out of the lineup, the entire organization came to his aid. At the time, they were one victory away from eliminating the Texas Rangers in the division playoff series, the first step on the way to the World Series. Before his surgery, Strawberry sent his teammates a video of himself, pointing a finger at the camera, commanding, "Do it!" Many of the Yankees said the grace that Strawberry showed in the face of his health problems renewed their belief in the strength of the team. The Yankees won the game, and Strawberry's surgery was a success.

Great teamwork in any organization starts at the top, with a fair leader who provides a creative, positive, stimulating environment for all players. Yankee owner George Steinbrenner has maintained a consistent mandate to win since buying the franchise in 1973. Steinbrenner went through eighteen managers in fifteen seasons, and has a reputation for throwing major-league tantrums. But over the years, he has learned from his mistakes and has become more patient. He has learned his role as a provider for the team. Steinbrenner allowed Torre to run the team independently. Everyone won.

Maybe the hardest part of winning is maintaining humility. It took Steinbrenner many years to realize that his odd notions of control and inflexibility were a losing combination. You can't lead people if they are not willing to follow you. Instead, you must inspire them to trust you with their well-being. Selflessness is the soul of teamwork. Steinbrenner has learned that employees liberated from the tyranny of expectations perform with more passion and commitment. Work to discourage competition among your individual players; instead, encourage people to support and care for one another.

The '98 Yankees are a distinguished example of how, when everyone performs for the good of the enterprise, teamwork will take care of the rest.

Have you ever seen a salesperson trying to sell advertising on a station with no ratings? Ratings are king. But salespeople should have the attitude that their advertisers are king. Then the left side and the right side of the radio station brain have to meet to be a successful station.

The way to reach listeners is by reaching out and touching them. Essentially, you need to look at it as if there were only one listener. If you were to say that person's name across a room, you would get their attention. If you're smart, your programming will resonate with people one at a time.

Brevity

It takes a real talent to be a real personality in fifteen seconds or less. To me, the people who are capable of doing that are just as talented as morning drive disc jockeys like Howard Stern. It's actually harder for someone with a lot of personality to find a way to get his attitude across on the air in short bursts of energy. That's what it takes to be a format personality.

Bill Tanner

Tanner is one of the best people for plugging into other people that I've ever seen. He seems to know what the latest discovery is almost before it's discovered. Usually he has already had a conversation with the new explorer and has become best friends with them. He is also one of the best politicians—I say that in a positive way—using the internal ebb and flow of a radio station to his advantage. I've never seen anybody who can have a down book and turn it into a positive opportunity like Bill Tanner can. If somebody wanted to learn the business of radio—the nuts and bolts of how to run a radio station, how to get things done—he's the guy to walk behind.

Consulting?
Yeah, I Can Do That

Having read Bill Tanner, Buzz Bennett, Lee Abrams, and Jerry Clifton's programming and consulting philosophies, you may be thinking that you'd like to join their ranks. One of the coolest things about becoming a consultant is that you

can unite your personal interests with your work style. Ask yourself: Am I ready to choose my own path? Am I ready to decide which clients I want to work with, always reserving the right to say no?

But let me warn you: it's not that easy. Every new consultant needs a compass to navigate the unfamiliar territory of working solo. I tried consulting in the late eighties and failed miserably at it. Later, I thought about the reason I had wanted to go independent, and it was the same reason so many other people today decide to become free agents: I was tired of working scared—scared that I'd be fired. Going solo gives you the juice to do your own thing and control your own destiny.

But why, then, do so many people who declare themselves consultants fail and eventually return to the clutches of corporate America? I've put together a list of tools that I didn't utilize, but that could have helped my consultancy succeed.

Timing

People think every little detail has to be worked out before they start in the consultancy business. They're wrong. Don't wait until everything is just right, because everything will never be just right. Prepare as best you can, be diligent, and stop putting off your jump to freedom.

Standing Out

There are a lot of consultants out there, so your first priority should be to distinguish yourself from the start. Give yourself the traditional fifteen-words-or-less challenge. Start by identifying all the qualities that make you distinctive. Ask yourself: What do I do that adds remarkable, measurable value? What will customers think is my greatest asset? From these answers, you should be able to form a branding statement about what makes you and your work exceptional.

Friendships

Surround yourself with advisors—not just your lawyer and accountant, but people in radio. Find colleagues you can trust to give objective answers, who will surprise and challenge you. Seek out people with wisdom and experience,

and tap into those resources. Surround yourself with friends who have diverse business connections.

Getting Paid

The best way to prevent not getting paid is to intervene before it happens. Before embarking on a new project, ask about the client's pay procedure, who in the organization must sign off on your contract, and how long it will take before you get a check. If you're wary of your new client, ask for half of your fee up front.

The best way to avoid a bad client is early prevention. Early warning signs of an impossible client include: 1) those who give you a hard time over your fee; 2) those who demand an extensive written proposal; and 3) those who ask you to do a lot of preliminary work for free. Trust your gut and say no to clients who give you an immediate feeling of distress.

Marketing

Consultants are often too busy to remember to market themselves to potential clients. Fortunately, the rules of marketing have changed, and ads in trade publications are no longer relevant. The quality of work, above all else, is your trademark—and your calling card. You've got to check the market on a regular basis to keep a reliable read on your value. Ask customers for honest feedback on your performance, your growth, and your value to their product. It's the only way to make sure you're still in a strong marketing position. Encourage word-of-mouth referrals and tips from existing clients on possible new customers—with the understanding that you have to avoid conflicts with existing clients in this age of consolidation.

Loyalty

A lot of people believe that loyalty no longer exists in today's business world. But the truth is, loyalty is the strongest quality you can possess as a consultant. Without loyalty to your colleagues, your team, your projects, your customers, and yourself, you'll never continue learning, growing, and building relationships. Delivering great results and having a strong partnership with clients is the best way to keep a steady diet of more customers.

Rest

So far I've described how to get and keep customers, but I think I also should emphasize the value of free time. It's important to replenish your creative well. When you're hiking in the woods or reading a novel, solutions to problems that you've been struggling with can become clear. I've learned that the more time I take off, the more productive I can be. Remember: You are your business. Give your most important employee—you—ample time off.

In an essay about branding, motivational author Tom Peters enumerated four things you must do if you're going to go solo. First, you've got to be a great teammate and supportive colleague to your customers; second, you have to be an expert at something that has value for your customers; third, you have to be a visionary leader; and fourth, you've got to be a businessperson obsessed with pragmatic outcomes.

A career as a consultant also offers escape from station politics and infighting. Imagine, no more bosses pitting one employee or department against another. You can set up a work schedule that you can control, and more importantly, you can achieve synchronicity by integrating your work into your life. If you work hard enough—and you will be working hard—you might join the elite group of Drew, Tanner, Abrams, and Clifton, who not only have helped their clients win, but have put their personal stamp on the industry.

18

St. Louis:
The Magic Is Gone

One of the best examples of teamwork I've ever experienced was at KMJM-FM in St. Louis, the station that Jerry Clifton and I jump-started and put on the road to success—that is, until we were rudely interrupted (read: fired) in 1983. What I liked most about Majic 108 (today the station is called Majic 105) was that no one there was a superstar. Instead, we had a talented mix of veterans from bigger markets who were feeling a little sorry for themselves, and youngsters whose gig at Majic was only their first or second in the industry.

The station marked my return to programming after five years in the record business. I still had enough reputation left to get a job, but I was out to prove to myself (and to Clifton, who had recommended me) that I could put together a great team and lift a lackluster station to new heights.

Fortunately, the previous coach wasn't a hard act to follow; he had left the staff in such a poor state of morale that just my showing up was almost enough to inspire confidence. I sensed in these people a strong desire to create. They'd always had ideas on how to make the station better, but nobody had been listening to them. The previous program director was a paper guy who never spent time with his jocks. He led through memos and liked to hotline (a private inside phone line used *only* by the PD to talk to jocks while they're on the air)

the air staff when they didn't execute his instructions perfectly. He never realized the potential that was at hand.

A wise coach knows that listening is an essential element for success. Listening puts you in touch, and being in touch means being informed. It's the only way to know what your players and your customers need. Here's an example:

My first week at Majic, I would come in early to answer the morning show request lines. During my afternoon drive show, I again answered the phone as much as possible, and at night I would hang around and talk to kids calling to ask for songs. The first thing I discovered was that the listeners called the station "108-FM," not "Majic." Every call was, "Is this 108?" or "Is this 108-FM?" or "Hey 108, would you play this song for me?" I immediately stopped leaning on "Majic" and made "108-FM" the focus of our identity.

The KMJM staff was young, bright, and eager, and I soon discovered that 90 percent of them were born and raised in St. Louis. They were instant sources of research: valuable people who had been treated badly. I gave them what they were asking for—freedom. I loosened up the reins and turned the format on its head, allowing room for creativity, innovation, and a lot of fun. I gave everyone a say in what was going on. As a result, during my tenure I never got to execute half of the great ideas that poured out of the minds of that team.

What happened in St. Louis is what happens with championship teams; the veterans help the rookies become better players. The relationship between coach and players is often fraught with tension, because the coach is constantly critiquing each player's performance. It never happened here. What did happen was, people would seek me or other team veterans out for aircheck critiques and guidance, and the group connected emotionally. I won't take credit for getting my jocks to place their individual needs second to those of the team, because it wasn't necessary—it just happened. It was great. All we had to do was listen.

It's impossible to get rid of all the discontent in any workplace, but creating an atmosphere in which people can fully express their concerns and criticisms without argument is a start. Then again, hearing people's words is just the beginning: Do you understand their hopes and fears? When you start to listen at a

deeper level, you'll start getting real information. Even when there are problems you can't resolve immediately, listening—getting information firsthand from your people—will assist you in finding resolutions to morale or product problems.

St. Louis is a large market, but it's not considered a glamorous one. The veteran jocks—myself included—had worked in major markets like San Francisco, Dallas, and Miami. To us, St. Louis was a step backwards. I had to change their perception, and I did it with honesty. I shared my vision. I let the staff know that I was working my way to New York City. My goal was to make every station I programmed along the way the talk of the industry. My mission was to put St. Louis—and specifically 108-FM—on the radio map. I asked them to join me on this adventure and in return, I would help them become the best that they could be. They listened.

The reason they heard me and responded so positively to my mission was because I had taken the time to listen to them first. We were at a point in our relationship where we could exchange honest communication, without fear of detachment. The synergy was there and our relationship was evolving to the highest level—loyalty.

Several of my rookies moved on from KMJM to become important industry figures. Bill Singleton was my music director and midday jock. Later, he worked with me in Washington, D.C., and at two New York City stations. Singleton is now a veteran New York voice-over artist, signed to the William Morris Agency. I asked Singleton, because of his storybook rise from a rookie to a top New York talent, what advice he offers newcomers to the industry.

"Listen to the veterans around you," he says without hesitation. "Learn why they are where they are. What were their successes and what were their failures? I learned that the best radio people are givers by nature—teachers who gladly share their knowledge with those who could benefit from their experience. I've done my best to follow the examples of my mentors from Majic 108 by sharing the wealth of information I've garnered.

"The reason Majic 108's on-air chemistry was so powerful, in my opinion, is because the synergy between the players *off*-air was such a potent force," he continues. "It became apparent to me that the veterans on the air staff were

genuinely concerned with upholding one basic tenet of radio—entertaining the listener. They served as a galvanizing agent, turning the staff into a fun-loving group of on-air professionals."

Another rookie who blossomed into an industry mainstay was John Mason, whom I hired for the overnight shift in St. Louis. I still enjoy telling the story of Mason standing in line at an unemployment office in Cleveland when I had him paged and told him, "Get out of line. You are now part of the Majic air force."

John Mason of Detroit's
Mason in the Morning

Mason had a desire to be great. He worked hard, and I quickly moved him to the 10 P.M. to 2 A.M. shift. Mason had a winning personality and would hang around the station all day (if I let him), learning and volunteering to help in station promotions. It was his energy and hunger to learn that made me decide to turn him into a morning man. This idea caused the only major programming disagreement I ever had with Jerry Clifton. Clifton thought I was crazy even to suggest that Mason could do morning drive; he wasn't particularly funny, zany, or outrageous—the usual qualifications—but I believed in Mason's warmth and character. I thought they were powerful enough to draw people to him.

Well, I won that bet: *Mason in the Morning* has been a top-rated morning show in Detroit for over fifteen years. Mason says it's his consistency and digging into the community that has kept him on top. "I've been blessed," says Mason, "to be on the air long enough to be part of the listener's morning life, to know the community, its problems, and its secret joys."

"When I first got to Detroit, I was the production director," he remembers now. "When the morning man resigned, I was asked to temporarily fill in, because I was the only person around with morning show experience. I was just having fun, not really worried about losing a job, because I still had my job in production. I was loose and just kicking the fun vibe. I think 'fun' had been the

missing ingredient in the morning show mix. At Majic 108, fun and creativity were the bottom line for the air talent—that's where I learned my life lessons about having fun, being real, and finding yourself while on the radio. I continued doing the show along with my production duties for about a year and a half, and then I became the official morning man."

Mason's approach to morning drive is personal. He has to know what's going on in the community. "The main thing is to maintain one-on-one contact with the listeners both on and off the air," he says. "You must offer yourself to the listeners. Giving up the real you makes people feel you're just like them. I get out there in the public and touch them. I know it all sounds cliché, but it's still the hardest thing to do. I ride the bus and talk to the riders. I'll tell the listeners a story about someone who owns a corner store, and that really trips some listeners out, because they've been in that store. I hang out in the neighborhood gathering places, and I listen to what's on the listeners' minds.

"What I do is called 'walking down the street humor,'" he explains. "I try to use and say the same little things that other people do to amuse each other. I put a lot of people on the air and I do commentary on everyday life. People enjoy the fact that I'm just like them. I relate well to the guy going to work and the mother getting the kids ready for school. I make it plain that I pay the electric and heat bills just like they do."

19

The Art of Production

One of the reasons I took the PD position at Majic 108 was to work with Production Director Terry Fox. Fox's work wasn't your slick, run-of-the-mill production; his material had wit, humor, sincerity, and excitement—true human emotions. Fox and I had been competitors in San Francisco in 1978, when he was the production director at KMEL-FM and I was the midday jock at KYA-FM. I was always impressed with the promos, sweepers, and overall production design he created for KMEL, which back then was a tightly formatted AOR station.

I also knew that Fox had been production director at KSLQ-FM in St. Louis when Jerry Clifton was national director for the Bartel radio chain. I had listened to many airchecks of KSLQ, including contests like the "Un-Lottery" (a disguised remake of Jack McCoy's famous "The Last Contest") and the "Fantasy Park" promotion, which was a fifty-two-hour music special that lasted an entire weekend. I later found out it took Fox six weeks (working day and night) to produce the simulated concert experience.

Terry Fox is an artist. He is the best radio production man in the country. Nobody mixes music, sound, and human emotion better than "The Foxman." His commercials, public affairs productions, and especially his station imaging, are superb. Back in 1982, we did a series of promos for 108-FM that still sound fresh

today. Most impressive was a contest called "The Big Switch," that encouraged listeners to switch from our competitor at the *low* end of the dial and make the big, prestigious switch *up* the dial for money, great prizes, better music, and FM-quality sound. We did weekly music promos that *sold* our new music selections to the listeners like they were breaking news. The impression was that 108-FM was just ahead of every new musical trend and artist. If we played it, there was something truly magical about it.

When I became PD, the station's slogan was "Continuous Music." With Fox's creative assistance, we changed our sweepers to "music marathons." Fox created a giant character (my voice, electronically tweaked), who would literally stomp across the radio dial; it was so dramatic that it put a lasting image in the minds of our listeners—that our "music marathons" were gigantic and not to be missed.

We worked together to create a series of promos about Dr. Martin Luther King, Jr. that included children discussing his accomplishments and wishing him a happy birthday; Fox still uses it every January 15. Our mini-documentary on the life of Malcolm X, produced for Black History Month, puts all the vapid vignettes one hears on Urban stations every February to shame.

Most radio promotions today explain the entire contest at once. We believed in building anticipation. Tease the audience first, get them interested with clues to what is about to happen on their station, leave them guessing...then *beat* their expectations. If a contest is complicated, explanation promos should be segmented into a digestible series that adds key elements each time around. Run a separate, general rules promo or give out a phone number that listeners can call for additional information. Finally, we would run post-event promos, selling the idea of how much fun the contest was, details on who won, and how we were working on something even bigger and better.

"I learned from Jerry Clifton years ago that the most important parts of a promotion are the tease and the post promos," says Fox. "The promotion could be something small, like a thousand-dollar giveaway, but if you tease it right, you can produce tremendous excitement and great interest. That's really the secret to keeping the listeners who aren't interested in contests interested in what the station is doing."

Fox's production career started when Jerry Clifton came to KSLQ and told him that he'd be good at production. That simple. "He spent time with me in the production room," Fox recalls. "I would watch him, one hand over his ear, doing those whisper-type promos he is famous for. At that time, I was only twenty-two years old and couldn't believe the group PD was taking such an interest in me. It really had a positive effect. He inspired me, made me realize how important production was to the overall personality of a station. Plus, he introduced me to what has become my canvas—the place where I go make pictures for the listeners. Clifton gave me new insight and a new career. That's why it was so neat to work with him again at Majic 108. It was great working with an old friend."

Fox also got to spend time in the production room with industry legend Jack McCoy, whose legendary "The Last Contest," which ran on KCBQ in the early seventies, was the envy of the entire radio industry. McCoy kept most of his stuff close to the vest, because he enjoyed playing a mystical role. "I watched him ad lib some promos once," remembers Fox. "His advice to me was: 'Just talk. Don't try to be an announcer, just talk and use each word to help you create pictures in the listener's mind. Hit a responsive chord.' I didn't know what he meant at the time, but it sure sounded right."

Terry Fox is now a thirty-year radio veteran. Like a lot of jocks I've known, Fox slept with his transistor radio under his pillow as a child. Every night he would listen to KAAY in Little Rock, WSM in Nashville, or the legendary black music station 1380 KWK in his hometown of St. Louis. By the time he was a junior in high school, the radio bug had caught him.

His first station was a 250-watt daytimer, WIMU in Highland, Illinois. "It was a family-owned station," says Fox. "I used to drive over there everyday from St. Louis and ask the owner for a job. One day he said yes. The owner's wife did the books, and a couple of guys were on the air. Every fifteen minutes we read the weather, played a current—another Montovani record—and read the obituaries. I was paid a $1.25 an hour and I was very happy."

As a young man, Fox did what a lot of guys dreamt of doing: He bought a Porsche and drove around the South, working at various radio stations. A tape he sent to Scott Shannon at WMAK in Nashville got him hired at WERC in

Birmingham, Alabama; he became "Shotgun Casey Walker" for three months. He did overnights at WMAK for a couple of weeks, worked at WORD in Spartanburg, South Carolina, for a brief period, then returned home to work weekends at KSLQ. Fox quickly moved to the 10 P.M. to 2 A.M. shift, then to early evenings. After several years of this vagabond existence, in 1977 he got married and left The Q in St. Louis for KMEL in San Francisco.

The first time I laid eyes on Terry Fox he was pretending to be a college student. I was doing my midday show at KYA when the OM brought Fox and another guy into the studio and introduced them as college students interested in radio. One look into Fox's baby blues, his long reddish blond hair, and the cynical smile on his face told me this guy was not whom he was pretending to be. The OM not only showed him our studio but the music sheets, library, clocks, and other assorted things he shouldn't have.

That same night, I ran into Fox at a party at the Record Plant. He was hanging with all the KMEL people. I walked over to him and said, "Hey what's happening, College Boy." He gave me a warm smile, shook my hand and introduced himself: "I used to listen to tapes of you, Walker, and Tanner when I was at KSLQ," Fox confessed. "I would do breaks imitating your breaks. I was inspired by you guys at Y-100. Nice to meet you, man."

Q: Do you remember when you impersonated a college student to get into KYA?

Terry Fox: Yeah, I remember how that station didn't sound like much until you showed up. Then I heard a promo you cut that caught my ear. You started calling the station, "Y-93, The Music FM." I said, wait a minute, that's Quincy McCoy from Y-100. So I decided to go over and investigate. *[Laughs]*

Q: You never would have gotten into Y-100 like that. We were suspicious of everyone. Battling Clifton made us very paranoid. Speaking of the devil, how did he get you to leave San Francisco to go to Majic 108?

TF: I went to Majic because I wanted to work with Jerry again. Plus, I was

ready to come home and settle down. At first I thought I'd made a mistake; then you showed up.

Q: What do you remember about our time together at Majic?

TF: We all challenged each other to do better. There was an amazing cama- raderie back then. We all loved each other and our craft, we listened to each other's tapes, and tried to outdo each other. We inspired each other by what we did on the radio.

Q: What was the first piece of production that really caught your ear?

TF: I was a kid with a 9-volt transistor radio, in bed, under the covers, lis- tening to Ralph Emery sign on at 10 P.M. on WSM. At the time, it seemed like a big piece of production but it really wasn't. He signed on with the sound effect of a Gemini space capsule blasting off. I'd be spinning the dial around but I never missed his sign-on. I thought it was just amazing. Hear- ing it on the radio, something I had seen on television, somehow it made it much bigger, and I began to see it the way I envisioned it. It became bigger than life.

Q: Programmers are always saying promos must be cinematic, which is easier said than done. How do you find sounds that are visual enough to help tell a story in a production?

TF: It just comes naturally to me. I've been blessed with the ability to mix sound and emotion to get the desired effect. I do attribute a lot of it to listening to what's around me. Sometimes it's the smallest sound that gets the reaction you need. Or just a phrase, read properly, that hits a respon- sive chord in people. Of course, the combination of sound with an emo- tional narrative is the essence of production—reaching a truth with the listeners.

Q: I've always believed that great radio stations need the four Ps: personality, promotion, public affairs, and production. If your station is missing any one of those Ps, you'll never be great. How does production help that winning formula?

TF: Production creates the overall impression of what the radio station is about. It creates the overall personality of the radio station. Of course, you have the individual personalities if it's a great station, but the production is the big picture of what it all means to the listener. It blends everything together. As human beings we all have an overall personality—we have our humor, sadness, ups and downs—but our friends have their general perception of us. Production illustrates that perception to the listeners.

Q: You've helped start a lot of stations from the ground up. What do you have to know about a station before you can create a "sound" for it?

TF: How the station wants to be perceived. As a fun, party-time station? Serious music station? A jukebox full of hits? I think the production should be designed for the people who listen a lot. Your production should be layered and interesting so that every time they hear a promo, they hear something new in it.

Q: Few stations these days have a signature, like CBS has the eye, and MTV has the M, KCBQ had the shotgun jingle, WYSP in Philly had the wind chimes. Ideally, each station needs a sound or image that reinforces their call letters. How do you do that?

TF: To be honest, production guys today—even the good ones—aren't asked to create the signature images that were necessary for a station's identity like in the sixties and seventies. This may have something to do with the effects of consolidation. A lot of stations under one corporate umbrella seem to be more interested in sounding alike than having separate, distinct identities.

Q: Some stations use the same voice to do regular station production and be the voice of the station. Does it matter? What do you think is best?

TF: I don't think a promo voice should turn around and sell the listeners something. The promo voice is the *honest* voice of the radio station—the Uncle Fred, who is not trying to sell you something.

Q: How do you like to put your promos together?

TF: I like to start with the script. I read it over and over again until I see what kind of message this promo is supposed to convey. I'll ad-lib it, and change it to make sure it's conversational. Also, because I work with digital equipment, it's easier to start with voice, and break the voice track down. What I try to stay away from are whatever the latest trends in sound effects are. Right now it's static, white noise, or the use of movie bites in promos. I've changed our promos to a straight-ahead approach, with a lot of realism and humanism in the vocal approach.

Q: I remember looking at your résumé once, and I think it said you invented the voice sweeper (a vocal signature played between records).

TF: I met Buzz Bennett when I was production director at KMEL in San Francisco. Our morning man, Wild Bill Scott, had worked at 13Q in Pittsburgh with Buzz. I walked into the studio one morning and Buzz was sitting there. He said, "Hey man, these things you created that play between the songs are great." We went into the production studio and I played him more examples of my sweepers and promos. After Buzz gave me what I considered his stamp of approval, I put on my résumé that I *pioneered* the voice sweeper.

Q: Do you have any tricks of the trade that you can share?

TF: I haven't used headphones in years. I learned long ago that the magnetic resonance of those headphones echoing through my ear canal made me pay attention to how I was saying the narrative, but it was taking away from how I wanted it expressed emotionally.

Q: How has consolidation affected your work in the production room?

TF: Not a bit. I don't produce for the people who own the station. I produce for the people who listen to the station.

Production:
The Sound of the Station

The difference between a run-of-the-mill station and a truly great one is the amount of effort put into sound design. Originality is key. Creating a sound that sets your station apart from your competition—a sound that projects charisma and personifies your station's attitude—will separate you from all the others.

Creative radio production can deliver the most sought-after objective of every programmer—a station's signature sound. In television, CBS has the eye logo and the Sci-Fi Channel has its Saturn logo to visually reinforce who they are. Every great radio station has a "sound"—whether music or a sound effect—that reinforces who they are even without the call letters being uttered.

Think about any great radio station you've admired in the past. I'm sure it had an individual sound that you could have recognized even if you were tuning in without seeing the dial. It could have been the engineered sound of the signal—compression or reverb. It could have been the jingles or special effects like chimes, bells, whispers, or shouts. Maybe it was an intriguing ID or stunning promos that left you wanting to hear more. The station probably used a combination of all these elements to produce a unique, identifiable sound, one that only *that* station had. It made you feel at home.

Great stations don't just happen. It takes a desire to experiment and explore innovative ideas and a commitment to building a marketing strategy around your programming. You must spend a lot of time in the production studio. Think of it as your "war room"; it's where you will create your station's unique sound. Remember: imagination plus inventive production equals great presentation, and it's great presentation that will make your station sound singular. Programmers with limited resources but unlimited imagination and production skills drive their competition crazy and, more important, captivate their listeners' interest.

Promos

The backbone of any successful radio station is creative promos. The average listener perceives a promo as a commercial, so, to deliver your station's message,

No Promotional Budget

For programmers who have little or no promotional budget, here are some ways to market your station during a ratings period:

- If you have no money for contesting and your competitors run big prize giveaways, consider positioning yourself as the station that doesn't insult its listeners with contests, but instead plays the most music. With this stance you can do a series of creative liners and promos putting down contests and raising the level of your station I.Q. with your adult listeners.

- You don't have to be a private detective to find free prizes. They're out there. Check with your sales department to see if your clients have giveaway items available with a copromotion. Make alliances with record, movie, and concert promoters for available tie-ins that may have big ticket prizes attached to them.

- Don't try to spread your giveaways through the entire book. Target your giveaways for Wednesdays, Thursdays, and weekends. Pinpoint specific hours in the morning and in the afternoon drive, and then alternate them. Concentrate your contest giveaways at the beginning and the end of the books. Run great winner promos, and keep them as fresh as possible.

image, and benefits effectively, you need tremendous writing skills. Good promos directly hit your targeted demos. They are interesting, stimulating, hip, lifestyle-oriented, and cinematic.

Seek out a strong station sound that reinforces your call letters without actually saying them (like the NBC chimes). That's a lot to demand from thirty to forty-five seconds, but promos should be magic. They should deliver a message from the station that's cool and ignites interest. Good promos should incorporate your station's signature. Good promos are an opportunity to wrap your positioning statement with dazzle, elegance, humor, and warmth—whatever the moment calls for.

Most stations suffer from sloppy production values and a lack of theater-of-the-mind dramatics, especially when it comes to sales or contest promos. These promos are usually just slapped together, because they've always been considered nickel-and-dime promotions. Promotions should be carefully shaped to enhance the station's image, and designed to create excitement. Good promos are well-written screenplays that tell a story with voice, sound, and music—they come from hard work in your production studio.

I strongly believe that promos should be played first in a stopset or between two records. Stations that drop promos arbitrarily in the mix are foolish and show little concern for getting their message across to their listeners.

Every station needs to support and cross-promote all dayparts, specialty programming, and promotions. Without this type of formatic foundation, it's almost impossible to expand TSL, increase share, or build cume (a station's total amount of listeners). The following is a brief description of horizontal and vertical promos.

Horizontal Promos

These promos are designed to publicize shows, events, or contests from one day to the next. *"Listen tomorrow morning, when DJ Ray announces the Hot Song of the Day. It could mean cool cash for you...from Hot-FM."*

To make these promos work, you must give the listener a reason to listen tomorrow. Begin promoting your weekend programming on Wednesdays. For example: *"Join DJ Ray for the Sunday Jazz Brunch, Sunday at noon, and listen for details to win a free trip to Jamaica...only on Hot-FM."*

Vertical Promos

These promos give people a reason to listen for the next twenty minutes, the next hour, and the rest of the day. *"Hot-FM wants you to win at work. When you get to the office, tune your radio to Hot-FM and DJ Ray will give your office a free catered lunch. Every day, another office wins...only on Hot-FM."*

Or:

"The new Chocolate Shades single, 'Cool Lover,' is out, and you can hear it in less than twenty minutes, only on the station that plays the new music first...Hot-FM."

These promos should be short and to the point, but they should also be creative. That means you must use dynamic words and exciting sounds when you devise promos for your station. Keep them fresh. Also try to employ some repetitive elements such as a basic sounder, key phrase, or jingle bed to help reinforcement and recall.

Production Values

Promos should advertise your station's uniqueness. To create that verbal benchmark, I recommend that you use one voice as the spokesperson for your station. This allows the listeners to become familiar with that person, and creates a rapport between the listeners and the station. It's time to get away from unrealistic, big, booming voices, which today's sophisticated listeners consider a cliché.

Try to keep the "promotional" voice separate from the "production" voice of the station. The production voice is associated with commercials and selling products to the listeners. Commercials still carry negative baggage, so it's not a good idea to have the production voice (no matter how good he or she is) disseminating your station's image messages. Find a voice that matches the character of your station's personality. Add pizzazz, and your station will get the attention you desire.

Production embellishments like recorded IDs and liners are great, but can do more harm than good if they're not effectively integrated into the station's overall sound design. Make sure all your elements fit the personality and style of your radio station.

Remember: Cinematic embellishments are the keys to the kingdom. Using theater of the mind allows us to make the mundane larger than life. The creative use of production values is the difference between a merely good and a truly great sound. The more you are able to tantalize and intrigue your listeners, the more loyalty you can expect from the listening relationship.

Tips for Great Cross-Promotion

First, it's important that all jocks promote ahead to elements in the next twenty minutes, the next hour, the next day. Jocks should never go into or come out of a break without giving listeners a reason to listen longer.

Second, everyone should promote the morning show and its features. The morning show should always be selling what's happening next, its institutional features, and interesting features planned for the next day. The morning show mantra should be *tomorrow, tomorrow, tomorrow.*

A fresh morning show promo, promoting the next day's events, should be cut on a daily basis and scheduled through the day. Ideally, this promo should be on within an hour of the show going off the air.

Schedule at least two "blank" liners a show, forcing the jock to be creative in promoting the next air personality, new music, or some other special event. For example: At Y-100, on a single three-by-five card only the words "twenty-thousand-dollar cash call" or "Y-100 Booty shirt" would be typed on the card. The rest was up to the jock and his imagination to put together a stimulating sell.

Cross-Promotion Liners

What is good cross-promotion? It's reading a liner card without making a mistake, promoting ahead to something (contest/music) coming up at your station, or to an outside event. *Great* cross-promotion develops a personality by using creative, interesting, colorful, or humorous language; it entices a listener to stay with the station until the event happens. Which one would you like to hear more of on your station?

Most stations do a poor job of selling the signature products that separate them from their competition. Fun and games are desperately lacking. Any station that can execute great cross-promotion will have a consistent spread of listeners from daypart to daypart, weekend to weekday, and weekday to weekend. Cross-promotion also gives your listeners the feeling that your station is a real family unit, people who care for one another. When was the last time you read *that* in your research? A good vibe goes a long way with diary keepers.

20

Breaking
Through to Success

It's hard to break through to success today—in almost any career—because there are so many obstacles to overcome. But by far the biggest barrier between us and our goals is the "Voice of Judgment" or VOJ—you know, that nagging voice of self-doubt within each of us. Successful people continually wage a war with their VOJ to cut down on the negative messages it sends to their consciousness.

In most people, the creative spirit and the VOJ do constant battle. Even before your ideas reach full consciousness, the VOJ is cutting them down. *Who do you think you are? They'll think you're crazy. You'll look like a jerk. Better keep quiet and let someone else do it.*

In their book *The Creative Spirit*, Daniel Goleman, Paul Kaufman, and Michael Ray say that, to succeed, people must recognize that the VOJ exists. "It is rooted in fear and holds us back," the authors write. "Our creative spirit is based on curiosity and our desire to better ourselves. To create is the highest thing in life; it's being alive. Have faith in your creativity, and you can knock down the voices of blame and criticism."

To paraphrase Pat Riley, in order to break through, you must make a covenant with yourself—decide that you are committed to the hard work and constant focus it takes to be great. Breaking through to success takes complete commitment.

Above the VOJ, and above all other obstacles, there is the glass ceiling. According to U.S. government hiring statistics, the glass ceiling is "an invisible barrier that prevents qualified individuals from advancing within their organizations and reaching their full potential."

These ceilings exist throughout our business, especially for minorities and women. On the surface, our industry, with its abundant entry-level jobs and apprenticeships, may seem immune to discrimination, but the truth is that in the radio industry, men and women of diverse backgrounds face institutional and psychological barriers that do indeed limit their advancement opportunities.

In an industry where the term "crossover" means widespread acceptance and success, we lag behind in allowing talented people to cross over into upper management. As hip as we pretend to be, we use the same lame justifications that square businesses do: "That job has always been traditionally male," or "We haven't been able to find a qualified minority candidate."

The truth of the matter is, there are many qualified professionals of all races and sexes. Remember, the key word here is "qualified"; no one is looking for handouts for unprepared people. I'm interested in seeing more people who are ambitious, hardworking, and who add value to the bottom line—regardless of gender or racial background—being rewarded fairly.

It's time that the radio and record industries eliminate their cliquish practice of hiring only friends and friends of friends. It's time to cross someone over who may offer some original thinking. The low number of minorities in senior VP and presidential posts at record companies is an historical shame—especially now, when there is such emphasis on international trade. And radio's resistance to promoting minorities and women into upper management positions is a lingering concern as well, especially with the increase in Urban music formats earning such high profits for some of the industry's richest companies.

In addition, the fallout from consolidation has not been healthy for black radio. Consolidation has led to downsizing, format changes, and the lowest number of black-owned stations in decades. With the death of the minority tax certificate, the finite number of radio licenses available, and the banking industry's sole interest in funding multiple station deals, the possibility of increasing the num-

ber of small-scale and minority owners is minute. There are fewer opportunities and more barriers that have to be broken down or jumped over.

Make no mistake about it: There are obstacles out there waiting to stop you. Moving up in any organization will depend on who's in control, and what their background and mindset is. If they already have a perception that you cannot do more, they will not include you. They will filter information to you, your assignments will be shaped in a certain way, and your exposure to new opportunities will be limited. If you are fortunate enough to be in an organization where the leadership doesn't care who or what you are and just wants an effective operation, then you're going to have much more opportunity.

> *"I question and soul-search constantly into myself, to be as certain as I can that I am fulfilling the true meaning of my work, that I am maintaining my sense of purpose, that I am holding fast to my ideals, that I am guiding my people in the right direction."* —Dr. Martin Luther King, Jr.

This is very good advice to follow if you want to be a leader in our business today. Why? Because so much of who we are is connected to our work performance. As long as you're learning, growing, building relationships, and delivering great results, you will stand out among your colleagues. You will break through.

I discussed success—and breaking through to it—with Verna Green, president and general manager of WJLB-FM in Detroit. Green was with General Motors for seven years; she began as an administrative assistant in communications and left as an organization development specialist, serving as an internal consultant to the rest of the corporation. "It was a great foundation for what I've done in radio," says Green.

"I participated on survey design teams and I administered 'quality of work life' surveys throughout the country. I had an opportunity to deal with hourly (line) workers, salaried employees, and management groups. I learned that textbook learning doesn't work the same way across different types of work groups." Green has an MBA, which she says gave her an even stronger business founda-

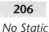

tion when she entered radio as a general manager in 1982. For seventeen years, she has been the GM of WJLB-FM, the Motor City's number-one Urban station.

Q: What kinds of management and leadership abilities are necessary to perform your job?

Verna Green: To manage this radio station, you need an understanding of who it is we're really trying to attract, and the commitment to do everything possible to meet the needs of those people. I don't know what abilities are necessary; I use everything I've ever learned.
I feel fortunate that I had an opportunity to be in other industries prior to being in radio.

Q: The general consensus is that a successful nineties management style is team-oriented and centers on communication and positive working relationships. Is that the way you run your station?

VG: That's right for my station, but I don't think it's the norm. I think that's what's written and what sells books, but I don't think most people buy into that—and I really don't think they practice it. Why? Because of the pressure the bottom line creates. If you're not making your budget, all that humanistic stuff tends to go out the window for most people. Why? Because now you have to adjust your entire workday to deal with complaints from whomever you report to about why you are not doing what you are supposed to be doing. This will become more of a factor as we move through these major acquisitions and major expectations of how to return a profit to stockholders.

Q: One of the results of consolidation is that many GMs are running two and three stations. Do you think consolidation is good for the glass ceiling?

VG: There is no easy yes or no answer; it depends on the individual situations. I'm fortunate, because part of our consolidation happened in a noncorporate environment, with a family-run company, and very quickly moved to a partnership situation. I took on dual station management at a

time when I could talk directly to the president of our company. I had worked with him long enough to where there was an incredible amount of trust. Plus I had a track record, so anything I wanted to do, within reason, I could do as quickly as I needed to take advantage of a competitive bene-fit. Now that I find myself in a corporate environment (AMFM, Inc.), I feel that having gained experience on another level makes it a little easier to deal with this massive structure.

Steps to Success

Photo by Jamie Putnam

Are the steps in this picture leading down or up? Your answer provides a lot of information about how you think about success. Successful people—and those striving for success—will tell you these steps are leading up to something. They are a pathway to the top, the light at the end of the tunnel, or perhaps the end of a hard road to glory.

So much of success is based on having and maintaining a positive attitude. If you want to lead, your entire belief system should shine with enthusiasm. You should empower your staff, and motivate them to strive for a unified goal. There is unlimited power and infinite potential in being positive.

Organization is another key factor to being an achiever. Successful people center their lives around their priorities. They organize their lives around their goals. They are successful because they *control* how they spend their time. They concentrate on things that will take them closer to their desired destination. Control your time to take you where you want to go.

I asked Louis C. Young, a personal development coach, about time and its importance to success. He responded, "You have no time to waste! Time is one of your most valuable resources. With [it], you can overcome any obstacle. The first step to time power is time know-how. Read books on mastering time, controlling your time and life, and overcoming procrastination. Talk to successful mothers, managers, and millionaires about how they control their time. Model yourself after them."

Young believes that before you can succeed, you must have a strong foundation for achievement. "Success can only rest on firm fundamentals," he says. "The base of your pyramid of success must be firm, solid, unmovable. A pyramid without a solid foundation will tumble down when challenged, stressed, or attacked."

Personally, I believe that success breaks down into four categories: risk, originality, virtuosity, and vision. These factors can mean the difference between advancement or stagnation.

Risk

Don't be afraid to fail. Playing it safe never got anyone to the top of their field. Go against conventional wisdom. Don't follow rules; break them and be different.

Originality

Always strive for new ideas. The only way to stop playing catch-up in your field is to create new ideas.

Virtuosity

Learn how to do what you do better. Start by identifying the qualities that make you distinctive. Strive for perfection. Place importance on your routines and learn to focus even when you don't feel like working.

Vision

Maintain a persistent vision. Your vision of your future represents your purpose, your goal. With consistent and positive energy in that direction, you have an excellent chance of reaching your goal.

Q: A recent study about women executives by the Hagberg Associates, entitled "Risk, Rescue, and Righteousness," found women were rated superior to men in management skills. Why are there so few women GMs?

VG: Because men still control the industry. There will be more women, but it's going to take a while to happen. Many things happen to a woman in an organization, especially if she's bright. If she is in an organization with threatened men, then they will do things to frustrate or sabotage her. All over the world, men grow up with a different attitude than women do. Men grow up with an attitude of entitlement. Women grow up with an attitude of obligation. I try every day to change that mindset. Because of those different outlooks, women will work harder and they will work selflessly for the greater good of the organization. Men will do what's needed to get that which they feel entitled to. It's a very big difference.

Q: Is risk-taking the only way to break through the glass ceiling? If not, what else can be done?

VG: The fact of the matter is that we're outnumbered; there aren't that many slots available. When you combine that with the fact that, coming up through the ranks, we've not had the same exposure or inclusion that other folks with a similar title have had, the odds against getting there are pretty insurmountable. That's not even glass, that's what's out there; that's why it's called a management pyramid. It's real narrow up there at the top. If I was someone who had always been in radio, then the next step for me, in the good old days, would be ownership. That is not going to happen because of the nature and structure of the business today.

21

Pass the Knowledge, Please

Pro basketball all-star and bad boy Charles Barkley has proclaimed loudly that he "ain't no role model"—in fact, that was a catch phrase in one of his shoe commercials. To further illustrate his point, Barkley once threw a man through a plate glass window for tossing ice cubes on him in a bar. He defended his free throw by declaring that he wasn't going to allow people to "mess with his manhood."

I have to agree with Barkley: He ain't no role model. A millionaire who likes to bully people on and off the court doesn't have a clue about the commitment and dedication required to inspire and encourage young people to achieve. "Famous" and "rich" are just adjectives, and have nothing to do with the qualities one must possess, at heart, to do the work of a mentor.

Who are mentors? They are women and men who are driven by a positive spirit, one that inspires and guides others closer to their own goals. They are people who remember where they come from and carry within themselves a sense of duty to their communities. They are connected by the common threads of persistence and determination, and by the desire to see their own success echoed in others who wish to follow in their footsteps. Mentors maintain a strong set of goal-related values; they're motivators who unselfishly offer support. Mentors encourage other leaders to step up and share their knowledge, as well.

There are literally thousands of young people—in every industry—who would value the insights of a mentor. The trouble is, most of them don't know how to go about finding one. If you're already in radio and you're waiting for someone to adopt you, don't. Instead, actively seek someone to become your mentor. Look for someone who has already achieved a goal similar to your own, then take action. Persistence and hard work will play a role in getting this person to pay attention to you, but you need to be vocal about what it is you're seeking: one-time career advice? an ongoing support system? Unless you ask for help, chances are no one will offer it.

Luckily, there is a new world of mentoring happening today, one in which the old rules don't apply. The most typical mentoring scenario—the mentor, usually a senior executive, reaches down and selects a protégé, usually someone with a shared interest, and assists this person up the ladder of success—still exists today. But in many ways, it's out of date. In a world where women have poured into the workforce and minorities are competing for equal opportunities, the old pair system doesn't provide much room for cross-cultural mentoring. Women can't depend on men to pick them as protégées, and minorities can't depend on being asked to play golf at the country club.

In times past, mentors were defined as the people who could bring you up the ladder in their wake; they were professionals who had already achieved the goal you are pursuing. But in truth, a good mentor is anybody you can learn from, and your ideal mentor could be anyone from anywhere—inside or outside of your radio station. Today, mentoring is more about commitment than chemistry. It's about personal growth, learning, and development rather than promotions or power relationships.

With this changed definition, many people are finding mentors in places they never would have looked before. For example, peers can become mentors when there are no obvious role models to look to. Helen Little, Urban format director for AMFM, Inc., and OM for WUSL-FM in Philadelphia, says that when she was a jock and a music director, "I never thought about learning from someone on my level. I always looked two levels above me and wondered what I had to do to get there. But the people who had the best solutions to the

problems I faced every day were often the people facing the same problems themselves."

Little also offers this advice: "If you find someone who is receptive, get as much information as possible from them. Learn, absorb, and seek out people who have the answers. Teach yourself, read books, attend seminars, and watch people who are doing what you want to be doing. Ask them questions, whether you know them or not. Learn continuously, because the more tools you have in your arsenal, the better equipped you are to do the job—any job."

Women still have the toughest time finding mentors, mainly, I think, because so few women hold positions of power. Most members of the mentoring class are men. Because most people are more comfortable passing knowledge on to those with whom they share a common bond, it should come as no surprise that women have found themselves on the short end of the learning curve. To combat this, women are leading the search for new ways to share experience and knowledge.

Many professional women have begun using a new term to replace the word "mentor," because they feel the phrase "Can you be my mentor?" implies a long-term relationship, which can intimidate some executives. The new phrase that's catching on is "learning partner." A learning partner is someone you connect with for a short period of time who can coach you on a specific skill.

One problem mentors face is that many people don't know exactly what they want; they just want to learn "everything." No serious manager has the time to teach someone *all* the ropes. You should be prepared with a list of areas that are of concern to you. Do a self-assessment: What skills do you need to get where you want to go? Are you aiming at something that can be done in six months...or two years? This will make the process easier for you and your learning partner. Together, make an outline of your expectations and agree on the terms of the relationship. Meetings with your mentor should have structure. Have an agenda; that way you won't settle for incidental advice.

At different stages of our lives, we need different types of mentors. Early on, you may want an aggressive type—the consummate networker. Later, you may need someone who has been around the block a few times and can alert you to

pitfalls ahead. Don't stay in a box by always looking for a mentor you're comfortable with; that's often not where the learning comes from. Sometimes the best matches are *mis*matches. Try to pair yourself with someone who will challenge you. Your most influential mentor may be demanding or someone with whom you have little in common.

In recent years, many companies have developed in-house mentoring programs and networks. These workplace programs allow valuable mentoring from peers, and easier bonding because of a shared interest in the company and its success. For radio to remain a vital part of the fast-changing world of communications and to thrive as a business in the twenty-first century, we have to begin constructing mentoring organizations and networks that can do three things: 1) maintain a strong set of goal-related values, 2) motivate, and 3) have an effective mission statement that energizes the group to be a constant source of support. This organization should teach by example and draw from the energies of everyone involved. It should balance cooperation and participation, instead of relying on the more usual autocratic setup.

The beauty of an in-house mentoring system is the possibility of an equal exchange of ideas. Someone new or under a senior manager may see the company in a totally different way. It's amazing what *you* can learn from people who want to learn from you.

The New Hughes Corporation

Cathy Hughes, chairman and CEO of Radio One, Inc., the largest black-owned and operated radio group in the U.S. (with twenty-five stations), is a businesswoman who follows her heart. She constantly reaches back into the community to hire promising talent. She also insists that her stations offer assistance, aid, and information to the communities they serve.

Back in 1980, she was struggling to keep her first radio station (WOL-AM in Washington, D.C.) afloat. She eventually had to resort to selling her house and

sleeping at the station to make ends meet. But Cathy Hughes survived.

In an interview at the 1998 *Gavin* Convention in San Diego, California, I found out more about the origins of Hughes' mentoring philosophy. "[Television journalist and author] Tony Brown was my very first mentor," she remembers. "He was my boss at Howard University in the School of Communications. He always told me I had potential, and he would give me unsolicited advice and direction. I found myself seeking his guidance more and more. When Tony reached out and gave me an opportunity, I remember saying to him, 'How will I ever repay you?' He replied, 'The way you repay me is by doing this for someone else.'"

Later on, she explains, "When I was confronted with a problem or needed information concerning a certain issue, I would seek out an individual who was an expert in that area, and instead of trying to have them embrace me or adopt me, I would just pose my questions. More often than not, it grew into a relationship.

"I think one of the mistakes that young people make today is expecting very busy people to adopt them. It's not realistic. You need to remember that you don't need a long-term, one-on-one situation to accomplish what you want or need."

Cathy Hughes is full of great advice for ambitious up-and-comers, and she can teach her lessons by offering examples from her own life. If you want to reach the top of your chosen field, read the following situations and find ways to adapt them to your own life and career:

Cathy Hughes, chairman and CEO of Radio One, Inc.

Don't Be Afraid to Ask

One day I was driving down Connecticut Avenue and I saw Bruce Lewellyn walking down the street. Bruce Lewellyn is a wealthy businessman who owns the Philadelphia Pepsi distributorship. I had never met him before, but I parked my car in a bus stop, jumped out, and ran after him. After he regained his composure from being honked and shouted at by a crazy woman running him down in the street, he eventually answered my questions.

This happened around the time I was getting my first loan for my first station. I felt the conditions the

bank was requiring were unreasonable. While walking me back to my car, he gave me the finest fifteen-minute lecture about finance I've ever received. As I was driving away, he said, "You're gonna make it." That parting remark was a tremendous boost for me at that time.

Make Your Own Opportunities

I encourage young people to hang out in the places where the individuals they're aspiring to be like congregate. Conferences and fundraisers have historically provided an opportunity to introduce yourself.

I gave a speech at George Mason University, and during the question-and-answer period, a young man asked me if I had any positions open at my radio stations. I answered by saying, "Radio stations always have positions open, young man. Do you have your résumé?" He said no. Later at a reception, the young man presented me with his résumé. He obviously left and got it. I immediately pulled out my cell phone, called one of my promotion directors, and told them to give him an interview. He impressed me with his determination, and I know I'll take an interest in him after he's working for the company.

Let Your Work Speak for You

Sometimes I will reach out to help someone who may not be soliciting my direction or advice just because I'm impressed with their work. I've done this a lot with college radio program directors who I feel have great potential to become full-fledged commercial PDs with some guidance. I always keep my eyes open for new raw talent, because we like to grow executives at Radio One. Corporate executives are always on the prowl for new talent, especially in radio, because there are so few veterans.

❦

Cathy Hughes is a fighter. She has the determination of Martin Luther King, Jr., the resilience of Wilma Rudolph, the courage of Harriet Tubman, and the strength of Muhammad Ali. She's a tough and smart businessperson who admits that, while the road to success has not been easy, she knew it wouldn't be and has therefore never let adversity keep her down. "While my friends and relatives thought I'd lost my mind," says Hughes of her early years as a radio station

Networking

Networking can make the difference between an extremely successful and fulfilling career and one that is lackluster. It is an excellent mechanism for expanding your horizons and a way to get around barriers.

Networking is a way to find and cultivate people who share similar goals. Attending industry conventions is a way to introduce yourself to people of influence in the business. Collect business cards and e-mail addresses. Join professional meeting groups and get into lengthy discussions and debates with your peers. This will help you develop relationships and provide new opportunities.

The secret to good networking is being willing to share information. Be a broker of information. Your relationship with others will only prosper when you help others profit from valuable information you've acquired. The more people get to know who you are, the more likely they will exchange important information with you. Ultimately this could lead to a great job.

Networking in our industry, to be effective, must be a lifelong pursuit. You must build your network into your lifestyle. Sporadic networking doesn't work. Once you lose contact because you don't need someone today, rebuilding that relationship could take months and may require a lot of valuable time on your part.

Networking from the Inside Out

Today, every program director has to become the business equivalent of a talent scout. You must find the best people, then get to know them, and recruit them. I've received many calls from programmers and GMs who are looking for the next great PD or morning show talent, but they usually call me after they have lost someone to another organization. They don't have a talent database, but more importantly, they don't have a system for retaining talent. Professor John Sullivan, head of the Human Resources Management program at San Francisco State University, offers a short course on recruiting and retaining employees. In an article in *Fast Company* magazine, he offered these suggestions:

Relationship Recruiting

- Create relationships with talented people who aren't ready to join your company yet.
- Send them e-mails.
- Invite them to the industry conferences.

Scouting Talent

- Capture names of impressive people you meet at conferences and other gatherings, and add them to your database.
- Don't just check references that talented applicants provide. Consider those references as job candidates and capture their names as well.
- Great people tend to know other great people. Be sure to ask new hires about other talented people they know.
- Stay in touch with talented people who leave your station.

Keeping Great People

- Measure and reward managers for attracting and retaining the best people.
- Treat superstars in a special way and tell them why you're doing it.
- Make attracting and retaining talent the most talked about value in your station.
- Ask people in the hallways, "Are you challenged, listened to, and recognized?"

Every company needs people who can contribute to the future. Don't wait for your morning superstar or great PD to leave; prepare today to keep talented people in the future of your company.

owner, "my bankers were watching me with great interest. They said the reason they never even considered foreclosing was because I exemplified the kind of determination it takes to make it in any business. "I'm proud to say that, even in my darkest days, I never had an employee go unpaid, a check bounce, or a financial obligation that I didn't honor."

In the early seventies, she became general sales manager and general manager at WHUR-FM, Howard University's broadcast facility in Washington, D.C.; she was the first woman to hold the position. When she took over the station, it was generating about three hundred thousand dollars a year; within eighteen months, she increased the bottom line to three million dollars. The station's ratings also received a huge boost, mainly due to a new program Hughes created—the original *Quiet Storm* show. When Howard University rejected Hughes' idea to obtain licensing rights for the *Quiet Storm* (which today would be worth millions of dollars), she remembers, "I decided that never again in life would I be in the position to be denied the opportunity to make millions of dollars for myself."

Next, Hughes worked for a group of private investors, who hired her at twice her University salary to get their station, WYCB in Washington, D.C., on the air. "They offered me an opportunity to build a station from the ground up," she says. "That was something that I needed expertise in if I was going to work for myself one day."

WYCB had no operating cash, so Hughes paid the staff out of her own pocket. When she eventually asked the board for her money back and equity in the station, she was told, "If you think you know so much, then go get your own radio station!"

The light bulb came on. "I stood up and gathered all my papers and said, 'That is the most brilliant idea I've ever heard,'" she recalls. "'I want to thank you for telling me what I should be doing with my life.'

"When I left that meeting, I was skipping. I was free at last. I knew it was the right thing," she says. "I knew that day that I would own my own radio stations. I *was* a broadcast owner!"

In 1980, Hughes and her then-husband, Dewey, purchased WOL from the Sonderling Broadcasting Company; Dewey Hughes had been an employee of

the station for many years. There were 121 bidders for the $2.2 million property, but the Hughes were awarded the license. Along with her son Alfred Liggins III, Cathy was able to launch WOL as a low-powered, talk-formatted AM station; and after impressing their bankers with their determination and increasing cash flow, they soon bought an FM and became one of the first duopolies in the country. Since January 1998, Radio One has been on a buying spree. Eighteen of its twenty-five stations were purchased in that time. "We want to be the dominant operator of Urban radio stations in the U.S.," says Hughes.

Q: The number of black radio stations in the U.S. continues to decline, yet your company is getting bigger. What are you doing that the other black companies aren't?

Cathy Hughes: I refuse to accept buyouts. This goes back to the days I slept on the floor [of the station]. We refused to accept anything but success in our company. This is a competitive mentality that God just blessed me with. Jesse Jackson once said, "Marriages only fall apart when people give up trying to make them work." In my mind, I translated that into, "Businesses only fail when people give up." I refuse to sell out to the big boys, I refuse not to grow, I refuse to accept the Telecommunications Bill as a *fait accompli* for my future. I have on my blinders with one purpose in mind: the building of Radio One.

The Telecommunications Bill was so cleverly camouflaged. It went after the small broadcaster. Well, all blacks are small broadcasters. We were the largest with twenty-five stations, and people were always saying, "Isn't it wonderful?" Hell no, it is not wonderful—it's an indictment of the condition of the industry, not a testimony to our greatness. Our goal is to remain the largest black-owned radio corporation, but also to double or triple the number of facilities we already have.

Q: Can you explain to me why established black companies that have been in the radio business for years don't consider joining forces and establishing one large group of stations? Is this an ego problem or just poor economic vision on their parts?

CH: Before the Telecommunications Bill passed, I went on a two-year campaign to try to educate and organize black broadcasters about the dangers of deregulation. I tried to organize letter-writing campaigns and protests. Today, members of NABOB [National Association of Black-Owned Broadcasters] say, "You tried to tell us." After the bill passed, my son Alfred approached all the black owners and suggested that we do what the Hispanics have done and all come under one umbrella. It was as if he told them to kiss his backside. The irony is that my company ended up being one of the first duopolies in the country. We still haven't given up. We still spend a lot of time talking to black owners about some type of joint venture.

Q: What type of management and leadership abilities are necessary to perform your job?

CH: What I do has changed significantly with the rapid expansion of our company. My son is my president and general manager. He's in charge of acquisitions. I always get the credit, but that's my son's area of responsibility. I stay on the day-to-day operations; I still feel that my function in life, my goal, is not to acquire radio stations but to create job opportunities for broadcasters of color. The vehicle I use to do that is a radio station. I've always believed that if you develop people and concentrate on building your personnel pool, the money will come, because you will have a team of hard-working, competent, dedicated individuals. That has always been my strategy. No matter how big we become, my job is to keep us one happy family and superserve our family members—our listeners.

Our company has an incredible track record of reemployment. Over our nineteen-year history, we have had numerous employees who have worked for us three and four times. They're people who have quit—or even been fired—who have come back more mature, dedicated, or understanding of our goals and missions. When I see the number of individuals who have excelled because of our emphasis on staff development, and the number of people who work for us that make six-figure salaries, that's where I get my joy. It's not the number of stations I own, it's the number of jobs I provide for the African-American community.

When you're a black corporation, you're always going to get a bad reputation. That's just the nature of the beast. Part of it has to do with competitors putting out lies and rumors to try and make us appear as if we were less than adequate. They try to make it seem like we just got up one morning and somebody just *gave us* radio stations—that sleeping on the floor and being in there seven days a week to make it happen had nothing to do with it.

Q: A lot of your competitors are using a clustering strategy in the nation's largest cities, often with Urban-oriented programming. How does that affect you, and are you doing the same thing?

CH: We believe that good radio is local radio. Steve Hegewood, my VP of programming, controls all of my FM formats, but all my stations have their own PDs, and they all have their own local emphasis. I'm not trying to mass-produce or boilerplate black radio, because I want to superserve the communities. Years ago, the reason I wanted to do a talk format [at WOL] was from reading *The Washington Post* and seeing what Katharine Graham was doing for her community and what my white competitors did for their listeners. I thought that if someone were doing that for the black community, not only would they have a successful facility, but they would also be filling a void in the community. This has always been part of our strategy and it works for us.

Q: One of the results of consolidation is that many GMs and PDs are running two or three stations. Another is that more stations are using syndication. Do you think consolidation is good for Urban radio? Does it produce more jobs?

CH: No. Number one, it causes the loss of the highest-paid jobs in radio. Secondly, I believe good radio is local radio, and you need to have managers and personnel in each market that can directly interact with those individuals that they're serving. Tom Joyner cannot help the mother of seven who is about to be set out because she doesn't have her rent money.

My senior staff will tell newcomers to the company, "She thinks she's a social agency, so you're not just an air personality, you're a social worker." That's what we do and I believe it's working. We are now the number-one station in Baltimore. It's the first time a black-owned station has been number one there. I don't have to tell you how rare it is that a black station is number one in a market, period.

Q: Many black radio professionals are expressing concern with Urban stations that are programmed for the black community, yet don't reflect it in their upper management. Is there any merit to their concerns?

CH: Part of the reason this happens is because we don't have a trade association that lobbies for us. The NAB sees to it that certain things occur; that's what we thought NABOB was going to do for African-American broadcasters. Today, it's critical for African Americans to have those management positions if they want to ultimately seek financing to own their own stations. It's not about whether you like these people or not; it's about keeping these people in these jobs so that someone can come behind them.

Q: Is there a window of opportunity for black entrepreneurs now?

CH: Maybe a very limited one. The way I got into the business—with a low-powered, stand-alone AM—is not financially feasible now. It's even difficult to get financing on a combo. Right now the banks are looking for multiple purchases. Even trying to get one station in a small market is nearly impossible, because the financing is just not there. But remember this: Just because the road I traveled has been plowed over does not mean we can't cut another road through the woods.

Q: You are a black woman who has broken through a lot of barriers and disproved a lot of taboos and misconceptions that have been holding women—and especially women of color—down from high positions. What advice do you give women who want to follow in your footsteps?

CH: You have to put on blinders and become totally focused and ignore the racism or sexism. You can't allow negative responses to deter you from what you're trying to accomplish. You have to make "no" a motivational response and figure out how to turn it into a "yes." Never be afraid to work twice as hard and twice as long to break even with your competitors.

I don't shy away from the notion that you have to be twice as good. I like being twice as good. It gives me a feeling of superiority.

22

Good Morning!

"As goes the morning, so goes the rest of the day."

For decades, this saying has underlined the importance of strong morning drive programs for commercial radio. Every radio station wants a killer morning show with a large cume that spreads listeners across dayparts. What does it take to create one? I've touched on many of the elements every successful morning show must have, including strong preparation and good fundamentals. But perhaps the most vital component is a unique personality.

Today's morning show personalities are a zany breed of people, loaded with spontaneity, humor, and the ability to excite their listeners. But who are these people who actually *enjoy* getting up in the middle of the night so that when your alarm clock goes off in the morning, they are there to get your day started with comedy, opinions, and a touch of the bizarre? Where do these people come from? Are they born or are they made?

In this chapter I've gathered opinions from several morning show veterans, each with a different position and perspective. Actor-comedian Jay Thomas, a former morning man in New York and Los Angeles, gives his seasoned take on morning radio today. The cynical morning team of Carter and Sanborn, which reigned in Philadelphia for twelve years, talks about chemistry. Also, two nationally syndicated performers whose styles couldn't be more diverse—ABC

Radio Networks' Doug Banks and shock-jock Mancow Muller, whose show is satellite delivered from WKQX (Q-101) in Chicago—share their opinons on what makes a morning show work. In addition, morning show producer Karen Lightfoot offers a glimpse into her often-overlooked—but essential—job.

Let's start with a shock. Veteran shock-jocks Howard Stern and Don Imus (*Imus in the Morning*) have earned millions of dollars performing their peculiarities publicly. But in an interview with *Gavin* magazine in 1998, America's newest morning shock sensation, Mancow Muller, said, "It's not about making money to me; it's about having fun...and if you have fun, the money will follow. I mean, you've got to be good at what you do, but if you love something, you're gonna do better at it than if you didn't.

"It's not about the music, it's about the radio personalities. It's such an unusual thought for people. Program directors just don't get it. Personality radio is where they make the big money—otherwise how could Emmis Communications justify paying me five million dollars a year?"

You read that right: *five million dollars* a year. Just think, if you were syndicated in eighteen states, you could be making that much money, too. But even with all his money and his own syndication company, Free Speech Networks, Mancow admits, "I'm not a fan of syndication. I had to do syndication to protect my interests."

After several documented instances of people recording his show and stealing his bits, including his novelty songs, Mancow decided he had had enough: "I filed a couple of lawsuits and actually had to trademark my name," he says. "There were five different Mancows across the country. They're a bunch of weak, soft copycats. I don't want to syndicate, but until radio starts producing enough talent to cover the needs, I'm gonna do it. I wish there were more young Mancows coming up. The fact is, there aren't. People are hungry for programming."

Jay Thomas missed the boat on the syndication craze. "I was just leaving radio when this syndication stuff started," he says. "I used to think that you should know your market—*be* Chicago, *be* Charlotte, be *local*. But today, if I went looking for a job, it wouldn't be a city that hires me, it would be a syndication company."

Thomas' remarks beg the question: Do you still have to be local to be a morning radio star? Or does it all come down to the strength of the personality? "Who cares about local, really?" asks Mancow. "I mean, I love Chicago—that's my home, and [my show] is gonna have a Chicago flavor—but funny is funny. Are you going to watch a local TV show over a national show simply because it's local? I've always thought radio was bigger than that. If it's better—if it's funnier—people are gonna listen."

I asked ABC Radio Networks' Doug Banks whether he thinks his syndicated broadcasts needed localization. "I think the bottom line of what we're doing is entertaining people," he responded. "If the product is well done—if I'm making you laugh, the music is on target, and you're enjoying what you're hearing—I don't think you really care about the localization."

"But don't get me wrong," Banks adds. "I'm not saying that localization is not a big part of what I do, or that I don't need it. The way my show is formatted, stations on top of their game can feed stuff to me an hour before we go on and make it sound extremely local. [ABC Networks has a system where stations can feed Banks copy before, during, and after a broadcast. He can record the information instantly if neccessary, and send it back to the affiliate.] In terms of making it local, it really comes down to the affiliates' participation. Some stations work very hard at localizing the show. I have affiliates who feed me stuff three times a day. The weather, traffic situations, liners, and drops. These are the things that bring it home and give the show local flavor."

Banks believes that national syndication is the future of radio. "With all the radio stations being bought up—larger companies buying smaller companies—there is a need for the product we provide," he says. "Not to slight all the guys and ladies doing good work on a local level, but we can entertain so many people, and the people get a bigger picture of what we're doing when it's on a syndicated scale. The main thing I've learned over the years is that any shift you do, you must have compassion and warmth for people. I think *that's* one of the biggest problems with radio today—someone told me years ago that when you do radio you talk *to* people, not *at* them. Today, guys get on the air and talk at you. It's no longer a one-on-one thing."

Ultimately, Banks says, "People tune in not only to hear the music, but to find out what this funny guy is going to say or do next. The bottom line is that people want to be entertained."

That said, Banks cautions that it takes more than an overactive funnybone to make it in the mornings:

Q: How much preparation time and preproduction is put into your show?

Doug Banks: When I was doing a local morning show [WGCI-FM, Chicago], I must admit that I had a great group of people around me. My preparation was done throughout the morning. I've never been a person who goes home the night before and says, "What am I going to do tomorrow?" I'm the type that picks up a newspaper in the morning, figures out what's going on and what people are going to be talking about, and that's where my preparation comes in.

Doug Banks of ABC Radio Networks"
Doug Banks Show

People ask me all the time, "Where do you prepare for your morning show?" And the honest-to-God truth is: in the shower. That fifteen minutes in the shower is the one place no one is calling my name. Nobody's asking me questions. My kids aren't saying "Dad…," and my wife's not saying, "Honey, honey!" My mind is completely clear, and by the time I get out of the shower, I can tell you exactly what I'm going to do that morning almost hour by hour.

Q: Are morning show people born or made?

DB: I think you're born to do mornings. By no means am I trying to slight anyone who has done afternoons or nights and all of a sudden they've been shoved into mornings—but that's often why it doesn't work. I really

believe that in order to do mornings, you've got to be born with some type of personality that does something to people—it either charges them, makes them think, or makes them talk. You've got to have that in the beginning. I don't know many successful morning men who were made. Most were born to do mornings.

Q: Do you think that listeners across the country are tired of prepared bits, punchline humor, and immature sound effects? Are they looking for honest-to-goodness real entertainment?

DB: I don't want to make anybody mad who uses joke services, tip sheets, or stuff like that, but I never used them. If I can't pick up a *USA Today* and find something that's funny, then something is wrong. My best material is from newspapers and my own life. I've got two kids. I've got tons of stories. There's plenty of material in everyday life. If people perceive you as down-to-earth—the guy-next-door—that's what makes you real. Relating to people is what this is all about.

Q: Is it more important to be personal than topical?

DB: I think so. I think people turn on the radio to be entertained. With today's electronic media, there are so many ways to get news and topical information that I think radio can be a nice break from all that. You can turn on the radio and just laugh or be gently provoked into thinking.

Q: The bottom line of morning shows used to be information, weather, news, and traffic—until Howard Stern rewrote the rule book. Stern lets listeners know him. How much of yourself do you give to your listeners?

DB: My life is an open book. I don't hide anything. I'll tell ya something, it took my wife about two years to get used to it. Our first two years of marriage, she was cringing every day. She'd say, "Doug please, I can't stand going to work because everyone knows intimate details about us." It took her a while to get used to it. But the point is, if you ask any of my listeners what can you tell me about Doug Banks, they can tell you things about my personal life. They know because it's a part of the show.

Better Mornings Through Chemistry

There is something about teamwork that is intrinsically appealing to radio listeners. Audiences respond enthusiastically to smooth banter and repartee between two likeable people. Teams like Burns & Allen, Klaven & Finch, Ted Brown and the Red Head, and Yvonne Daniels and Sid McCoy all had one thing in common: they all related first to each other, and then to their listeners, on a truly emotional level.

Today the morning team tradition continues, but few pairs possess the intrinsic magic it takes to relate to today's wiser, more cynical listeners. At WUSL-FM (Power 99), Philadelphia's morning team of Carter & Sanborn was an exception. After being partnered by then-PD (now VP/GM) Dave Allan in 1987, they remained together for twelve years, constantly injecting freshness into their act.

"I thought they would complement each other," remembers Allan. "Carter was a great disc jockey; his timing and board work were exceptional. Sanborn was a creative talent, good with bits and character voices. I put them together for a test, and the chemistry was instantaneous. Of course, I'm no genius—a lot of it was luck—but a lot of the magic of great morning shows comes from happy accidents."

Though Carter & Sanborn split in 1999 (they said they wanted to go out on top), they remain a great example of a morning show that works on two levels: 1) they appreciate each other, and 2) the audience connects with them.

Q: What are the essential ingredients that kept you guys together for twelve years?

Carter: We made a pact on day one that we would come in every day and have fun.

Sanborn: There is definitely chemistry here. He can start a sentence and I can finish it.

Carter: Yeah, people say we're married and stuff. The thing is, we have a lot of the same likes, dislikes…

Sanborn: …the same warped sense of humor…

Carter: …and we're from the same era.

Sanborn: But we also have our differences, which is good.

Q: *What kinds of differences?*

Carter: Well, you would see Sanborn at the Santana concert or Yo Yo Ma, and you would see me front row at Busta Rhymes or the Stones. We're pretty different, but when we're in the studio, we're pretty much on line. To get back to the pact: If it wasn't fun anymore, we wouldn't do it. We both worked in "Morning Zoo"-type situations before, so we knew how teams could get out of hand. We learned not to take it so seriously.

Q: *How much preparation and preproduction did you put into your show?*

Carter: We were always doing prep; prep never stopped.

Sanborn: We had five people on staff. We had a producer and executive producer—both female—who did a lot of research in terms of the female listeners we targeted.

Carter: One of the things that was unique about us is that we didn't do a lot of sports. As far as prepared skits, we did a lot of that in the beginning, but then everybody began doing it. Then the market changed. We got Stern, Joyner, and Imus in here, and it forced us to step it up a notch. We were lucky that, in our format [Urban], nobody was trying anything new between the music—they were still into horoscopes and the color of the day—which gave us an opportunity to be different.

Q: *Do you think that punchline humor is passé?*

Sanborn: I think it's how you present it. You can take a punchline and do something around it where it comes out natural. But if you're just setting it up as a straight *"pa-dum"* one-liner, I think people are tired of that.

Q: *Some people say the old wisdom of being topical is over, that being personal is what listeners want today.*

Sanborn: You've got to do a combination of the two. We got very local at times, and sometimes the whole day would be nothing but reaching out and getting personal—taking on controversial subjects....

Carter: The key is, you have to know your audience. You have to know what they're eating, doing, what they're listening to. If you don't, they can see through it and they will go someplace else. If the music changes, you have to change too. We went from mainstream to hip-hop, because that's what's at the forefront in our listeners' minds. It doesn't mean we have to walk around in baggy jeans, but you do have to know the language and what you're talking about.

Sanborn: You have to be able to relate.

Q: Your target audience, the 18 to 34 listener, has become bombarded with so much commercial hype that they've become very cynical. How did you relate to this advertising-weary group?

Carter: You have to be in their face. One thing we stressed was that they've got to see you. This is a great business for hiding, but once people see you and see that what you're giving them is real, they'll become closer to you. We did that a lot.

Q: One of the secrets of Howard Stern's success is that he lets his listeners know him. His personal life is an open book. How much of your personal lives did you offer to your listeners?

Carter: We didn't make it a point to work in the "my wife did this last night" material, but there are times when we brought it in.

Sanborn: Actually, it was quite rare, but if it related to a particular topic...

Carter: ...we'd bring it up...

Sanborn: ...but mostly in general terms. We didn't get real specific about our personal lives.

Q: Did the map of your show contain specific times for features and open times for spontaneity?

Carter: It depended on the day.

Sanborn: We liked to prepare an outline, but then if something happened—like someone significant died or something heavy went down in the city—we would throw out the skeleton and just jump into the event. But we always have something on the burner.

Q: Is the word "consistency" still key to morning shows?

Sanborn: Oh, yeah. There are certain elements in the show you have to hit every day in addition to the spontaneous and unusual. We had certain benchmarks on the show—like birthday wake-up call and Horace's Horoscope—that people got dressed by. They knew if they weren't dressed by the time Horace came on, they were running late.

Carter: One of the sad things now is that these elements aren't being taught. A lot of talent coming up today don't have a clue and, what's worse, they're not students of radio.

Q: How much did you let the audience get involved in your show?

Carter: As much as possible. We called them "The World's Most Dangerous Audience."

Q: If you had to pick one thing that separated Carter & Sanborn from the rest of the morning shows, what would it be?

Carter: We ran faster and jumped higher.

Morning Show Producer

Karen L. Lightfoot was born and raised in Chicago. She grew up listening to WGCI-FM, one of today's leading black-formatted stations. After graduating from Columbia College in Chicago, Lightfoot joined the Doug Banks morning show at WGCI-FM as producer; she stayed with the program for eight years. Lightfoot also produced comedian George Wallace's morning show at WGCI,

and in 1998, she was named executive morning show producer of *Sway and the Breakfast Club* at KMEL (106 FM) in San Francisco.

A morning show producer is the PD of morning drive, and Lightfoot has all the qualities of a great PD. She builds an effective organization around solid values and a strong work ethic. She understands that the definition of success in our business needs to include both financial strength and an ability to generate teamwork. She is also one of the country's top morning show producers.

Q: I always thought it made more sense to critique talent after a good show, highlighting the positives.

Karen Lightfoot: Exactly. You try to recreate the moments. What were you feeling here? What were you thinking there? It's like in golf when you hit the ball good off the tee—you remember that feeling. Same thing in basketball when the ball rolls off your fingertips and you hear the sound of the net going "swish"—it's all in remembering the rhythm.

Q: How much a part of your show is listener involvement?

KL: Most of the time the listeners are pretty content just being entertained, but you can tell if they're paying attention by just asking a question, because the phone lines blow up. Everybody wants to be the first to give their opinion.

Q: What's more important these days, being topical or being personal?

KL: That topical thing is over. They have to *feel* you. If the listeners don't feel you, it's not happening; you're not connecting. When they feel that you can step into their world—and they can be in yours—that's the best combination you can have.

Q: What kind of humor are listeners reacting to today?

KL: Listeners today don't want prepared stuff, they want things that touch them every day. Things that hit them in their own pocketbook, conscience, or heart are important. The buzzword right now—and I hate it—is "com-

pelling." "Compelling" always equates to drama, and you don't have to reach that emotional level to make listeners feel you.

Q: How much preparation time and preproduction is put into your show?

KL: We prepare a lot everyday. We listen to material after every show that isn't outdated and reconstruct it for the next day. We all get here at least an hour ahead of time and read the papers and watch cable TV for any breaking events. We all do our share of note-taking. We each have a role, and understanding that role, we know what to look for.

Q: Does the map of your show contain specific times for features and open times for spontaneity?

KL: Nothing is ever written in stone, because you never know what's gonna happen. You may think an idea or concept is only going to work for one break, but then you say it and all of a sudden the lines just explode and you're doing it for the next two hours.

Q: At the 1998 Gavin *Seminar, I heard you say on a morning show panel that any station that is good is local, local, local.*

KL: People want to hear what's going on around them. The more you localize things, the more attracted the audience is to you. It's just another thing they can relate to.

Q: What are the essential qualities to become a great morning show producer?

KL: First of all, you need to be a pure producer, not someone who's sneaking in the industry to get on the air. Being a producer is a really tough job and you have to wear many different hats. For instance, I have to bond with my talent in many different ways—sometimes I'm a mother, a disciplinarian, or a baby-sitter. Even though we're all grown up, egos have to be handled with tender loving care sometimes. You have to be highly organized, detail-oriented, and have follow-through. Good producers

never lose sight of projects they're working on. Persistence is another necessary quality.

Q: A lot of people believe that a morning show producer is one of the most important jobs in radio today, and that it may be the best training ground for new program directors.

KL: I've heard that a lot. People keep telling me that would be a good position for me. I find programming so administrative, and yet I do think my job is somewhat of a training ground for it, because in reality I'm the program director of the morning show. I run that show from top to bottom; the whole look and feel of the show is under my command.

23

New York City: Just Like I Pictured It—Skyscrapers, Legends, and Spirituality

*The New York City skyline
circa the 1970s (photo by Phil Bray)*

The first time I ever saw New York City, I was twelve years old, sitting next to my mother in the front seat of her 1962 Cadillac. We were on our way to Brooklyn for one of Mom's visits with her fortune teller and friend, Miss Hodges. Mom had taken me along to help pass the time during the five-hour, 242-mile drive from Utica to New York City, a drive Mom somehow always made in less than four hours.

I had just graduated from comic books to James Bond and Mickey Spillane novels, and I was immersed in big city intrigue, so when Mom pointed out the Manhattan skyline, it had a double-edged impact on my adolescent imagination. I was simultaneously intimidated by the tall buildings and attracted to the city's magnetic pull and bristling energy. I was hooked, and soon I became my mother's companion for most of her covert trips to the city to have her fortune told. (My father is not the fortune-teller type.) I usually skipped school and I was sworn to secrecy never to tell anyone about our adventures.

On the drive down to New York City, I would focus most of my attention on the radio dial. As stations faded out and in, it was my responsibility to make the necessary adjustments. WTLB in Utica had a fairly strong daytime signal that stayed with us as we headed east, fading about 150 miles into the trip. Then WABC's signal began gaining strength. Once we reached the Tappan Zee Bridge, I began switching between and among WMCA, WABC, WWRL, and WNEW, which was my mother's favorite. She said WNEW was like listening to *The Ed Sullivan Show*—"They played the music of the stars."

Immediately after we arrived in Brooklyn, Mom would go behind a curtain with Miss Hodges and I would sit on the stoop with my transistor radio, checking for new music. Out of the radio poured "Sherry" by the Four Seasons, "Duke of Earl" by Gene Chandler, "Johnny Angel" by Shelly Fabares, and one of my all-time favorite songs, "Do You Love Me?" by the Contours.

Music always seemed hipper and fresher in New York City. "He's a Rebel" by the Crystals, for instance, sounded edgier—much more dangerous—when I heard it in the city. But not even this pop-packaged rebellion could inspire me to venture too far from Miss Hodges' stoop. This feeling would stay with me until the late seventies, when filmmaker Woody Allen ignited my romance with New York.

In 1979, I was in Berkeley, California, working for Fantasy Records as Director of Promotion, when I went to New York on business. It was my thirtieth birthday and a couple of my coworkers took me to see Woody Allen's new film, *Manhattan*. I was already a big fan of Allen's, but this wonderful film—a valentine to the city—captured my heart and made me see New York City with new eyes. It was

then that I embraced the city's wealth of history, art, and music, and vowed to explore as much of it as humanly possible. I knew that New York City had to become my home.

WKTU-FM

Opportunity knocked in the fall of 1984, when I was hired as assistant program director at WKTU-FM. I had spent the previous two years with Bill Tanner in Washington, D.C., trying to turn WASH-FM (an A/C station) into an Urban-leaning Top 40.

I was recommended to WKTU's program director, Neil McIntyre, by the station's new consultant, Sunny Joe White, a person who deserves his own chapter in this book or any book that deals with the history of pop radio. Sunny Joe White, who died in 1996, was a good jock, a great PD, and a brilliant marketing executive who created two legends in the city of Boston—KISS-FM and himself. Like all good programmers, he borrowed from stations he admired, like Miami's Y-100 and his friendly Beantown rival WBCN, and created one of the strongest personality-based radio stations in the country. Sunny developed (or reinvented) many radio personalities—most still working today—who proudly point to him as their catalyst, inspiration, and brother. Sunny gave them a chance, maybe because he understood better than most how rare it is to get a chance to prove how good you can be.

My relationship with Sunny Joe dated back to the late seventies, when he was the PD of WILD in Boston, that city's only black music outlet at the time. WILD was a daytimer (meaning it has to sign-off at sunset), but Sunny Joe made it a vital part of the city's radio landscape. A few years later, I wrote him a letter of recommendation to Heftel Broadcasting (my former employer at Y-100) who were signing on WKYS (KISS-FM) in Boston—a Top 40 station.

With this position in 1979, Sunny was given the opportunity of a lifetime. He proved that it didn't matter that he was black, it just mattered that he had the right stuff for the job. He put together a multicultural, multitalented, cos-

mopolitan station in a city not well-known for its brotherly love—but that's the kind of power a guy like Sunny possessed; he loved Boston and made Boston love him back.

Sunny Joe sent me to New York to meet McIntyre and the station's GM, a pugnacious, blunt-spoken guy named Mel Karmazin. Karmazin was also president of Infinity Broadcasting, which owned WKTU, WBCN-FM in Boston, and four other stations. McIntyre had recently taken over the programming reins at WKTU, a station that had fallen victim to the end of the disco era and slumped in ratings.

"Sonny Joe White was great for radio," McIntyre remembers. "He was one of the last programmers who really understood the music industry and was really into the showbiz part of it. Sunny had a good feel for what the public wanted. He proved that with the tremendous success of KISS-FM in Boston.

"Mel loved Sunny Joe. He knew Sunny was special and would help us perk up WKTU's ratings. Sunny had a lot of great ideas, and Mel is the kind of guy that, if you have an idea, he will back you 100 percent...but your final result had to be a success."

I was one of Sunny's ideas. He thought I could assist McIntyre in establishing a new Top 40 identity for WKTU. An astute programmer with good people skills and a wry sense of humor, McIntyre was a veteran New York programmer with an incredible radio history that included PD stints at KDKA and KQV-Pittsburgh, New York's original Top 40 station WINS, and a six-year run at WPIX-FM in the Big Apple.

Now we needed to find out if we had the right chemistry. Our first lunch, which lasted over three hours, answered that question. As we ate, I made McIntyre tell me story after story about his experiences in radio. "KDKA in Pittsburgh was one of the most creative places I ever worked, mainly because of the people," he told me. "Everybody wanted to participate; everything was one for all and all for the station. It was very creative and imaginative. It was one of those places that, if you had a good idea, by the time everyone contributed it would actually be 100 percent better. When you have players like that—whether it's a baseball team or making a movie—everybody's thinking is expanded. Everyone's talent encourages everyone else to produce and it's a hell of a lot easier reaching the goal."

I asked McIntyre what it was like working for, as I called him, "this Karmazin guy." I knew the station's ratings were low and it would take money to revitalize the station's image: Would we have the support of his company? McIntyre smiled and said, "I've run a lot of stations with one hand tied behind my back. You come into a station that everybody knows needs a paint job, even the management has known it for years, but nobody wants to pay for the paint or the brushes, and nobody knows how to paint. So sometimes you have to dress it up as best as you can with what you got. This is not one of those stations. If we ask Mel for something because we believe it will help us win, he will give it to us."

It was time for me to meet Mel. We walked a few blocks to 60th and Madison, the old address of the once-famous Disco 92 station, which in just a over a year would become WXRK (K-Rock) the homebase of *The Howard Stern Show*. McIntyre stuck his head in Karmazin's office, and we were waved in by a man with salt-and-pepper hair, who jumped up from behind his desk to greet me with a smile, a handshake, and his rapid-fire speech. "So you're the one that we need. You're the one that's going to save us, Sunny says. I guess Neil likes you or you wouldn't be here. So how much is this privilege going to cost me?" I answered, "One hundred thousand dollars."

He shot back: "Yeah, but you'll take ninety, won't you?" Of course I did.

My eighteen months at Infinity was one of the most educational times I've ever had in the radio business. I watched Mel inspire loyalty, get results, and make people wealthy. His style is direct—maybe rough to some—but at the same time he is a great listener who offers assistance and genuinely likes people. But most of all, he loves his work.

One of the things about Karmazin that impressed me most was the way he structured, designed, and executed management meetings. The one I attended was in San Diego. Before the trip, all the managers were asked to prepare a presentation for the gathering. This was an opportunity for all of us to improve our management skills or get answers for problems facing our stations. In San Diego, every morning beginning at 7 A.M. until 1 P.M., various speakers engaged us on subjects ranging from critiquing techniques to research. There were presentations of successful sales, promotion, or programming strategies by each station. It was a great learning experience. After the morning session we were free to do

whatever we wanted, which included sightseeing, hanging out by the pool, or poker. Work hard, party hard—that was the unspoken philosophy.

Today, Karmazin is the chief executive of CBS Corporation, or as many industry insiders call him, "The King of All Radio." He is the biggest individual shareholder of the company that owns the CBS Television Network, fourteen major-market TV stations, 160 radio stations, cable-TV channels Country Music Television and the Nashville Network, and a bunch of outdoor advertising properties. He has always treated me with respect when we see each other.

I caught up with Neil McIntyre to talk about those days at WKTU, working for Mel, and radio programming. After forty years, McIntyre is out of radio, but he still listens like a PD.

Q: I tried to interview Mel for this book, but he was too busy making deals. I went to a speech he made in San Francisco a couple of years ago, and I asked, "Do you think that consolidation is hurting creative radio?" He answered no. He said he expected all of his stations to strive to be as creative as possible.

Neil McIntyre: Mel respects creativity. He's never surrounded himself with cookie cutter-type men or women. Just look at the list of people he's hired. There were a lot of creative people in the original Infinity Broadcasting group that helped him rise to the top.

Q: You've seen Top 40 radio right from the beginning. What's the difference between radio of the sixties and seventies and today?

NM: Radio was pretty inventive and original in the sixties. Sometime in the late seventies things began to get stale. The music sort of went to hell and the moment research got a hold of your station, it started wagging the PDs. Research was supposed to be just a guide that helped you make better decisions—that's what everybody says—but it's not the truth.

What happened was, you didn't go against the research unless you were a fool and wanted to be out of work. Companies spend so much money to get their research done so that when the research says five is six, and you're saying five is five, everybody thinks you're stupid.

Everybody was overwhelmed with the idea of getting rid of all the negatives. They wanted to vacuum all the negative stuff out, so that everything was positive. Once the programming was taken away from the PD and was left to focus groups, the creativity was gone. Those people might like twenty seconds of a song, but they sure as hell can't put magic on a radio station.

Q: Speaking of negatives, I remember that when we were at WKTU, you wanted to hire Howard Stern. I think that was the only time Mel ever said no to you.

NM: That was not the only time. [*Laughs*] We were looking for people, and I suggested Stern to Mel as my first choice. Mel said to me, "If you hire Howard Stern, your sales manager is going to quit. What do you think of that?" Back then, when Stern was on WNBC, a lot of ad agencies weren't buying his show. Then later when they [Infinity] hired Stern to do afternoons, I just about fell over.

I've hired a lot of guys that people thought were nuts. It comes down to the question: Is he worth the trouble? Will he add to or break up the station's chemistry? I thought Stern was an obvious choice. He was an attention-getter. When you're listening to a guy on the radio and you say to yourself, "Hey, shut up and play a song," then he shouldn't be talking. But if you're listening to a song and you're saying, "I hope this thing ends so I can hear what this guy has to say," then you know this guy's got something special. And that's the way it was when people listened to Stern on WNBC.

Q: Personalities like Stern and Mancow seem to know how to give an audience what it wants. But listeners used to listen or be loyal to a station, and not just one of its personalities.

NM: People have lost sight of the fact that a radio station must be able to draw attention to itself by its programming. Stations today lack the luster to pull that off. Take K-Rock in New York. When Stern is on the station it has around an eight share. The rest of the day they have about a two share. I think stations are missing the fun quotient in their presentations.

It was the fun that drew people into radio. Radio was like going to an amusement park.

When stations started losing their creativity can be traced back to when the programmers lost their confidence. They lost their confidence in their own thinking—they weren't so sure anymore. Guys like Jerry Clifton, Buzz Bennett, and Bob Pittman came in on the wave of research, but they were strong enough leaders to use it only to back up their creative vision. After their tenure at their specific stations, the research moved to the forefront, and the programmers were forced behind the wave.

Q: *Are there any programmers today that get you excited?*

NM: Radio today is pretty plastic. I can't think of the last time I heard a really unique contest or promotion. All the contests are cash-call in drag. You've got programmers today who just sit behind their desks and play with their computers and never get out in the streets. A lot of these guys have never been in the subway or gone grocery shopping.

Jerry Clifton was one of the last guys to really shake this town up, programming-wise. He's a great competitor. When I was at WPIX and he was at 99X (today WRKS-FM), he was always doing stuff and making me nuts. He was very difficult to compete against. He hired Jay Thomas to do mornings. Jay and I were neighbors and became good friends, and he was part of our team that tried, in vain, to revive WKTU.

Two Giants

McIntyre and I built a good lineup at 92 WKTU. Jay Thomas did mornings, followed by Y-100 graduate Jo Maeder (The Madame), who would join Jay's show every day at 7 A.M. and stay on until noon. I did the noon to 3 P.M. shift, followed by Dan Ingram in afternoon drive.

Working with Dan Ingram was a dream come true. He was my hero, my all-time favorite Top 40 jock. When I was just beginning my career, it was Ingram's wry, relaxed, genuine sound that I tried to emulate. And listening to Chuck Leonard's hip approach gave me the feeling that I could also be myself even with the restrictions of a format.

At WABC, Dan Ingram and Chuck Leonard became prime examples of true craftsmanship with their charm, humor, and smooth delivery, along with their ability to say a lot in only a few seconds.

McIntyre and I met Ingram for lunch at a restaurant called The Slate to see if he was interested in coming to work for us. The Slate was a hangout for a lot of the CBS news guys. I remember seeing Harry Reasoner sitting at the bar. I was nervous about meeting Ingram, worried that I would be let down, that he would be a prima donna.

Ingram, I am happy to report, is a gentleman, a scholar of the business, and a very funny person off the air as well as on the air. We became friends and Ingram passed along professional advice freely. Today Ingram, who was the number-one afternoon drive personality in New York City for twenty-one years at WABC, still practices his craft on his highly rated weekend shows on WCBS-FM. In 1999, I caught up with Big Dan after a shift and asked him about the state of personality radio.

Q: What do you think is the biggest difference between music radio today compared to the sixties and seventies?

Dan Ingram: Nine out of ten stations don't have people who are personalities, and those that do are fairly restrictive in what they allow them to do. WCBS-FM is one of the few stations in the country that hires personalities to do their thing. Of course we have a format to follow, but they give us the space to be ourselves and do what we do best.

*Dan Ingram and Quincy McCoy
at a WKTU party*

Q: As a performer, what do you feel are your responsibilities?

DI: To give the audience something they can identify with. If I say such and such, and the audience reacts with: "Oh, that's what he meant!" and it makes them laugh or smile, that's what it's all about. You do that a couple times a show, that's all that counts.

Q: If you had to pick out one quality about Rick Sklar (PD of WABC from 1962 to 1977) that made him a special programmer, what would it be?

DI: Rick Sklar was a promotional genius. When we would do a contest, he went all out, and there was always a major response. Here's a great example: When the Beatles came to New York, Ringo Starr's Saint Christopher's medal got swiped by a girl as he was getting out of a limo. The girl ran away. When I was interviewing him he said that the medal was given to him by his auntie, and it was very special to him, could we get it back? I said, "We'll find it for you!"

Well, Sklar put an announcement on the air that ran every fifteen minutes: "If you have Ringo's medal, please bring it to the WABC studios." In a half hour the girl showed up with the medal, Sklar called her parents and said, "We would like to send you and your daughter, and two other people of your choice, to any Broadway show you want to see. Plus we'll put you up overnight at the Waldorf Astoria hotel." In the meantime, on the air we're still banging this promo: "Have you seen Ringo's medal?" We played it all day and all night long.

Then Sklar schedules a news conference for four o'clock the next day. The girl and her family and all the New York press are there to see her give back the medal to Ringo. Ringo gives the girl a great big kiss and says, "Thank you. I know this must have fallen off into your hands." Needless to say our ratings went sky high. That's the kind of promotional stuff Rick Sklar would pull off.

Q: What made WABC special to you? Chuck Leonard said not only was everybody professional, but there was a real sense of camaraderie there.

DI: Oh, yeah, we were a good bunch of buddies. No one was on anybody's back. We had an enemy and that was WMCA. That makes life easier in the long run.

I don't think any of us at the time realized what a monster the station was. We knew something big was going on when we were being called in the industry "the most listened-to radio station in North America." Being a part of that was amazing. Our 50,000-watt clear-channel transmitter used to hit the skywave and I would get mail from New Zealand, London, South America, and a ton of mail from the Caribbean. At night our signal was picked up in two thirds of the country.

Q: Were there any on-air personalities you looked up to?

DI: Al "Jazzbeaux" Collins was my hero. Al Collins was a disc jockey's disc jockey. He connected with the audience. Arthur Godfrey was another guy; I knew what he was doing. Godfrey talked second person singular to the audience; "you" meant a specific "you"—alone, one person. He never said, "Good evening everybody." Because anybody who says, "good evening everybody" is talking to *no* one. There is only one person listening to you. You can make that person anything or anyone you want. The "you" has got to be second person singular.

Jazzbeaux was one-on-one just like Godfrey was. If he was talking to you, sometimes he'd call you Max. He always had the orange Tasmanian Owl, he had the whole setup of the Purple Grotto, three stories down under the city. He was a weaver of fantasy. Radio to me is the best stage in the world, because you can imagine anything you want. Jazzbeaux was great at theater of the mind.

Q: What was the best advice you ever got about being on the air?

DI: The very best advice I ever got was from Hal Neal, GM of WABC, who was my mentor and very good friend until the day he died. Hal was also the guy that hired me. Just before I went on the air, he said to me: "Just be yourself."

Ingram-isms

Preparation

Absolutely necessary. For my three-hour weekend shows I do about an hour and a half of preparation. I bring a laptop with me to work now, and when I think of a funny line, I jot it down.

Brevity

It's like what the Strunk and White book says about words; if you can say it in ten words, great. If you can say it in eight, that's even better, as long as you don't lose the meaning. I believe in brevity and I also believe that once in a while, you have to break the rules to get your point across. People's lives are too busy. They don't have time for long jokes and long, drawn-out punchlines. You'll lose them. What I do is ten seconds long at the most. I do quick in-and-out humor.

Q: Do you remember the moment when you became yourself on the air?

DI: Clear as a bell. I was doing the morning show at WNHC in New Haven, Connecticut. Up until then I had been very much the announcer type. It happened to be Thanksgiving Day and everything was closed. I couldn't get a cup of coffee that morning, nothing. Everything was dead. I got to the station and turned on the transmitter, turned on the aircheck machine, and about three songs in, I said: "Is there anybody up out there? I feel like I'm all alone in the world. If anybody's listening, give me a call. I just want to talk to somebody." The phone rang off the hook. I talked to someone stuffing a turkey, another guy painting a wall, all kinds of people. I was doing nothing but talking to people between records. When I listened back to my aircheck, I sounded like a real person. Not the announcer fella, not my hero Al Collins, just me talking to real people one at a time. It was like an epiphany. I never went back.

Q: What advice would you give to young radio professionals who want to be great air personalities?

DI: Number one, aircheck yourself a lot and find out what you do well. Most people don't have any idea of what they really sound like until they hear themselves a lot. When you find something you like, do that. If there's a market for it, you'll make it.

Chuck Leonard, Pioneer

When Chuck Leonard was hired at WABC in 1965, he was the first black jock on a major Top 40 radio station to be a part of the regular lineup. Back then, blacks had only worked at Top 40 stations doing separate programming, like specialty R&B shows. Leonard changed all that and, in the process, opened the door for many others during his fourteen-year stay at WABC. "Before I signed the contract they had to convince me I wouldn't be a 'show Negro,'" remembers Leonard. "I told the GM, 'If you're hiring me to be a token, I'm really not interested,' but ABC was a class organization. They sure knew how to spoil a guy."

Leonard's career began in the early sixties at WPGU and WILL on the campus of the University of Illinois. He was a jock on both stations, alternating among jazz, opera, and classical music shows. He became the first black program director for the university stations—a remarkable achievement at the time.

After graduation, Leonard worked the Negro radio circuit, with stints at WIN in Cincinnati, WEBB in Baltimore, and WWRL in New York. It was while he was at WWRL that he was heard by WABC's afternoon drive jock, Dan Ingram, who recommended him for the 10:30 P.M. to midnight shift. Eventually the shift became 10 P.M. to 1 A.M.

After leaving WABC in 1979, Leonard did morning and afternoon drive for eight years at WRKS (KISS-FM) in New York. In 1993 he was doing morning drive at WBLS, when I arrived as program director. At WBLS, where I found more political intrigue than I was comfortable with, Leonard helped me navigate the ter-

rain. We became fast friends and shared Ingram stories and jokes. We worked together until I left the station in 1995. Leonard still handles weekend shifts WBLS and does voice-over work.

Q: In a Gavin *interview in 1996, you said that today you're just competing against yourself—not trying to exceed but trying to excel. Are you saying that today the talent pool is not as intimidating as in years past?*

Chuck Leonard of WBLS

Chuck Leonard: At WABC, it was a challenge to try to outdo the other guys. Today, it's not because these young guys are subpar, it's because they're so rigidly controlled and afraid to let their personalities come through the format. They're afraid they might get noticed. [*Laughs*] It's a question of, do they want their audience to love them, or do they want to go to jock meetings and be pointed out as an example of what's bad. To me, formats are like castor oil. They're good for you, but if you stay on them too long, there will be side effects.

When a jock is trying to use his tools intelligently within the context of the format to create entertainment, he's working not just for himself, he's working for the program director. The PD should be allied with this. Rick Sklar would say, "The liners are there, but I don't want to hear anybody read them. The liners are written by someone other than you, and it's *not* the way you would say them. Make the intent of the liner your own."

Q: As a pioneering black jock on a major Top 40 station, you had no room for sloppy or bad breaks.

CL: Absolutely not. There is [still] no excuse for it. I was more demanding on myself than any of my program directors were. It became more difficult to meet my own standards, but that's the fun of it. That's how you prevent burnout, because you're constantly getting better.

Leonard's Lessons

Preparation

Proper preparation prevents piss-poor performance.

Fundamentals

If you don't have certain performing techniques and programming values, you're not going to make it in this business. The ability to read, ad-lib, and create the flow of a show—these are the things I consider fundamentals.

Teamwork

Teamwork goes beyond just cross-plugging. It's making sure that whoever follows you is brought into an environment which is conducive to his or her creativity. You must replace all sense of envy with a sense of belonging. Realize that sometimes you're a role player. Radio stations have positions much like a football team. The morning man might be your quarterback and your afternoon drive guy might be your fullback, and your evening man might be a wide receiver; but everybody has a job to do. You're all playing the game of football, but you're all playing it a little differently, because your position requires you to approach it differently.

Listeners

They should be your most precious friend that you give that extra moment to when they have a problem or a question. However, today, because of a lack of personal creativity, we tend to rely on the listener to produce excitement. Putting listeners on the air has led to listeners just mimicking themselves.

Q: Is there any one thing in particular you miss about WABC that you haven't experienced at any other station?

CL: One thing I definitely miss are the weekly music meetings. It was one of the most exciting parts of the ABC week. It made us feel like a team. Every

Tuesday at 10 A.M., we met in Sklar's office. Every jock was invited and in many respects was expected. We heard new music, filtered through Sklar's universe, and we gave him our feedback. We actually voted on records.

I remember we made Sklar add "MacArthur Park" and "Hey Jude" at those meetings. Rick didn't want to add them because they were such long songs, but our reaction was too strong, and he went along with us.

Q: WABC was a perfect example of great personality radio. That station sounded like no other. What made the chemistry of WABC unique?

CL: Part of it came from the direction. At WABC, I worked for a guy who was much maligned by record people because his playlist was so tight. But he didn't control the personalities as much as people assumed. Rick Sklar's philosophy was, "I hire intelligent people, because I know they're *not* going to make a fool of themselves too often. I tell them what I want, but I let them do it their own way." I think the challenge of doing it our own way kept things interesting for each jock.

Q: Who did you look up to in the business?

CL: The reason I'm in this business, more than anything else, is that I got inspired from listening to Sid McCoy (the voice of TV's *Soul Train*). When I was a kid, Sid was on WCFL in Chicago. He was just the smoothest, most professional-sounding broadcaster I had ever heard, and I wanted to grow up to be just like him. And a guy named Jim Randolph from Chicago, who was one of the first bright, young, black program directors. Jim was a professional back in the days when that wasn't prevalent. I must say that Dan Ingram is still the best format disc jockey I have ever heard. Finally, I like [famous New York air personality] Frankie Crocker's act. He is a good example of someone who has captured the concept of theater of the mind.

Q: What advice do you offer young people who want to become air personalities?

CL: There are no minor leagues anymore, so newcomers must listen a lot more keenly and do a lot more in-studio practice before they walk in. Today you have to jump in and swim with the big fish almost right away.

Unfortunately, this situation is going to push a lot of talent, who would have been a boon to the radio industry, into other entertainment fields, [into] careers that offer more tangible promise.

WNEW: Where the Memory Lingers On

After Infinity changed WKTU's format to AOR to align itself with all the other rock stations in their chain, most of the staff was laid off. The Madame stayed on in midday, but Ingram left. Jay Thomas soon headed for Los Angeles, where he landed at Power 106 and acted in various TV sitcoms. I went back to work for Metromedia. Vicki Callahan, a vice president whose executive responsibilities included WNEW, appointed me program director. My mother, who, sadly, was suffering from Alzheimer's by then, would have been very proud.

As a kid I used to listen to the *Milkman's Matinée Show* on WNEW late at night; I loved hearing Frank Sinatra's voice pouring through the yellow face of my old Philco radio. Decades later, when I landed the PD job at WNEW, I felt right at home. On the bulletin board above my desk was a sign that read: "It's Sinatra's world. We just live in it." We used to say that WNEW was the house that Frank built. Just as Sinatra was *the* pop star, WNEW had been *the* pop station. Of course, that was before the rock and roll revolution changed New York City's radio landscape forever.

My six-year reign as PD began in 1985, when WNEW was an aging AM music station that played American pop standards, big band music, Broadway show-tunes, and jazz. A 50,000-watt, full-service station with news and sports every half hour, WNEW also had music librarians who programmed by ear. These people were encyclopedic when it came to the music and those who composed it. When I got there, the station's music director, Tom Tracy, had been programming shows at WNEW for thirty-four years.

"It was November 13, 1951, and it was a Friday, when I was hired," remembers Tracy. "I was fascinated by the chandelier they had hanging in the lobby of the radio station. I was standing outside on 46th street looking in. Something

said: 'You should go in there and apply for a position.' Just as I started in, a woman got out of a cab in front of the station. I held the door open for her, she said hello and went inside. I followed her in and went upstairs to the receptionist desk. There was a guy reading a book with his feet up on the desk. When I reached the desk, the guy never put his feet down or took his eyes off the book. I asked him for an application for employment. Without looking up, he said, 'We don't have any openings.' I said thank you and turned to leave. That's when I noticed the woman I'd opened the cab door for, standing at the top of a stairway looking down at the guy and me. I said goodbye to her, she said goodbye to me, and I walked out. On Fifth Avenue a man caught up to me. He was from the station and said they wanted me to come back. I was taken into the office of Bernice Judis—the woman from the cab. She was the station owner (along with her husband Ira Herbert) and she said: 'You know what? I just fired that receptionist and I'm hiring you in his place.'"

Tracy retired from WNEW after working there forty-three years. What makes the story more incredible was that Tom Tracy was a young black man with no radio experience, who landed a job at the top New York radio station in 1951. "Quite rare in those days to find blacks working in pop radio, but that was the kind of place WNEW was," remembers Tracy.

Tracy and I hired a twenty-one-year old intern, Lenny Triola, at the music library because of his breadth of music knowledge and his devotion to Frank Sinatra. It was great to add another Sinatra fan to the family—especially one so young. Today, Triola is the entertainment director for Tavern on the Green in New York City.

"I was twenty-one years old when I started working in the library," remembers Triola. "It meant a lot to me as a young, insecure guy to be around guys like William B. Williams, Ted Brown, Les Davis, and Al 'Jazzbeaux' Collins. It built up my confidence. These guys had seen and done it all. I listened and learned a lot of great lessons on how to live my life. I was allowed to make mistakes. In five-and-a-half years in the music library I learned from the master, Tom Tracy, how to shape shows for each personality. I learned what was a New York record, and where the song fit into the history of the station."

Called a dinosaur by many, WNEW stubbornly held on to very respectable 35 to 64 numbers because of its lineup of strong, smart, stylish personalities including Ted Brown, William B. Williams, "Mr. Broadway" Jim Lowe, Al "Jazzbeaux" Collins, Steve Allen, our resident Sinatraphile Jonathan Schwartz, and Les Davis.

Davis, who began his radio career in 1959 at WBAI-FM in New York, grew up in the Bronx listening to WNEW. "To me, working at WNEW was equal to how most kids wanted to grow up and play second base for the Yankees," remembers Davis. "I wanted to work at WNEW. The station always sounded great. They had the best guys with the best balance of music, voices, and sophistication. I thought William B. Williams was the epitome of what a radio personality should sound like—polished. Williams was all over Manhattan doing live remotes and hanging with the stars. Man, that's what I wanted to do."

In 1965, Davis sent a tape to the station and was told by Chief Announcer John Dale that he would be put on the relief list. "I would have killed to get on the station then," says Davis. But it never happened. Instead, Davis developed his own legend. As the morning man at WRVR-FM, the city's first commercial jazz station, Davis became known for his live remotes from famous jazz clubs like Green Street, the Village Vanguard, and the Blue Note. In 1985, I hired Davis to do weekends at WNEW. Later, he did a nightly jazz show, eventually becoming the host of *The Make-Believe Ballroom* for almost three years.

The Chairman of the Board

Frank Sinatra's music had worked well as the backbone of our format for five decades, and we saw no reason to change horses. Unlike every other core artist I have ever dealt with, Sinatra never burned out.

Over the years, Sinatra's and WNEW's fame were wedded—for better or worse. In the early fifties, when Sinatra's career took a dip in popularity, WNEW never stopped playing his music. One guy in particular—William B. Williams, host of the *The Make-Believe Ballroom*—showcased Sinatra's music daily. It was Williams (we called him Willie B.) who dubbed Sinatra "The Chairman of the

Board." Every day from 11:30 A.M. to noon, WNEW would play a half hour of Sinatra's music, called *The Report from the Chairman of the Board*. Sinatra, known for his fierce loyalty, never forgot that Williams and the station believed in him when the arbiters of show business had pronounced him washed up.

The WNEW listeners identified with that intimate relationship, and it paid huge dividends for the station. It was the ultimate in branding; we were the Sinatra station. Jonathan Schwartz's *Sinatra Saturday*, a four-hour show devoted to the singer, was always a highly anticipated weekend event. We had more than nine hundred Sinatra songs in our music library, and for years we did a special promotion called "Sinatra A to Z," during which we played every song commercially released by Sinatra in alphabetical order, beginning with "A Baby Like You" straight through "Zing! Went the Strings of My Heart." That promotion began around noon on Thanksgiving Eve and ended late Sunday afternoon. We always left out one song and paid ten thousand dollars to the person who identified it.

In return for this support, "Ol' Blue Eyes" allowed us to use his image in our promotional campaigns. We were the only station that Sinatra would personally call to announce his latest album or concert dates; the only one on which he made personal appearances. He thanked us from the stages of Carnegie Hall and Madison Square Garden for our support. What more could you ask from a core artist?

"Some of my greatest memories of being at WNEW were when Sinatra was in New York," says Lenny Triola. "I remember walking over to the Waldorf Astoria, and you knew he was in there, listening. It was simply marvelous."

I was hired at WNEW for two reasons. First, my love of music. A well-rounded knowledge of American popular music was a prerequisite for any position at WNEW. In the early days of the station's history, personalities had to take a music test before they were hired. Everyone had to audition to prove they had the 'NEW sound. Secondly, I was hired to install some Top 40 formatic structure to improve the station's cume. Its TSL was one of the highest in the market, because of the tremendous loyalty of our listeners. Instituting any format change took ingenuity, because most of the veteran personalities were used to playing spots and the music any way they liked. They all considered contests things the "kid" sta-

tions did and frowned on the concept. Luckily, once they understood the benefits of clustering commercials, music sweeps, and engaging adult contests, they responded enthusiastically.

WNEW did things that other stations envied—like creative music selling and the use of humor—that kept loyal listeners laughing and informed. WNEW was a household name, widely considered a New York cultural institution. Whatever the age group or ethnic background, everybody knew WNEW was a class act that had a sacred connection to Sinatra.

Because of the Chairman's blessing, WNEW enjoyed great relationships with other artists as well, from Nat "King" Cole to Barbra Streisand. Every young artist who sang pop standards—Liza Minnelli, Michael Feinstein, Harry Connick, Jr.—graced our airwaves with their presence and music. We were the ship that launched—and helped keep afloat—the careers of cabaret singers, comedians, and casino headliners.

Recently, I've rediscovered some of the great moments, stories, and people I met while working at WNEW. It was truly a special place for many performers—and especially for all of us who were fortunate enough to work there. Of all the great artists I met while working at WNEW, Ella Fitzgerald stands out.

My love affair with Ella was well-known all over New York City. Every Saturday for two years, Ella and I would spend the afternoon together on *Everything Ella*—two hours of nothing but Ella singing with the greatest musicians in the world. Some of my friends and associates called it a shameless love fest.

Ella and her peers created music that passed from one generation to another. Their songs are an intergral part of growing up in America. I remember voicing my concern for the life of the station to William B. Williams, who answered optimistically: "As long as men and women fall in love, the lyrics and the melodies will linger."

Unfortunately, despite William's optimism, it looks like this tradition has come to an end. WNEW is now a part of radio history, a victim of leveraged buyouts and cutbacks at the hands of cold-blooded suits who took over the station in the late eighties, chanting the mantra, "This is a business, not an art form." First to go was Vicki Callahan; her sympathetic stand and belief in the

station's format didn't fit the new mold. Next to go was the twenty-four-hour news department, followed by a severe cut in the hours of music played on the station. It was replaced by syndicated programming that ran the gamut from call-in psychiatry to sports shows. The inconsistencies in the station's programming caused a sharp drop in listeners and revenue. What our new operators couldn't grasp was that, if radio is to flourish as a business, it must be a quality product.

Today there are only a handful of stations playing standards, big band, jazz, and Broadway showtunes. The music of Ella, Frank, and Irving Berlin has been typecast as appealing only to listeners over the age of 50, a hard sell to bottom-line-oriented managers and ad agencies, whose ideal audience is made up of professionals. Thus the music is usually relegated to the AM band.

The death of Ella Fitzgerald in 1996 and Sinatra in 1999 signaled more than the silencing of two of the greatest pop singers of all time. As long as Ella and Frank were alive, I knew that the great American song had two magnificent ambassadors—and maybe, just maybe, some enlightened broadcasters would embrace popular standards and give them renewed life on the radio.

When Ella fell ill in 1993, my mind immediately flashed to Carnegie Hall in 1988, Ella and her "Sweet 16" voice bowing gracefully after her third standing ovation. That's the Ella I'll always remember—the timid, shy woman whose pure and innocent singing had such sweet-natured power over her fans. It was the power of *Everything Ella*.

Fittingly, it was Lenny, the young music librarian, who called to tell me about Sinatra's passing. I pulled out a tape from my WNEW tape archive and listened to a William B. Williams interview with Sinatra. I listened to the warm rapport between the two friends and remembered Sinatra sitting next to Willie B. at a live remote in the lobby of the Waldorf Astoria. I remembered watching Sinatra hosting a memorial service for his friend Willie at Riverside Memorial Chapel.

On the tape, Willie B. asked Sinatra how he wanted to be remembered: "I'd like to be remembered as a man who was as honest as he knew how to be, in his life and in his work. I'd like to be remembered as a decent father, a fair husband, and as a wonderful grandpa. I'd like to be remembered as a loyal friend."

A hundred years from now, when people are trying to find out what gave the twentieth century its pulse, all they'll have to do is listen to tapes of Sinatra and WNEW.

Seek

It was a golden October day in 1989; the kind of day that made Manhattan sparkle and filled all its inhabitants with confidence. I was at the top of my programming game. I had injected WNEW with just enough Top 40 formatics to turn the New York institution into a hip cultural icon. The seasoned staff had fused into a passionate community, committed to establishing themselves and the music they treasured as vital in the greed-ridden days of eighties radio. I was being handsomely compensated. Physically, I was in the best shape of my life, and I was madly in love with my new bride. And yet, even though I had traveled from market 129 to number one, I felt like something was missing.

I was on my way home that evening, walking down the brownstone-lined streets of Clinton Hill, Brooklyn. I was wearing an expensive suit. In my briefcase was an expensive bottle of wine and in my other hand was a bouquet of flowers. As the sunlight danced on the historic buildings and the leaves fell softly like in a Frank Capra movie, something whispered to me: *All is not well.* I stopped in my tracks. My first reaction was fear. Had something happened to my wife? But quickly the voice spoke again and dispelled my worry. The voice said: *Something is missing. Look within yourself.*

The voice was so close that I looked around. I saw nothing but the shimmering fall landscape and the sun setting behind the chimney of a brownstone. I walked on and enjoyed a wonderful night with my wife. It wasn't until a few years later, when I was fired after six years at WNEW (I lost the battle of trying to keep music and personality the focus of the station), that the voice returned and gave me more direction. This time the voice had a body attached to it.

I was home in upstate New York, visiting the church of my youth, when the Reverend Franklin Upthegrove said, "Many times we feel like we're on top of the world. Mentally we're stimulated and active. Physically we're feeling fine

and our bodies are strong. We feel complete. But let me tell you this: There is something missing. And I believe it may be the most important part of the puzzle of life. Spirituality. Without a belief system, you cannot fuel the other two parts. To be a complete human being you must be awake, aware, and in tune with your surroundings. You must have the mental, physical, and spiritual resources all balanced in your life."

That moment changed my life. Suddenly, previous events in my life became crystal clear.

In the ego-driven culture of radio, where such a high premium is placed on individual achievement, I was blinded for years by my own self-importance. I believed that as long as I was sounding good, the whole station prospered. I thought that as long as my career was successful, my marriage would blossom. As a young man, I was completely obsessed with my career and ignorant of any concept of balance between family life and work. I learned the hard way that the only path to number-one radio stations or happy marriages is a shared one. In business or marriage, you either grow together or you grow apart.

My first wife once said to me, "You love radio more than you love me." Looking back, I remember how I loved being on the air. I wasn't truly alive until I did an airshift. I was addicted to the bursts of creativity from break to break. I thought of each set as a momentary piece of disposable pop art. After an airshift, it would take me hours to come down from the adrenaline high of performing. After every broadcast I would listen to an aircheck, searching for moments of brilliance—I usually ended up cringing and wincing at breaks I should have executed better. I was dedicated to the idea of becoming great, and my obsession cost me a great deal on a personal level. But it also took me on a strange and wonderful adventure that redefined my idea of artistic expression.

I was too young to realize that all the adversity and stress I was suffering would later come to shape my ideas about coaching. The distance that my divorce demanded (I was nineteen years old when I got married and divorced after eleven years), along with its sadness and confusion, caused psychological wounds

in my sons and myself that still seek redemption today. However, it produced a nurturing side in me that continues to evolve. Part of my motivation is rooted in a haunting feeling I have, the result of my inability to mentor my boys as they grew into teenagers. That void translates now into my desire to support other young people in radio; caring about and nurturing somebody else's children. This is how my personal agenda began to unfold—from me and my show, to a profound interest in coaching others.

Shortly after my ouster from WNEW I was reminded again that I wasn't yet spiritually connected. I had reached some economic success, but I wasn't making an impact in my profession, or society. I realized that, although nearly thirty years had passed since my career had begun, there were still only a handful of black radio professionals crossing over behind me. The radio community that I love and became a member of in 1968 was becoming unrecognizable—the yellow light of creativity that made it great was dimming.

I decided to take action. I decided that I would become a coach, and find creative expression and personal fulfillment in my work by sharing my knowledge and encouraging others to do so. But first I had to find a spiritual understanding that I could connect with.

I was depressed after losing the WNEW job, because I had become so emotionally attached to that station. In retrospect, it was my commitment to the music format that caused differences with the GM who wanted to take the station in a different direction. The way I felt reminded me of what Bill Tanner once told me that consultant John Rook used to say about radio: "Never waste too much energy on something you're not having sex with." Programmers get so attached to radio stations that they become crippled. But that was the only way I knew how to program.

In an effort to get me out of my funk, my wife, Carla, took me to a neighborhood church that she had recently joined. There I met and heard the Reverend Dr. Herbert Daughtry for the first time, and for the first time I understood the meaning of faith. That day, Daughtry explained success with this simple equation: Keep God first, and He will keep you first.

In a series of sermons he called "The Kingdom of God Is within You," he laid out his seven-step plan to success:

1) *Clarification.* Be as definitive as you can be about the idea or goal you desire.

2) *Concentration.* Think about it. Focus on it. Direct your full attention to it.

3) *Association.* Associate your idea with positive experiences.

4) *Repetition.* Repeat the idea over and over.

5) *Visualization.* Visualize the idea. Imagine it. Think it. Feel it.

6) *Meditation.* Let your mind caress the ideas. Nurse them. Ponder them. Explore them.

7) *Actualization.* Act on the idea, however feebly or haltingly. Release your faith.

For me, this was a great beginning. Daughtry and his system of faith and prayer opened the door for me. I would enter his church on Sundays and continue to "soul search" and practice, all the while increasing my faith.

I wasn't sure what I wanted to do anymore. I starting writing to help exorcise some of the demons brought on by my depression. I wasn't sure if getting emotionally involved with another radio station was the wise thing for me to do. So I did what my mother would have done—I went to see a fortune teller.

Carla recommended a woman named Lorraine Nightheart, and played me a cassette of one of her early visits. I was impressed with this woman's insights into a person she had never met before. Minutes after arriving at Lorraine's West Side apartment she said to me, "You need a cause. You need something to hook your soul into. That's why you're feeling frustrated with your career. Things are going okay; it just doesn't have any soul. It's not resonating. This is what you need to be writing about. Writing about your own process. The light is starting to come on for you. You're trying to break through fixed opinions. Just write, because that is the nature of who you are."

My writing journey started with an unproduced screenplay. To keep writing—and eating—I took a position as a morning show producer at WQCD (CD

101.9) and began contributing movie, book, and play reviews for the station. Later, I became their in-house consultant. Then Jerry Clifton called, and I went back to programming as operations manager of KBXX (The Box) in Houston.

I had mixed feelings about leaving New York and moving to Texas. Carla and I were expecting our first child, heading out to unknown territory. But The Box turned out to be a great experience. GM Carl Hamilton, and PD Robert Scorpio were very inspirational. Hamilton preached family values and introduced me to new motivational methods and books by Tom Peters and Pat Riley. He taught me how to create a value system within the staff that increased loyalty and teamwork. Hamilton also encouraged me to write.

Scorpio (now the station's OM) was the best example I've known of a programmer absorbing his marketplace. His knowledge of Houston, its people, customs, musical tastes, and trends was uncanny. He worked hard and stayed in the streets. I never worked with a more in-touch contemporary programmer. We divided responsibilities and I like to think we taught each other a lot. For his part, he encouraged my storytelling. And I would use some of his suggestions at jock meetings where we shared the responsibility of dealing with the talent. It was in Houston that I began to form the idea of a book on radio fundamentals.

A year later, Clifton had me back in New York City, programming WBLS-FM, another legendary station that had slipped in the ratings. The experience would rank as my all-time worst if it weren't for the incredible personal relationships that I made and strengthened during my two years there. I got to work with Chuck Leonard, I was reunited with Batt Johnson and my former long-time assistants, John Mullen and Bill Singleton. I met new talents like Helen Little, who I hired for middays and as music director. (She is now OM for WUSL-FM, Power 99, in Philadelphia and Urban format director for AMFM.) Robert "Hollywood" Rhodes, a part-timer who I put in afternoon drive, is now production director of WJLB-FM in Detroit. These people, along with many excellent support staff members, helped raise WBLS back to a competitive level.

The WBLS experience drove home the point that there were a lot of newcomers as well as veterans who lacked basic radio fundamentals. At WBLS, most of the on-air staff I inherited were completely unaware of skills such as efficient backselling or effective cross-promotion. Even members of the off-air staff, in

prominent positions, lacked the in-depth industry knowledge necessary to grasp key marketing and branding techniques.

In discussions with other programmers across the country, I discovered that this problem was not unique to New York. There was a need across the radio landscape for coaching and leadership, and I wanted to help. But first I had to face the conflict in my heart. Was I committed enough to my new vision of mentoring to give up a lucrative lifestyle of major-market programming?

I realized that I could only help if I stopped programming stations—where I was only able to reach a small fraction of people. I needed a position where I could connect with a greater number of PDs, MDs, personalities, and newcomers. I incorporated Reverend Daughtry's seven-step system into my life plan, and within a few months, I was offered and accepted the Urban editor's job at *Gavin* magazine. Just as Lorraine had predicted, I found my cause, writing for the one and only trade publication dedicated to helping radio professionals thrive.

Bill Gavin

Bill Gavin had inspired me as far back as my first years as a radio professional. I remember one particular editorial of his from 1972. He wrote:

What can be wrong with a rigidly controlled sound is that eventually, its utter sameness tends to reduce listener interest. Pop music never was and never will be a segregated type of format. There are no color barriers or sound barriers to the music that people like. Integration in music, as anywhere, involves acceptance of differences. Each record should be judged on its own individual merit. True tolerance and understanding of many musical forms are essential ingredients for the music director's job. They are also great assets for the person who sets the course of the station's music policy.

The first time I read this quote, I was a twenty-two-year old air personality trying to make my mark in Top 40 radio. That quote was welcome music to my soul, because I was praying that leaders in the business would take Bill's mes-

sage to heart. This was back in the day when radio was *more* segregated than it is today; not only was crossing over black music a triumph, but adding a black air personality to a Top 40 station lineup was an heroic gesture.

I didn't know Bill Gavin when I read those words of inspiration, but he instantly became someone I wanted to meet. His words indicated that he understood the struggles of black musicians and jocks who were trying to become a part of mainstream radio. Later, when I became a music director and PD, I made those words central to my programming philosophy.

The first time I met Bill Gavin was in 1975 at one of his regional gatherings in Florida. I was music director for WHYI (Y-100) in Fort Lauderdale/Miami. Bill Gavin asked Assistant PD Robert W. Walker and me to attend a meeting in Cocoa Beach to discuss what made The Y a successful radio station. The setting was a small roadside motel, and its cozy conference room was filled to the brim with radio people from all over the state—thirsty for knowledge.

Our surroundings weren't fancy, but Bill Gavin was there, and he kept everyone on point by asking probing questions that made us all dig deep for answers. It was at this meeting that I realized that radio is a collaborative art form. I learned a lot about what worked in other markets and some new things about myself. But more importantly, I developed friendships that have continued to this day—and a lasting respect for Bill Gavin's honest approach to radio programming.

Bill Gavin's initial commitment to educate radio people has grown over the years into the industry's best radio conference. His love for diversity in hit music and creative radio has inspired thousands of radio professionals—myself included.

It's been four years since I started writing for *Gavin*. From the start, my goal was to help radio professionals do their jobs better. In my columns, I have presented ideas from programmers, consultants, computer experts, and visionary writers and thinkers. I've dealt with issues that enhance and endanger our radio culture. And, once in a while, I allow myself to lapse into some radio reverie. Although I write primarily for Urban radio, I like to think that the series of columns I write under the umbrella "Radio Paradise" are possible creative scenarios for the entire radio landscape.

24

My Radio Paradise:
A Dream Convention

Aretha Franklin's rousing renditions of "Amazing Grace" and "Lift Every Voice and Sing" rallied the spirits of the thousands of conventioneers. When keynote speaker Henry Louis Gates, Jr., chair of the Department of Afro-American Studies at Harvard University, took the stage, he got right to the point: "In part because of traditional homophobic tendencies in our culture, and in part because of ignorant stereotypes about HIV and AIDS, our people—our leaders—have been in denial."

The audience met his statement with reflective silence. Gates, pounding the podium, asked, "With this virus posing what I believe is the biggest threat to black folks' freedom since slavery, why isn't there a sense of urgency in our community to end this epidemic? Why have the NAACP, the NBPC [National Black Programmers Coalition], the National Black Caucus, and the majority of black churches refused to take on this fight?"

I looked around the room at all the black radio and record executives, who have the power to reach the very people who are being rapidly eliminated by HIV and AIDS, and wondered: Why have they failed to beat the tribal drum of warning? Are we under a spell of the blues? Is this a wicked curse that has impeded our ability to take action? Gates concluded his speech with the chilling phrase "Denial is death!"

The convention hall erupted with thunderous applause, which soared when Gates opened the curtain behind him and out walked Kwesi Mfume of the NAACP, Congresswoman Maxine Waters of the National Black Caucus, and Irene Ware of the National Black Programmers Coalition. Gates led them to center stage, where they all joined hands as a symbol of their commitment to join forces against our toughest enemy. Just like in church, everyone began shaking hands with the person next to them. Some were raising clenched fists into the air, shouting, "Denial is death!" over and over again.

As we filed out of the meeting room, members of the NBPC board of directors handed out pink flyers announcing "Afro-American AIDS Awareness Day." On this day, every black music station in the country would stop playing music for twenty-four hours and dedicate its entire broadcast day to AIDS and HIV programs and information.

The next meeting I walked into was "How to Buy a Radio Station." The place was packed. On stage, moderating a panel of investment bankers and brokers, was CEO of Radio One, Inc., Cathy Hughes. Her co-moderator was John Douglas of Douglas Broadcasting. Hughes and Douglas are the two African Americans who own the most radio properties in the country. Hughes was saying, "The way I got into the business—with a low-powered stand-alone AM—is not financially feasible now. It's even difficult to get financing on a combo. Right now, the banks are looking for multiple purchases. Even trying to get one station in a small market is nearly impossible, because the financing is just not there. But remember this: Just because the road I traveled has been plowed over does not mean we can't cut another road through the woods."

Later, I opened a door with a sign on it reading, "The Mentoring Room." Inside at various tables, students visited with station owners, GMs, OMs, and PDs. There was a huge sign-up board and several computers posting information about jobs, internships, and networking organizations around the country. The next thing I knew, I was on stage addressing this roomful of young faces: "One theme that pulses through the 'Urban Landzcape' is our desperate need for a mentoring program," I began. "We need to energize and organize young black programmers and record professionals, and help them develop into dynamic leaders.

"We all agree that the issues of deregulation, consolidation, downsizing, syndication, racism, and sexism can be overcome if our leaders—those with proven track records—begin passing on knowledge and encouraging growth. Today is the beginning of that process."

After lunch, I found a session called "Youth Workshop." I stood in the back and listened as Reverend Herbert Daughtry told the crowd, "We must teach our daughters to ignore songs and music videos that compare them to a jeep or portray them as unlovable 'bitches and hos.' We must teach our daughters and sons to be media smart: Ignore movies, television shows, billboards, and magazine ads that consistently encourage the use of alcohol, tobacco, drugs, violence, and unhealthy foods."

In my wanderings, I discovered an exhibit of photographs—Louis Armstrong, Bessie Smith, Duke Ellington, Count Basie, and Jimmy Rushing. On stage, a sign read, "Survival Through the Blues." I soon found myself mesmerized as Albert Murray read from his book, *Stomping the Blues*:

> The blues as such are synonymous with low spirits. Blues music is not. With all its so-called blue notes and overtones of sadness, blues music of its very nature and function is nothing if not a form of diversion. With all its preoccupation with the most disturbing aspects of life, it is something contrived specifically to be performed as entertainment. Not only is its express purpose to make people feel good, which is to say in high spirits, but in the process of doing so it is actually expected to generate a disposition that is both elegantly playful and heroic in its nonchalance.

From behind Murray, a quartet led by Wynton Marsalis began playing Louis Armstrong's "Potato Head Blues." The mood of the music was joyous and up-tempo. *Webster*'s definition of the blues as always being melancholy, slow-paced songs, became suspect. Blues music is about heroism, survival techniques, resilience, honor, nobility, dignity, and perseverance. In other words, the blues have always gotten us through.

I crossed the hall and entered a room that was decorated like a 1940s nightclub. Onstage, an elegantly dressed orchestra was setting up. A few minutes later,

Quincy Jones walked on stage in black tie and tails, carrying a baton. "Ladies and gentlemen, welcome to the 'Jazz Is You' workshop," he said. "This all-star group of musicians and I are going to take you through a quick-but-dazzling history of jazz, from its blues roots in New Orleans to its transformation into an art of universal import." With two taps of his baton, the orchestra (which included some of the world's finest musicians: Ron Carter, Benny Carter, Sonny Rollins, George Benson, McCoy Tyner, Jimmy Heath, Wallace Roney, Roy Hargrove, and Al Foster) began playing "Buddy Bolden's Blues" from 1902. The band segued into medleys of Memphis and St. Louis blues. Then something amazing happened....

Duke Ellington took the baton from Quincy Jones, and Count Basie sat at the piano with McCoy Tyner. Lester Young, Coleman Hawkins, Charlie Parker, and Miles Davis joined the horn section. Art Blakey sat next to Al Foster on drums. Out walked Ella Fitzgerald, Sarah Vaughan, and Louis Armstrong as the band began playing "Stomping at the Savoy." The three legendary singers began swapping verses and scatting ad-libs. Everybody started dancing, swinging, spinning, twisting, and kicking their legs up high. For a while, we were transported back to the old Savoy Ballroom, once the glory of Harlem, and for a short time, like many before us, we were stomping our blues away. For the moment, forgotten were the AIDS epidemic, the closing windows of economic opportunity, and the continued struggle for respect that black music professionals face on a daily basis. We were celebrating in music and dance our new goals for self-improvement and survival.

I rolled with the music from one side of my bed to the other, hoping to keep the dream going. Then I realized if I wanted to see any of the dream scenes come true, I should wake up, write them down, and share them.

AIDS awareness. The power of ownership. Teaching youth right and wrong. Expanding the horizons of the blues and the heritage of jazz. Celebrating ourselves. It all begins with waking up.

Bibliography

Albom, Mitch. *Tuesdays with Morrie*. New York: Doubleday, 1997.

Autry, James A., and Stephen Mitchell. *Real Power: Business Lessons from the* Tao Te Ching. New York: Riverhead Books, 1998.

Dru-Marie, Jean. *Disruption: Overturning Conventions and Shaking up the Marketplace*. New York: John Wiley & Sons, Inc., 1996.

Fong-Torres, Ben. *The Hits Just Keep on Coming: The History of Top 40 Radio*. San Francisco: Miller Freeman Books, 1998.

George, Nelson. *Buppies, B-Boys, Baps & Bohos: Notes on Post-Soul Black Culture*. New York: Harper Collins, 1992.

Goleman, Daniel, Paul Kaufman and Michael Ray. *The Creative Spirit*. New York: Dutton, 1992.

Gordon, Nightingale. *WNEW: Where the Melody Lingers On*. New York: Nightingale Gordon, 1984.

Halberstam, David. *Playing for Keeps: Michael Jordan and the World That He Made*. New York: Random House, 1999.

Hamill, Pete. *News Is a Verb: Journalism at the End of the Twentieth Century*. New York: Ballantine Books, 1998.

Jackson, Phil, and Hugh Delehanty. *Sacred Hoops: Spiritual Lessons of a Hardwood Warrior*. New York: Hyperion, 1995.

Kao, John. *Jamming: The Art and Discipline of Business Creativity*. New York: Harper Collins, 1996.

Mayer, Jeffrey J. *Time Management for Dummies*. Foster City, California: IDG Books, 1995.

Mikes, Jay. *Basketball FundaMENTALS: A Complete Mental Training Guide*. Champaign, Ilinois: Leisure Press, 1953.

Miller, James B., and Paul B. Brown. *The Corporate Coach: How To Build a Team of Loyal Customers and Happy Employees*. New York: Harper Business, 1993.

Miller, William C. *The Creative Edge: Fostering Innovation Where You Work.* Massachusetts: Addison-Wesley, 1987.

Murray, Albert. *Stomping the Blues.* New York: Da Capo Press, 1976.

Nachman, Gerald. *Raised on Radio.* New York: Pantheon Books, 1998.

Peters, Tom, and Nancy Austin. *A Passion for Excellence: The Leadership Difference.* New York: Warner Books, Inc., 1985.

Riley, Pat. *The Winner Within: A Life Plan for Team Players.* New York: Simon & Schuster, 1993.

Schwartz, Peter. *The Art of the Long View: Planning for the Future in an Uncertain World.* New York: Currency Doubleday, 1991.

Sklar, Rick. *Rocking America.* New York: St. Martin's Press, 1984.

Articles: Magazines, Newspapers, and Miscellaneous

Abbott, Spencer. "Wake Up! A.M. Personalities Sound Off." *Gavin,* 16 October 1998.

Adelson, Andrea. "Coming Soon to a Radio Near You." *The New York Times,* 28 December 1998.

Bunzel, Reed. "PD Crunch." *Gavin GM,* September 1997.

Bunzel, Reed. "What Is Branding?" *Gavin GM,* January 1997.

Diamond, David. "What Comes After What Comes Next." *Fast Company,* December/January 1997.

Drew, Paul. "New Ideas for Radio's Next Century." A speech presented by Paul Drew at the Radio Only Management Conference, 3 May 1996.

Hamilton, Bob. "Jerry Clifton: Program Director." *The Hamilton,* 16 May 1983.

Labaton, Stephen. "Refereeing the Future." *The New York Times,* 11 April 1999.

Pareles, John. "Fracturing the Formula: A Hope for the Offbeat on Small FM." *The New York Times,* 9 February 1999.

Schrage, Michael. "The Gary Burton Trio: Lessons on Business from a Jazz Legend." *Fast Company,* December/January 1997.

Siklos, Richard, with Ronald Grover. "Can Mel Karmazin Reinvent Network TV?" *Business Week,* 5 April 1999.

Weinstein, Bob. "Networking Is Not Just for Computers." *San Francisco Sunday Examiner & Chronicle,* 25 April 1999.

Zoll, Daniel. "Bad Reception." *San Francisco Bay Guardian,* 25 November 1998.